Introduction 5

1. Pre-production – Planning and Scriptwriting 25

2. Pre-production – Concepts, Ideas and Research 47

3. Pre-production – Development 73

4. Pre-production – Sound 105

Related study material is available on the Laurence King website at
www.laurenceking.com

Animation

Andrew Selby

Laurence King Publishing

LAURENCE KING

Published in 2013 by
Laurence King Publishing Ltd
361–373 City Road
London EC1V 1LR
Tel: +44 20 7841 6900
Fax: +44 20 7841 6910
e-mail: enquiries@laurenceking.com
www.laurenceking.com

A catalogue record for this book is available
from the British Library

ISBN: 978 1 78067 097 3

Design: Unlimited
Series designer: Jon Allan, TwoSheds Design
Picture research: Jemma Robinson

Front cover image: *Lost and Found*, produced by
Studio aka; based on the book by Oliver Jeffers;
adapted and directed by Philip Hunt
Back cover image: Toon Boom Storyboard Pro
Images, courtesy of Toon Boom Animation Inc. –
toonboom.com

Printed in China

Animation is a compelling and extraordinarily adaptable form of audio-visual expression that is highly effective in fusing moving images and sounds together to tell stories and explain ideas. The medium allows exponents to explore theories and inform audiences, and its flexibility as an artificially constructed form means that it is well suited to a vast range of communication applications. From obvious examples such as films, television series and advertising commercials, through developing uses such as websites, mobile applications and gaming, to more diverse applications in the fields of medicine, engineering and architecture, animation proves that it is a medium that has the ability to entertain, inform, educate and inspire. Animation permits and encourages the creation of cinematic visual trickery by making unreal events seem real and transporting an audience to new places of discovery. Major Hollywood studios are increasingly turning to animation and special effects (SFX) techniques to realize their creative ideas, and other organizations and governments are also waking up to the possibility of using animation to explain, reinforce or promote their message.

In recent decades, animators have found increasingly inventive ways of using animation. Today it pervades much of the landscape of popular culture, being a medium of choice to push boundaries, cross traditional disciplinary divides and support and enhance other creative work. While animation's history is relatively short compared to other arts disciplines, this needs to be juxtaposed against the prolific and accelerated advances in technology, such as the growth of the Internet, the developing reliance on mobile technology and the need for greater visually oriented support for social media. Such technical leaps have created changes in global social and economic conditions and have encouraged increased interest in the subject of animation – an interest that is likely to grow and spread over the coming years.

The spirit of animation as an evolving form of audio-visual expression is encapsulated by Oskar Fischinger's *Kreise*, released in 1933.

The significance of animation

In his book *The Fundamentals of Animation* (2006), Paul Wells states that: 'Animation is the most dynamic form of expression available to creative people.' When one starts to examine the subject in depth, it becomes clear that animation has a profound effect on the daily lives of many of us. Most people experience animation through children's television programming and animated feature films. Some of the greatest sequences in world cinema are animated feature films that are etched into our collective memories. Who can forget the magical 'The Sorcerer's Apprentice' sequence in the 1940 film *Fantasia*? Or, in the more recent realms of animation history, the enchanting story of Carl and Ellie's love affair, life and passing, in the Disney•Pixar animated feature film *Up* (2009). These collective memories and experiences are largely attributed to the dominance of the greatest pioneer in animation history, Walt Disney (1901–66). The impact that the Walt Disney Studios has had on cinema audiences – indeed on popular culture generally – is vast and far-reaching, albeit supported by important outputs from Warner Bros. and UPA (United Productions of America). However, this American 'super studio' dominance has also meant that other versions of animation have sometimes been overlooked or not given the credit they deserve by mass audiences.

For many, the true significance of animation can be measured by such elements as its inclusion in the annual Academy Awards, the growth of international film festivals, the distribution of feature films, documentaries and short films on cable or satellite channels, and the Internet revolution that has opened up new audiences for the form globally. Furthermore, the study of animation as a subject in its own right – including its history, technical advances and wider cultural context – is recognized through a multitude of internationally published specialist magazines, academic journals, seminars and conferences, trade magazines, online forums, blogs and microblogs.

Walter Elias 'Walt' Disney (1901–66) is indelibly linked to the growth and development of animation. The company he co-founded with his brother Roy, the Disney Brothers Cartoon Studio, has today evolved into The Walt Disney Company and is a media and entertainment powerhouse.
© Disney

Uses of animation

Animation has the potential to reach developed, fledgling or emerging audiences in a way that live-action film is unable to because of subjective, cultural or technical shortcomings. The form can seemingly make the 'impossible' possible and has the potential to communicate with young and old alike, regardless of ethnicity, gender, religion or nationality. If used intelligently, animation can draw viewers together, crossing boundaries and uniting audiences under thematic ideas and concerns, making it a very attractive medium for artists, designers, producers, directors, musicians and actors to use to recount stories, ideas and opinions to a diverse range of cultures.

In many walks of everyday life animation is used to explain concepts, deliver important information, promote goods and services, and keep us on the move. Over the last few decades, animation has played its part by both driving and supporting the technical and conceptual demands of a wider

world. We now see the medium used to track satellites orbiting the earth, explain the power of the planet's weather systems on oceans, mountains and deserts, predict the force of earthquakes or suggest possible worlds beyond our solar system. Animation is employed to deliver specific engineering data, integrate complex pharmaceutical and clinical procedures, and develop research models to enable a broad range of activities to occur in many different and varied fields. From being the central core of an animated feature film or supplying particular special effects in a live-action feature, right the way through to animated applications on a mobile phone or animated navigational buttons on a website, animation has a role to play in imparting content to the audience.

A model for future communication

The success of animation as a communication form in the future may lie in its residual power to be designed and read in myriad screen formats. The advent and growth of digital technology has revolutionized the way that audiences access and watch animation. Digitization has streamlined the production and delivery of animation and has broadened the scope for audiences to become familiar with the subject. Cinema and broadcast media have evolved with three-dimensional (3D) projection, specialist surround-sound features and satellite and cable content, but with the development of mobile technology delivery is no longer confined to a fixed place, meaning that animated functionality and content features widely on games consoles, smartphones and MP3 players. Furthermore, animation is also 'screened' in increasingly unconventional yet interesting ways as part of live-action performances, art installations and exhibitions and in virtual- or augmented-reality worlds where it can either lead or support other material.

Animation is also able to contribute towards our understanding of the shape of our future. Unlike live action, animation can be used to creatively predict scenes through imaginary visualization, rather than simply record events or situations from life. Additionally, certain animated sequences have the advantage of being significantly cheaper to produce than live-action equivalents, and can provide greater information for the audience in a fraction of the time it would take to explain these occurrences in the real time of live action, as information can be overlaid or run concurrently, enriching the viewing experience.

Animation can also borrow, appropriate and assimilate other research material from compliant resources. A good example is beamed satellite information in the articulation of animated maps on satellite navigation systems in vehicles. The animated graphical user interface (GUI) is designed to present this instant information to the driver of the vehicle clearly and coherently, not only finding the way to a destination, but also updating data to warn of hazards that lie ahead and communicating alternative actions.

The world of augmented reality through mobile devices opens up huge possibilities for animation to play a vital role in imparting and explaining

Animated physics-based simulations are used to spectacular effect at the American Museum of Natural History, where the film *Journey to the Stars* explores the life cycle of stars through an immersive audience experience.

French pioneer of early cinema, Georges Méliès, experimented with techniques such as double exposures and dissolves in his magical fantasy, *Le Voyage dans la Lune* (*Voyage to the Moon,* 1902).

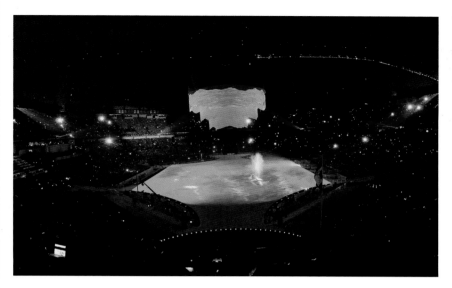

The special effects created by Spinifex for the opening ceremony of the 2010 Winter Olympics in Vancouver, Canada, merged 3D animated whales projected onto a virtual Pacific Ocean inside the stadium, with each breach triggering a physical waterspout.

information from a remote source in a real-world, real-time setting. Various organizations, institutions and groups are focused on exploring the possibilities of this emerging technology for industrial, economic and personal use, whether through illustrating animated walk-through visualizations of property for sale, providing interactive museum or gallery guides, or making hiking more exciting by providing an interactive commentary and alternative view of the outdoor landscape.

The defining principles of animation

The word 'animation' derives from the Latin verb *animare*, meaning 'to give life to', suggesting that the *illusion* of movement has been given to inanimate forms. Animation essentially involves the artificial creation of images in a sequence that appears to move through the 'persistence of vision': our eye reads the images in quick succession and our brain tricks us into believing that the images are moving. In reality, the movement is created by the spaces in between the frames. The Scottish-born animation pioneer Norman McLaren famously said: 'Animation is not the art of drawings that move, but rather the art of movements that are drawn.'

In technical terms, the basic principle of creating animation is that images are captured singly through a photographic lens or a scanner in a predetermined order. These shots become records of the single images and are known as 'frames'. When the recorded frames are played back in chronological order, they create a collection known as a 'sequence' that appears to make the images move on screen. Different frame rates are required for different viewing experiences. For example, a common frame rate is 24 frames per second (fps) for television and film production (although some countries' broadcast formats differ, and 25 fps is a recognized format),

but where animation is created for online output, slower data-processing speeds caused by reduced or fluctuating bandwidth mean that a reduced number of frames is preferable, despite altering the fluency of movement.

Capturing individual frames on flat surfaces (paper, cels or digital files) relies on 'registering' or 'keying in' individual frames into an exact position so that the shooting of each frame is consistent and controlled. Through the digital advances that have been made from the traditional approach to animation, pioneered throughout the first half of the last century, much of traditional cel drawing and painting is now done digitally. The process of stop-motion animation involves the gradual movement of an object or artefact under or in front of a fixed or incrementally moving camera, capturing each slight movement as a single frame, and then playing this back to see a progression of recorded moving imagery.

While good animation requires technical knowledge and understanding to produce smooth, logical and coherent movement, great animation assumes this knowledge as a given and provokes and entices the creator to produce work that synthesizes technical prowess with more substantial emotive and conceptual ideas, celebrating and enriching the central idea, theme or narrative of the production.

These background cel paintings from the animated feature film *Akira* (1988) demonstrate the layering technique employed to create complex scenes using registration marks to ensure continuity.

Twelve principles of animation

In 1981, legendary Walt Disney Studios animators Frank Thomas and Ollie Johnston (two of Disney's 'Nine Old Men') set out some defining principles of the form in their book *The Illusion of Life: Disney Animation* (1981). The title alludes to a central theme in animation education – that if creators using animation desire the ability to reimagine life, they must first understand the nuances of life itself. The book describes twelve central principles to link animation to the natural laws of physics while embodying the idea that the process of animating could contravene and contradict these laws within reason. This logic would be an unwritten trust between the animator and his or her audience.

Two of Walt Disney Studios' 'Nine Old Men', Frank Thomas and Ollie Johnston, believed that creating lifelike animation could only be achieved by understanding the nuances and complexities of the natural laws of physics applied to the human body. © Disney

- **Squash and stretch** – this principle acknowledges that objects have an implied weight and flexibility, and recognizes that when an object moves, its weight shifts through the flexing of its form. The bouncing ball is often used to illustrate the principle, where the form at its lowest point (impact) is illustrated as a squashed ball, while its accelerated rise to its highest point is illustrated as a stretched ball, recognizing that the gravitational forces inside the ball are moving.
- **Anticipation** – in reality, any movement is prefigured by the desire, intention or need to move, and the body prepares itself for the predicted action. In animation, creating the illusion that the body is mindful of this anticipation gives life and credibility to the object. An example might be a baseball pitcher drawing back his arm before throwing the ball to the striker.
- **Staging** – this involves composing elements of the frame to control the viewers' experience. So placing characters in particular positions, lighting them in certain ways and positioning the camera to record these deliberate intentions all accentuate the appearance of the subject in its surrounding environment, contributing to the audience's understanding and enjoyment of the piece.
- **Straight-ahead action and pose-to-pose drawing** – straight-ahead action concerns the movements of individual figures in staged scenes, and is best demonstrated by first imaging a simple action and then drawing each frame of that action from the start to the finishing point. This creates movements that are highly detailed and fluent and are described as 'full animation'. Pose-to-pose drawing is a more economical approach, using fewer frames and resulting in a more dramatic and immediate effect. Animators often use both straight-ahead action and pose-to-pose drawing, mixing the two subtly to reflect the focus, pace and concentration of the story being animated.
- **Follow-through and overlapping actions** – the laws of physics dictate that after a body (human or object) has stopped moving, the

momentum created by its movement is continued, or 'followed through', before coming to rest within the body. Acknowledging this principle and building it into the depiction of the figure or object results in a more believable movement. Similarly, observation of a body acknowledges that elements of the human form move at different speeds from each other and create 'overlapping actions'. A good example might be the contrast between fleshier and bonier parts of the body. Building in these differences in movement gives believability and sensitivity to the form, allowing the viewer to suspend disbelief.

- **Slow in and slow out** – not all actions happen at a uniform speed, but there are instead periods of acceleration and deceleration that appear to reflect the subject's natural reactions to a movement. To achieve this, a greater number of frames is created at the beginning and the end of a moving sequence, resulting in more naturalized and believable movement.

- **Arcs** – animators use implied arcs to emulate natural movements to aid believability. Reflecting the speed of an action, arcs emulating faster movements are stretched over longer distances with low peaks, while in slower movements the arc is shorter with a higher peak to reflect a shorter distance. For example, a baseball pitcher throwing a fast ball will be illustrated by the ball following an invisible stretched arc.

- **Secondary action** – this principle recognizes that movements seldom happen in isolation. The simple act of walking (primary action) might be complemented by the ability of the figure to chew gum, talk to his girlfriend and wave his hand.

- **Timing** – the importance of timing is translated through the number of frames designated for an action to occur, controlling not only the speed of the action but crucially also introducing, establishing and reaffirming wider conditions, such as the characters' emotional state and their connection to the plot or other characters.

- **Exaggeration** – the principle of exaggeration, whether applied to the physical design and actions of characters, or to the wider narrative function of the animation itself, presents opportunities to stretch and distort reality, achieving seemingly impossible feats by amplifying conditions and breaking rules and conventions.

- **Solid drawing** – this involves the confident handling of drawing as a three-dimensional discipline articulated through understanding anatomy and form. Solid drawing helps to maintain believability.

- **Appeal** – understanding the intricacies of drawing gives 'appeal' to characters and makes them interesting focal points for the audience to make necessary plot, design or associated connections with. In this sense, appeal is not necessarily 'attractive', but rather an embodiment of character traits that touches an emotional inner core in the audience.

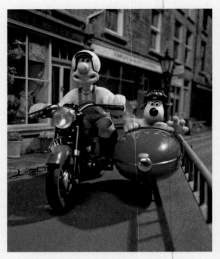

The defining principles of animation are neatly embodied in the work of the British Aardman Animations studio, ably demonstrated by the enduring pairing of Wallace and Gromit.

The animation pipeline

Taking time to understand the principles of animation is important, as they form a critical and universally recognized framework. It is equally important to understand how an animated production is created. All animation projects have a workflow, known as a 'pipeline', that recognizes three distinct phases: pre-production, production and post-production. To understand this pipeline it is useful to outline a simplified animated workflow that clearly identifies the logical steps needed to construct an animated film (see below). However, when considering this outline it is important to keep in mind that some creators do not come from traditionally recognized backgrounds of art and design, but from diverse though associated areas of interest such as music, film, photography, engineering and architecture. These creators may deviate from this traditional workflow depending on where the inspiration for the production comes from, the resulting constituent parts that it uses, the production processes employed, and the method of screening the final film, episode, advert or application. It is even possible that some aspects may be omitted altogether for a variety of perfectly sound and justifiable reasons.

Pre-production

In the pre-production phase, scripts, visual and sound concepts and ideas are explored and tested through research in order to prepare material before filming and recording.

Briefing: A project is originated personally, commercially or for non-profit organizations, including details of client requirements, budget, timescale and technical constraints. Depending on the nature of the project, production companies may be asked to pitch for jobs, or an agency might approach a particular director having seen examples of previous work that the client has indicated they like. In independent animation, the animator often writes a synopsis to try to attract funds from funding bodies, organizations or external sponsors. The director is tasked with envisioning the project through to completion.

Script: The script is written in response to the brief given, and may be based on an observation, an interpretation of an event, or an adaptation of a story. The script is completed, analysed and edited, until the contents are agreed.

Concepts and ideas: The script is given to a director, who directs the crew to interpret the material visually and aurally. Concepts are explored and developed, and the resulting ideas are given rough visual and aural forms so that first impressions of the production can be formed and considered.

Research: Ideas are explored through more focused and sustained research, collecting information through observations and recordings and assembling

These pre-visualized images give an indication of the overall feel of the intended output.

this material into a methodical order that can be used in the studio environment to add more detail and expression to the initial ideas.

Treatment: The project is pitched to the client or funding body through a written synopsis known as a 'treatment', where the story or idea will be summarized through a presentation comprising one or more of the following elements: a written statement, visualized images (or a storyboard), a temporary soundtrack, sample voice-overs and atmospheric special-effect ideas. The production method of creating the work is established and agreed according to the budget set or established for the production, and the release format is agreed.

Storyboard: A storyboard is developed to illustrate the emerging narrative, setting the scene, introducing characters, establishing where dialogue fits with action, suggesting camera shots and angles and determining sound effects. This is tested as an 'animatic', merging vision and sound to start to make sense of pacing and timing of the material for the audience. As the production develops, so does the quality of information held on the storyboard.

Development: Sets, scenes and characters are visually developed in tandem with the collected research material as the crew work out how to animate the information contained in the storyboard. This involves detailed analysis of how the production is constructed (how to move items on set, how characters walk, talk and interact, how lighting will be set and cameras will capture each frame) so that any production issues are resolved prior to filming. The production schedule is established and published for the crew.

Sound: The choice of 'sound stems', dialogue, narration, music and special effects is finalized and designed in close conjunction with the visual development taking place. Music is commissioned if a score is required, voice talent is auditioned for narrative and dialogue roles if needed, and the crew working on special effects are tasked with originating or collecting

relevant material that can be first recorded on location or in the studio, before being edited in the studio and mixed together to form a soundtrack.

Animation can be used to enhance an audience's understanding of a story or set of ideas, allowing the possibility of an interactive experience.

Production

The production phase sees the project take shape, with artwork being created, film shot and sound recorded.

Production for 2D animation

Creating key frames: The major frames of action are drawn as key poses for the central characters.

Motion tests: Character movement is tested through pencil tests to make sure movements are fluid, coherent and in keeping with the character's personality and appeal.

Backgrounds: Scenes are illustrated to provide a backdrop against which character action takes place and to contribute to the overall mood and atmosphere of the production.

In-between frames: Cels are drawn in between the key frames to render the whole action of the character. The cels are shot or scanned and cleaned up and saved as individual frames in the software program.

Inking, painting and compositing: The frames are artworked to render them in a final state, building up details on individual layers if necessary to achieve an overall look through compositing.

Picture editing: The frames are played back to check for accuracy, speed and coherence within the story.

Rendering: The layers in the frame are flattened through a process known as 'rendering' to create final frames.

Workprint: Whether working in two or three dimensions, special effects are considered along with music, narration and dialogue to create an intermediate version of the production, known as a 'workprint'. This helpfully establishes the shape of the production, illustrating its appeal and values, as well as highlighting the inconsistencies, mistakes and faults.

Production for 3D animation

Modelling: A character or object is sculpted and formed through development drawings and research to remain faithful to the creator's vision of it.

Rigging and animating: This process establishes how the modelled form will move, either manually through the animator flexing the form, or digitally through permissions granted in the software application to 'handle' the form on a predetermined axis, through walk cycles, lip-synching and so on.

Effects and lighting: Visual effects in support of the main movements of the form are executed and recorded, often worked in tandem with lighting design to evoke atmosphere and create highlights on aspects of the form for dramatic purpose.

Compositing: Recorded three-dimensional elements are brought together, manipulated and outputted, often changing the feel and impetus of the recorded footage to maximize dramatic impact and accentuate the story or idea in an interesting way for the viewer.

Rendering: As with 2D animation, the layers in the frame are flattened through the rendering process to create final frames.

Workprint: And like in 2D animation, a workprint is created by looking at the special effects, music, narration and dialogue all together.

Sensitive lighting design can radically alter the mood of a production.

Post-production

The post-production phase takes all the collected filmed and recorded material and synthesizes it into a product, adding special effects and titles, so that it is ready for release and distribution.

Special effects: The concluding stage of the project allows special effects to be placed, accentuated and mixed to enhance the viewing and audio experience.

Panning: The sound can be further designed into a supportive landscape for the visuals, placing sounds in different parts of the auditorium by controlling how the speakers will output the recorded sound stems.

Colour correction and mastering: The working print is fine-tuned, removing any minor inconsistencies and creating a seamless and pure visual and audio experience.

Titles and credits: The work is prefixed and suffixed by the titles and credits respectively, acknowledging the role played in creating the animation for screening by the crew, the funders, the producers and the broadcaster's supporters. A release print is made through the studio or a specialist photographic lab, depending on the agreed release format.

Release and distribution: The completed work is distributed through distribution agents who liaise with broadcast networks, organizations or festivals to screen the work for consumption.

Academy Award-winning British animator Suzie Templeton is renowned for the high-quality construction of her animation sets.

About this book

This book aims to explore animation in an easily digestible, inspiring and exciting way. The subject is introduced from the perspective of following a traditional workflow, or pipeline, as outlined above. The chapters that follow reflect these stages of pre-production, production and post-production and are intrinsically linked to originating, developing and creating an animated film.

Chapter One: Pre-production – Planning and Scriptwriting explores the scheduling of an animated production and gives an overview of the roles and responsibilities of crew members working on the project. The chapter investigates practical approaches to writing for animation as a form different from cinema. It introduces key concepts of animation vocabulary and language, and emphasizes the interpretive possibilities of the form, both linguistically and stylistically, for the creator.

Chapter Two: Pre-production – Concepts, Ideas and Research examines where ideas originate and how they are developed using a framework to test,

evaluate and strengthen them for the creator and audience alike. The importance of relevant research and associated research processes is explained, including the importance of accuracy in collation and archiving of materials, and how these can be utilized in the development of ideas.

The Ottawa International Animation Festival held every year in Canada celebrates the best new releases from Canada and the rest of the world, with its 'Meet the Filmmakers' slot being especially popular.

Chapter Three: Pre-production – Development looks at the art of storyboarding, layout and drawing as essential tools and processes to enable the animator to develop his or her project.

Chapter Four: Pre-production – Sound looks at the definition and use of 'sound stems' as an important part of the pre-production process in defining and shaping the animation. Narration, dialogue, music and special effects are considered, allowing the reader to understand how sounds are recorded, edited together and processed ready for production.

Chapter Five: Production examines the variety of production methods used to create visual and aural animated content using common techniques, such as cel animation, stop motion, computer-generated imagery (CGI) and more unorthodox and unusual methods.

Chapter Six: Post-production explores the integration of the visual, aural and special-effects aspects of the animation process into a cohesive package ready for distribution and viewing. The chapter explains the analysing, editing, rendering and packaging process as the animated production is prepared for release and distribution.

Chapter Seven: Animated Futures looks at careers in animation and contains useful reference information about how to prepare for and find employment through education and training, and by gaining experience through placements and internships.

Through the use of specifically researched illustrations and captions this book enhances the reader's understanding and knowledge of the medium and provides a rich and enjoyable overview of the animation process. Information in the text and boxed features gives valuable guidance and support to student animators creating animation and wanting to expand their education into a career in the field. Key words and technical terms are defined in more detail in the glossary section at the end of the book and a comprehensive bibliography highlights further reading opportunities.

An animation timeline

This timeline documents the history of animation through developments in technique and technology over the last two centuries.

1779
Paul Philidor creates the first acknowledged phantasmagoria show

1798
Stage magician Étienne Gaspard Robert pioneers the idea of the phantasmagoria 'production'

1832
Joseph Plateau invents the phenakistoscope

1834
The Daedalum (later known as the 'zoetrope') is designed and produced by British mathematician William G. Horner

1854
Austrian Franz von Uchatius invents the kinetoscope, which is then further developed by Thomas Edison

Praxinoscope (1877)

1877
In France, Charles-Émile Reynaud patents the praxinoscope, which introduces mirrors to the principle of the original zoetrope

1896
Frame-to-frame trick effects are pioneered by French film-maker Georges Méliès

1901
Walter Elias ('Walt') Disney is born in Chicago, Illinois

1902
The first transatlantic radio message is received in Britain, originating in the United States

1906
J. Stuart Blackton creates the first cartoon, *Humorous Phases of Funny Faces*, using animated chalk drawings that are double-exposed on negative film

1907
The Teddy Bears is created by American Edwin Stanton Porter, using stop-motion figures

1908
Émile Cohl, the Parisian caricaturist, releases *Fantasmagorie*, widely considered to be the world's first fully animated film

Fantasmagorie (1908)

1910
Russian animator Vladislav Starevich creates *Piekna Lukanida* (*The Beautiful Lukanida*), the first puppet animation to use stop motion

1911
International Business Machines (IBM) is founded. Winsor McCay, the prolific newspaper cartoonist, animates figures in his film *Little Nemo in Slumberland* from his comic strip of the same name

Gertie the Dinosaur (1914)

1914
Winsor McCay creates *Gertie the Dinosaur*, the first animated film to feature a character with a recognizable personality and to be made using the key-frame technique. Raoul Barré and Bill Nolan set up the Barré-Nolan Studio, the first commercial cartoon studio in New York

1916
Pioneering animator Max Fleischer is granted the patent for the rotoscope and uses the process to trace live-action film of his brother to create *Out of the Inkwell*

1917
The world's first animated feature, *El Apóstol*, is released in Argentina

The Sinking of the Lusitania (1918)

1918

Winsor McCay creates *The Sinking of the Lusitania*, an important milestone in the use of animation to create propagandist film

1919

Paramount Pictures release the animated short *Feline Follies*

1920

The Debut of Thomas Cat becomes the first recognized colour cartoon

1921

Walt Disney begins to create popular animated films for the Newman theatre chain in Kansas City

1923

Disney merges live action with a cartoon in *Alice's Wonderland*

1925

Scottish inventor John Logie Baird transmits moving silhouette images, the forerunner to modern television broadcast

1926

Using cut-out silhouettes, German-born animator Lotte Reiniger completes the feature-length *Die Abenteuer des Prinzen Achmed* (*The Adventures of Prince Achmed*)

Die Abenteuer des Prinzen Achmed
(The Adventures of Prince Achmed) (1926)

1927

The British Broadcasting Corporation (BBC) is founded

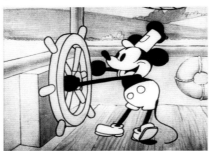

Steamboat Willie, 1928. © Disney

1928

Steamboat Willie, starring Mickey Mouse, becomes the first Disney cartoon to feature synchronized sound

1929

The first of 75 animated shorts known as the Silly Symphonies, *The Skeleton Dance*, is animated by Ub Iwerks, Disney's partner at Walt Disney Studios

1930

Betty Boop makes her first appearance in Fleischer's *Dizzy Dishes*. In France, Starevich's

Le Roman de Renard (*The Tale of the Fox*) becomes the first feature-length puppet animation

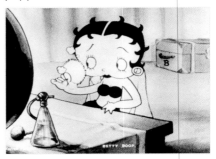

Betty Boop (1930)

1932

Disney releases *Flowers and Trees*, the first known Technicolor cartoon (in three colours)

1933

Willis O'Brien produces his stop-motion gorilla for *King Kong*. *The Three Little Pigs* premieres, the first Disney film to suggest animated personality and to be originated on storyboards

1934

Donald Duck is introduced to cinema audiences in the film *The Wise Little Hen*

Komposition in Blau (Composition in Blue) (1935)

1935

German Oskar Fischinger makes the abstract animation *Komposition in Blau* (*Composition in Blue*)

1936

The BBC broadcasts the first high-definition television service from its transmitter at Alexandra Palace, London

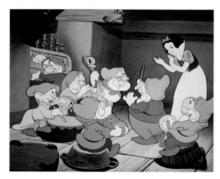

Snow White and the Seven Dwarfs (1937). © Disney

1937

Disney releases the epic *Snow White and the Seven Dwarfs,* the world's first full-length, sound-synchronized Technicolor animated film

1939

Gulliver's Travels, created by the Fleischer studio, becomes the first film to challenge Disney's monopoly on cartoons

1940

Disney releases *Pinocchio* and *Fantasia* but both are surprisingly poorly received by audiences. The first Tom and Jerry cartoon is created and released by William Hanna and Joseph Barbera

1941

The Walt Disney Studios strike is a painful episode in the company's history. In China, Wan Laiming and Wan Guchan produce the animated feature film *Princess Iron Fan*

1942

The epic feature film *Bambi* is released by Disney

1944

The birth of the United Productions of America (UPA) studio. The Gaumont British animation studio is originated in Britain

1946

The controversial *Song of the South*, a version of the Uncle Remus stories, is completed using a mixture of animation and live action, but never released

1947

Tintin makes his animated debut in a puppet version of *The Crab with the Golden Claws*

1948

The feature-length puppet animation *The Emperor's Nightingale* is created by Czech film maker Jirí Trnka

1949

Fast and Furry-ous sees the first appearance of Chuck Jones's creations Road Runner and Wile E. Coyote

1950

In the cinema, Disney releases *Cinderella*, while *Crusader Rabbit* is the first cartoon created for television in the United States

1952

The technique of pixilation is introduced by Norman McLaren's film *Neighbours*

Neighbours (1952)

1953

In America, Warner Bros. animator Chuck Jones creates the influential *Duck Amuck*

1954

George Orwell's novel *Animal Farm* is animated by John Halas and Joy Batchelor and will become hugely influential

Animal Farm (1954)

1957

Bugs Bunny makes his most famous appearance in Jones's cartoon *What's Opera, Doc?*

1958

The much-awaited *Sleeping Beauty* is a commercial disaster for Disney and painfully disrupts plans to produce animated features in this genre for more than thirty years. The first colour animated feature in Japan, *The Legend of the White Serpent* (known in America as *Panda and the White Serpent*), is released

1960

Hanna and Barbera introduce Fred Flintstone and Barney Rubble in the animated television series *The Flintstones*

1961

Havoc in Heaven heralds the beginning of audiences becoming familiar with Chinese animation

1963

Japanese television cartoon *Mighty Atom* spawns many other Japanese productions. The popular television series *La Manège Enchanté* (*The Magic Roundabout*) is created by Serge Danot in France

1964

John Stehura creates the experimental film *Cibernetik 5.3* using punch cards and tape

1965

The Czech adult puppet film *The Hand* is created by Jirí Trnka, and becomes a rallying cry against the repression of the totalitarian state

1966

Walt Disney dies at the age of 65 and never sees the completion of the planned Disneyworld adventure park in Florida. British children's television sees the arrival of the stop-motion *Camberwick Green*

1968

The Beatles provide the soundtrack to director George Dunning's animated film *Yellow Submarine*

1969

First showing of *Sazae-San* in Japan, still running today and credited as being the world's oldest continuously running animated series for television. In Britain, *The Clangers* land on television, courtesy of Oliver Postgate and Peter Firmin

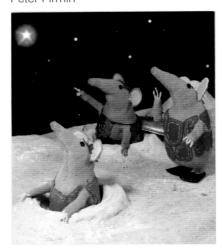

The Clangers (1969)

1971

Sony launches the U-matic system, the world's first commercial video cassette format in Tokyo, Japan. The first IMAX cinema opens in Montreal, Canada

1972

The video games company Atari is founded

The Wombles (1973)

1973

The Pannónia Filmstúdió, based in Hungary, creates *Hugo the Hippo*, using some voice-overs provided by singing sensations of the day, The Osmonds. In Britain, *The Wombles* is created by Ivor Wood at Filmfair, who later creates *Postman Pat*. The first cellular phone communication is made in New York City

1974

Bob Godfrey's *Roobarb* hits British television screens. Hayao Miyazaki and Isao Takahata work together to create the Japanese television series *Heidi*

1975

George Lucas founds Industrial Light and Magic (ILM) and pioneers the use of motion control cameras in *Star Wars Episode IV: A New Hope*. Bill Gates and Paul Allen found Microsoft in Albuquerque

1976

Apple is founded by Steve Jobs,

Steve Wozniak and Ronald Wayne in California

1977

Caroline Leaf comes to world attention with her vivid portrayal of family bereavement as seen from the eyes of a child in *The Street*. Ed Emshwiller creates *Sunstone*, a short computer-graphic film in 3D

Sunstone (1977). Courtesy Electronic Arts Intermix (EAI), New York.

1980

Chinese animation re-emerges as an important force with the creation of the film *Nezha Conquers the Dragon King*

1981

IBM's personal computer is launched using Microsoft DOS (Disk Operating System)

1982

At Disney, Tim Burton uses stop motion to create *Vincent*, and *Tron* heralds the arrival of CGI in major studio productions. *Star Trek II: The Wrath of Khan* becomes the first film ever to have a completely computer-generated sequence, created by ILM.

Tron (1982). © Disney

1984

Disney attempts to revive its fortunes and prepare for the inevitable demands of the CGI animation onslaught by hiring Michael Eisner and Jeffrey Katzenberg. Apple launches the first Macintosh personal computer with a mouse and graphical user interface (GUI)

1985

Will Vinton's important feature film *Mark Twain* is completed using the technique of claymation

1986

Luxo Jr. becomes an important marker for CGI animation. Its director, John Lasseter, later goes on to direct for Pixar

1988

Hybrid animation and live-action feature *Who Framed Roger Rabbit* is released. *Akira* debuts in Japan, directed by Katsuhiro Otomo

Akira (1988)

1989

The character of the Pseudopod in *The Abyss* is the first computer-generated 3D character. On television Matt Groening's *The Simpsons* becomes a series in its own right. Meanwhile at CERN, the European particle physics laboratory, Tim Berners-Lee invents the World Wide Web

1990

ILM develops computer-generated textured human skin for the film *Death Becomes Her*

1991

The Ren and Stimpy Show provides some edgy animation for television, created by John Kricfalusi

1992

Welsh television channel S4C commissions the series *Shakespeare: the Animated Tales* using a mixture of animation processes

1993

Steven Spielberg uses animation in *Jurassic Park*. The stop-motion feature *The Nightmare Before Christmas* is deftly produced by Tim Burton and directed by Henry Selick

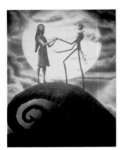

The Nightmare Before Christmas (1993). © Touchstone Pictures

1994

Michael Eisner and Jeffrey Katzenberg's bitter dispute at Disney impels the latter to co-found the DreamWorks studio with Steven Spielberg and David Geffen

1995

Launch of *Toy Story,* directed by John Lasseter, the world's first feature-length CGI cartoon. *The Wrong Trousers* wins an Oscar for Nick Park. DVD optical disc storage technology is developed by Sony, Philips, Toshiba and Panasonic

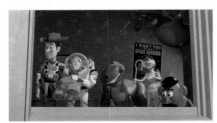

Toy Story (1995). © 1995 Disney/Pixar. Mr Potato Head is a registered trademark of Hasbro, Inc. Used with permission. © Hasbro, Inc. All rights reserved.

1998

Pixar's *A Bug's Life* enters into an insect war with DreamWorks' CGI feature *Antz*

1999

Aleksandr Petrov's *The Old Man and the Sea* is the first animated film released in IMAX format and wins an Academy Award for Animated Short Film

2000

Aardman Animations begins an uneasy partnership with DreamWorks with the animated *Chicken Run*

2001

Hayao Miyazaki's Oscar-winning *Spirited Away* is launched to critical acclaim

2002

Motion capture is successfully used to create Gollum in *The Two Towers. Ice Age* is released by Blue Sky Studios

2004

Brad Bird directs Disney•Pixar's CGI superhero feature film *The Incredibles*

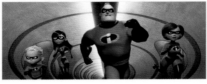

The Incredibles (2004). © Disney/Pixar

2005

Tim Burton's eagerly awaited *Corpse Bride* and Nick Park and Steve Box's *The Curse of the Were-Rabbit* are released, heralding a new interest in stop-motion animation

2006

Disney completes its acquisition of Pixar. HD DVD and Blu-ray are launched globally, promising unmatched visual output quality

2007

Disney•Pixar's *Ratatouille*, directed by Brad Bird, is released. CEO of Apple, Steve Jobs, unveils the iPhone, a multi-touch smartphone that will spawn a generation of applications (apps) that use animated content as a central operational feature

2008

British director Suzie Templeton wins an Oscar for the acclaimed stop-motion animation *Peter and the Wolf*

2009

Up, directed by Peter Docter, became the first Disney•Pixar feature film to use Disney Digital 3D. Henry Selick's darkly atmospheric 3D CGI stop-motion feature *Coraline* is a hit at the box office

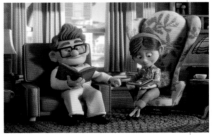

Up (2009). © Disney/Pixar

2010

Shaun Tan's picture book *The Lost Thing* is adapted into an animated short by Tan in collaboration with Andrew Ruhemann and wins the Academy Award for Animated Short Film

1.

Animation is an entertainment medium like no other. It offers extraordinary flexibility, as each part of its process can be handled and controlled by the creator. It operates using a different (but recognizable) vocabulary from that of live-action film, enabling different forms of expression to exist in a space for an audience to engage with. As such, it permits new versions of worlds or environments for films, giving tremendous creative freedom for writers, artists, animators, directors and producers to transport audiences to different dimensions of 'reality', which seem real but are in fact imagined.

This chapter examines the contribution that early planning and scriptwriting play in this creative freedom. It establishes how the pre-production phase of an animated project is planned, managed and delivered by people with differing job roles in the production's life cycle. It also explores the importance of scriptwriting – including different approaches and development – as one of the first possible starting points in pre-production.

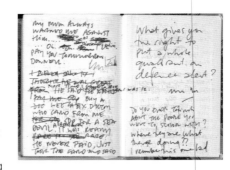

Planning a script involves writing and rewriting as the outline plot begins to evolve.

The animation pipeline in pre-production

As outlined in the Introduction, the pre-production phase of the animation pipeline involves the exploration of scripts, visual and sound concepts and ideas and their testing through research in order to prepare material before filming and recording.

Preparing a tangible framework for this phase is essential, as this governs the budget, the scheduling of the technical pipeline arrangements, and the managing of the workflow arrangements of the crew in the studio. The hard work done at this early stage permits greater creative risks to be taken in pre-production. Careful planning allows animators, storyboarders, scriptwriters, composers, musicians, special-effects creators and designers to fully explore the subject.

This creative freedom for concept selection and idea origination, development and execution is crucial to the whole project, and a thorough grasp of the subject will positively affect the quality of the final output. Creating the right conditions for ideas to flourish is essential, especially those centred on the core animation properties of performance, movement and narrative. Establishing a clear set of parameters is a key exercise in helping to plan, structure and manage the project (see box opposite), and this good preparation and planning will almost certainly deliver the project on time and on budget – two essential considerations in the world of animation.

Scheduling a production

It is essential to ask the following questions, or variations thereof:

- Has the project been approved?
- Who is the project for and what is its intended outcome?
- Who is the target audience?
- Who is funding and/or supporting the work?
- Is there a budget and if so, what is it?
- Who controls the budget?
- What is the time frame in which the project needs to be conducted?
- How much time is allowed for research for the project?
- How is the time frame split between phases of pre-production, production and post-production?
- Who has responsibility for making final decisions?
- Is there sufficient scope in resources or budget for a crew?
- What should the crew be made up of?
- Who owns the project once the production is completed?
- Who is responsible for designing the content and style of titles?
- Are there any cultural, social or philosophical issues with the proposed content that require legal clearance?
- Are there any special considerations that need to be given for audiences with particular needs and requirements?
- Who owns the rights for any associated materials that could be developed in the future?
- What happens if the project is cancelled?
- How will the project be delivered?
- What is the broadcast format for the project?
- How will the finished animation be distributed?
- What technical and physical resources are available and are there extra funds available for this?
- Are there associated production values (material to be gained for documentary or promotional purposes) that need consideration?

Implicit in the planning process is the need to understand the variety of jobs involved in creating an animated project, what each job entails and at what stage these roles operate, either independently, jointly or collectively across the whole production. Members of the crew need to know and understand their roles from the outset. In a feature film or television series, roles are clearly defined and animators may often be hired by a studio to establish or supplement teams. In independent productions, an individual may undertake a number of roles simultaneously, depending on the size of the crew and the size of the budget, in order to see the production through from concept to completion.

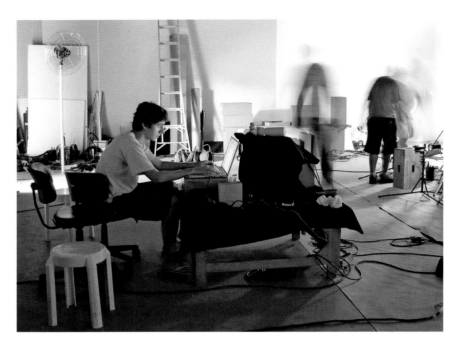

The director is in charge of the production, including overseeing storyboarding, development and production of the animated work.

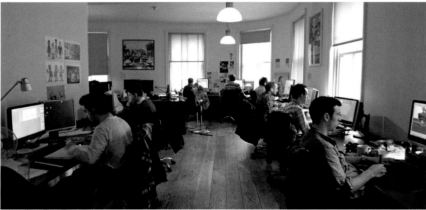

An organized studio environment creates a productive and efficient workplace, even if the building was formerly a high-street bank, illustrated by Nexus Productions in London.

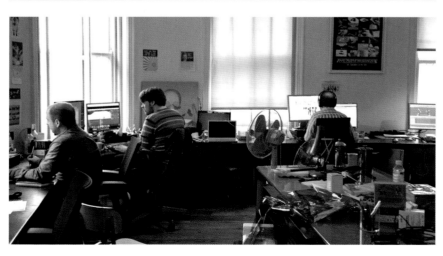

Animation job roles

Pre-production:

Director – person in charge of the production, including overseeing storyboarding, development and production of the animated work.

Producer – works closely with the director, supervising and controlling the teams at various stages of production and post-production to bring the project in on time and on budget.

Art director – responsible for the intrinsic look of the project and for communicating this vision to the production teams.

Film editor – works closely with other members of the core team to review and edit passages and combinations of prepared animated sequences so as to tell the story most convincingly.

Production supervisor – liaises with the director and producer to manage the project and ensure teams are prepared to pass and receive work through phases of production.

Supervising animator – works closely with the director and producer of the project and is a vitally important link between their vision and the animation team's ability to create it.

Researcher – can work individually or as part of an organized team, unearthing contacts, investigating story leads and collecting reference material for the pre-production and production teams.

Story:

Story supervisor – makes sure that the script or story is being followed, checking for accuracy with any factual events.

Story coordinator – provides the link between the storyboard artists and the supervisor.

Storyboard artist – responsible for problem solving, planning and visualizing how early script ideas and concepts might be realized.

Animation:

Directing animator – sometimes known as 'lead animator', this is generally a senior animator who has experience of previous productions and is able to manage the collaborative team of animators.

Animator – an artist who understands the principles of imagined movement and creates multiple frames of images using various techniques.

Art:

Art manager – responsible for coordinating the smooth running of the animation art department.

Picture researcher – collects important contextual visual material to aid the art department in its creation of sets, props and characters.

Conceptual artworker – brings initial ideas to life, working quickly to visualize concepts often while ideas are being verbally discussed.

Designer and illustrator – work closely with the animators to design and create backgrounds, sets and props to support the production.

CG painter and designer – a technical artist who works digitally to originate, develop and enhance artwork for production, often using drawing tablets and working on screen.

Sculptor – an artist who translates two-dimensional drawings into usable and sometimes functioning three-dimensional forms, from maquettes to fully formed sculptural models.

Character designer – researches, originates, develops and executes the design for characters in both human and object form.

Props designer – responsible for the creation of props that characters will use on set.

Set designer – responsible for the environment of the project; works carefully with the lighting designer and camera team to ensure sets are convincing but also accessible and functional in the production phases.

Layout:

Layout manager – receives approved storyboards, and is responsible for briefing and managing the layout artists so that they remain faithful to the spirit of the storyboards and the director's vision.

Supervising layout artist/designer – like the supervising animator, this is a role reserved for a senior member of the layout team who has experience of bringing conceptual artwork as stills and sequences to fruition in the layout phase of production.

Layout artist – responsible for developing the storyboard images into highly finished visuals and/or full camera-ready artwork, depending on the animation treatment chosen for the feature.

Set dresser – works closely with the set designer, ensuring that his or her vision is expressed through the

variety and attention to detail of the chosen material properties of the set.

Editorial:
Editorial manager – takes control of the story, ensuring that there is continuity between script and artwork, pointing out inaccuracies and bringing teams together to find solutions in the pre-production phase.
Assistant editor – supports the editorial manager in his or her role by acting on decisions taken and making sure the production teams communicate well with each other.
Editorial production assistant – provides administrative support for the editorial and post-production departments of a studio.
Storyreel music editor – has the responsibility of ensuring that the initial sequential material is accompanied by a basic soundscape, which might be actors reading from scripts or a 'rough cut' of a proposed soundtrack.

Camera Team:
Camera manager – takes charge of how scenes can be filmed by liaising with the director and the producer and communicating these decisions back to the camera team.
Supervisor – ensures that the camera manager's instructions are followed in the studio.
Engineer – operates the cameras and ensures parity between the intended shots and what might be physically possible in the studio environment.
Technician – prepares, maintains and services the cameras before,

during and after production to ensure a fully functioning set.
Calibrator – makes sure that digital monitors are calibrated at regular intervals to ensure consistency and parity in sequential work.

Production:
Production controller – responsible for ensuring that pre-production material is processed on time and on budget through the production process.
Accountant – ensures that the project is kept on budget by managing salaries, expenses and remuneration for costs incurred in production.
Purchasing/Facilities manager – person charged with making necessary decisions and purchases to allow the project to come to fruition.
Production coordinator – supports the production controller by acting on decisions made and communicating these with the appropriate teams.
Production schedule coordinator – holds regular meetings with the production teams to review progress and coordinates changes to keep the schedule on track.
Marketing/Promotion coordinator – works with the production schedule coordinator to collect, review and select supporting material from the project that can be used to market and promote the project ahead of its intended release.
Supervising sound editor – coordinates the various aspects of sound production.

Sound-effects editor – coordinates the gathering, appropriation and implementation of sound effects used in the production.
Sound designer – includes all aspects of sound in an animated production not composed by musicians.
Sound editor – decides what sounds should be incorporated to support musical scores or interludes.

Computer Systems:
Computer system manager – oversees the digital technical production facility.
Hardware/Software engineer – operates and maintains computer hardware and software being used in the feature's production.
Logistics – responsible for moving sets, props and project materials in or between studios if filming is happening at another location.
Technician – provides technical support to the engineers by testing and repairing equipment and making sure all aspects of the technical production process work effectively.
Media systems engineer – responsible for the design, installation and maintenance of the digital infrastructure underpinning computer-generated imagery (CGI) studio productions.
Modelling and animation system development – usually work as a team to develop software and hardware systems, either pre-empting or responding to technical issues that might arise or have arisen during the production process.

1.

Post-production:

Post-production supervisor – sometimes known as a 'technical director', this role ensures that the completed animation is produced and packaged for distribution.

Re-recording mixer – checks and mixes recordings of dialogue, sound effects and scores to ensure parity between sound and vision.

Foley editor – named after the famous Hollywood practitioner Jack Foley, who was an early exponent of the art, the foley editor's job is to decide what sound effects need adding in post-production to artificially enhance an action, and to work with foley artists to achieve these effects.

Foley artist – a skilful job that requires a good ear for sounds and the ability to imitate them imaginatively through sometimes unconventional and unexpected devices.

Foley recordist – works with the foley artist to capture sounds that can be used to enhance effects not possible using conventional recordings.

Casting consultant – plays a pivotal role in understanding the director's vision of what encapsulates the core credentials of each character that will require a voice to be cast, and acts as an important liaison between the studio and casting agents and actors.

Voice casting agent – represents actors whose voices are sought to read scripts and record dialogue for created characters.

Music:

Music editor – has the responsibility for compiling, editing and synchronizing the musical score in production and ensuring that the musical sound landscape is correctly processed in post-production.

Production sound mixer – member of the crew responsible for collecting all sound recordings, including deliberate and accidental sounds captured both in the studio and even on location that could later be utilized by the foley artists.

Music production supervisor – fosters the relationship between musical and visual parts of the production by selecting and licensing music used.

Orchestra contractor – works in a communication and enactment capacity in selecting orchestras that are able to perform musical scores, interludes and anecdotes as directed by the composer or music production supervisor.

Recording assistants – create high-quality studio recordings of the orchestral and other musical works that will become part of the production's score.

Dialogue recorders – capture sound recordings of actors reading parts for different animated characters.

Title Design:

Colour timer/grader – responsible for re-grading film stock by altering, enhancing or subduing its appearance using photochemical, electronic or, more commonly, digital processes.

Negative cutter – works closely with the editor to cut film negative precisely to be identical to the final edit. Traditionally, the film is cut using scissors and repaired using a film splicer and film cement. In recent years, the arrival of digital intermediates means that the skills of the negative cutter have been used to lift selected takes from rushes and composited to reduce the amount of digital scanning required.

Title designer – is responsible for designing the opening and closing titles and credits for the production.

Distribution:

Distribution manager – works with other distribution networks, providers and agents to negotiate international distribution rights to the production.

Distribution agent – works on behalf of distribution networks and media broadcast organizations to win contracts to show productions globally.

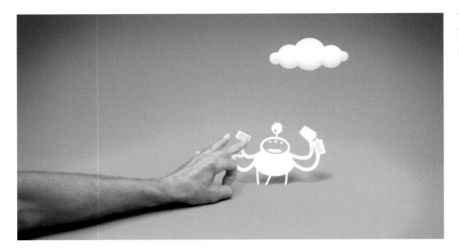

The simple but imaginative script for Skype enabled director Grant Orchard to play with visual and aural elements to illustrate the immediate and user-friendly nature of the product for consumers.

Scriptwriting

Animation as a form enables a multitude of ways of thinking about and describing narratives. It can bring historical and contemporary stories to life, embellishing and heightening our appreciation and enjoyment. In order to use animation as a storytelling vehicle, creators must decide where the root of content is to be found. A script is one starting point, but it is equally possible for some animated productions to exist without a script, the director instead preferring to use the storyboard as a visual scripting device, especially where there is no fixed dialogue or narration attached to a particular shot.

Although animation shares some of the narrative conventions of live-action film, such as the composition of scenes or the structuring of shots to tell stories or explain ideas, writing for animation requires some particular considerations that emerge out of the distinctive nature of the form itself. First, unlike live action, animation is not bound by the constraints of physical forces and limitations, such as gravity or conventional human movement. Second, the process of making an animated production is elemental. Sections are effectively pieced together and reviewed as a production grows, thereby granting flexibility to change the script to enable scenes or sections to be filmed, or edited, which can better explain a plot or idea. Understanding and appreciating that there are different approaches to writing for animated productions is important and the rest of this chapter examines what a script is, why it is written and how it informs the production.

What is a script?

A 'script' is a document that details the 'plot' of an animated production in written form allowing a story to be told. Structurally, a script is broken down into smaller consecutive sections called 'scenes'. Each scene outlines the main action chronologically, including fundamental details such as who is speaking and what figurative actions or gestures are accompanying their

```
                    Belly
                  Dialogue
                   J. Pott
                   ©2010
          00:50 ALEX:
I'm going swimming
          00:52 OSCAR:
I'll come with you
          00:53 ALEX:
No Oscar, you're too little
          01:03 Oscar:
Wait, Alex!
          01:05 Alex:
Urrrrghhhhhhh!
          01:16 Monster:
Shh. Don't worry, I'm here.
          02:03 Monster:
We should go rescue him
          02:05 Oscar:
I don't want to
          02:18 Monster:
Urgh, Oscar, you're getting heavy
          02:40 Monster:
I love that you're here with me
          02:49 Oscar:
Excuse me...excuse me! Have you seen my brother?
His name is Alex.
          02:56 Whale:
Alex, alex, alexalexalexalexalex... (deep breath)
          03:05 Whale:
Yes, I have seen him, I feel him in my belly.
(howling belly growl)
          03:26 Whale:
Mmm, pardon me. Something I ate.
          03:29 Oscar:
My brother?
          03:31 Whale:
Not your brother. I have a backlog of digestion
          03:35 Oscar:
Blegh
```

```
          03:36 Whale:
Listen, if you want him back he has about... (belch)
an hour to go. (long breath in) I hope you find what
you're looking for...
          04:16 Dolphin:
Oh thank god you're here, help me. Please help me!
I haven't got much time.
          04:26 Alex:
Mm, I had this under control. I don't need your
boyfriend's help.
          04:42 Oscar:
He's not my boyfriend.
          04:44 Alex:
Oh yeah, then how come you love each other?
          04:46 Oscar:
We don't!
          04:51 Monster:
What, what is it?.
          05:07 Alex:
Oscar, we have to get out of here.
          05:09 Oscar:
No, I'll stay here with him.
          05:16 Monster:
I think you should go...I don't want you here.
          05:42 Monster:
Hey buddy, I miss you.
          05:48 Oscar:
Yeah.
          05:50 Monster:
What I said in there...you know I didn't mean it, right?
          05:56 Oscar:
Yeah, yeah, right. I know.
          05:59 Alex:
Come on Oscar, our ride's here.
          06:52 Monster:
Long howling moan
```

speech. It might also include details such as forthcoming actions, musical interludes, narration or sound effects to support the storytelling. The script allows the director the opportunity to interpret the story by utilizing distinctive visual and aural processes and gives the producer a clear rationale about how the production will be finally pieced together for release and distribution. More broadly, the script enables an animator to plan how to dramatize actions detailed in each scene in pre-production, and to create these dramatic movements when the project goes into production.

The script helps establish a rhythm and pace in telling a story or can explain an idea through particular events or 'beats'. Creating a written rhythmic feel to the script is a highly individual process, and writers develop their own writing traits that allow them to specialize in different spheres of animated productions. Scriptwriters also originate and develop stories in certain styles, just in the same way that animators can utilize different visual production techniques and processes to elicit different responses from the target audience. Some scriptwriters prefer to write alone, while others like to bounce off story ideas and developments as part of a writing team.

In his book *Scriptwriting* (2007), Paul Wells proposes four different models of writing that are useful when thinking about the origins and development of an animated script: traditional scriptwriting for animation, studio-process script development, series-originator writing and creator-driven writing and/or devising. Each approach is valid, but will depend on the composition and working arrangements of the team involved with a project. Traditionally, scriptwriting for animation has involved the scriptwriter (or scriptwriting team working with a script editor) devising a textual script, using processes common to live-action scriptwriting for use in animated feature films or television series. More recently, a studio-process script development model has become more popular, where an in-house studio visual creative team

British animator and illustrator Julia Pott created a simple script that permitted her to use animation to externalize bubbling internal emotional reactions in her animated film *Belly* (2011).

develops a script in response to a brief or an idea, using supporting developmental tools and processes such as a storyboard, sketches, character designs and animatics.

Other approaches include the series-originator writing method, where a 'bible' is created by the production team for an animated series, containing central information regarding characters, storylines and plots that can act as a core compendium for writers hired to work on the series but who perhaps will contribute ideas from a distance. Finally, the method of delivering a script using creator-driven writing and/or devising exists where an individual or a creative team develops material for independent productions using unorthodox methods, including bullet-pointed plot ideas.

As a general rule, a script is originated and developed by the scriptwriter (or writing team), together with a script editor, director and producer, to explore ideas for the animated production. Developing a script involves constantly writing and revising the written approach. The finished script is known as a 'treatment' and represents the culmination of a writing journey that continually originates, develops, executes, tests and rewrites material until a satisfactory conclusion is reached, and which allows the production to take account of different directional, artistic and technical points of view. Scripts can be developed for months or even years before being given the 'green light' to go into production. They are increasingly used in animated feature films to help secure finance from outside investors in conjunction with a 'pitch' (see pages 64–66) and are a vital bridge in attracting and securing the services of actors for voice-over recordings as the production progresses.

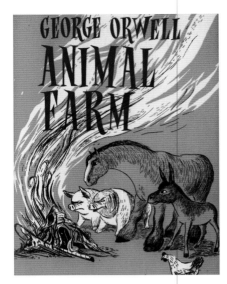

Working from George Orwell's 1945 novel *Animal Farm*, the production team at Halas & Batchelor make decisions on how the text should be adapted for screen.

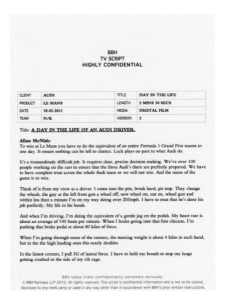

The script from director Chris Curtis' *A Day in the Life of an Audi Driver* includes specific details regarding the commissioning client, running time of the advertisement and format, as well as rhythmically breaking up sections of the script to provide a pace to the narrative.

The vocabulary and language of animation

The range of possibilities afforded by the medium of animation becomes particularly apparent when thinking about the vocabulary and language of the form. Animation can establish, utilize and promote a particular vocabulary in addition to that found in live-action film, helping to better describe, and inform the audience of, ideas and plot lines. This vocabulary includes the use of exaggeration and transformation, symbolism, penetration, controlling the elements of speed and time, depicting histories and predicting futures, and portraying the invisible or unexplained.

Having the scope to exaggerate or transform narrative storytelling ideas through a process of highlighting and promoting them, allows the writer to control their impact. In animation this is a very useful tool as there is greater opportunity to accentuate or diminish actions, movements and sequences. Similarly, the ability to use symbolism both permits the description of 'invisible' forces, such as satellite tracking or waves of sound or heat, and focuses an idea for an audience – for example, a rising bump on the head of a character who has just been hit by an object, expressing obvious and tangible pain.

Chris Shepherd's film, *Dad's Dead* (2002), inventively uses a mixture of animation and live action, allowing the viewer to veer between reality and imagination by posing dark and subversive questions in an otherwise familiar environment.

The term 'penetration' acknowledges the capacity of animated material to effectively delve into and hunt around particular objects – for example, a human eye – taking the viewer on an unexpected journey around and through the inner workings of the object to explain its structure and purpose. Of arguably greater magnitude still, the facility to control the speed and time of actions opens up huge possibilities for the scriptwriter, enabling centuries to be collapsed into a few seconds of footage, or split-second reactions to be drawn out, investigated and explained. Depictions of unseen events, whether they are historical or have not yet happened, or are perhaps invisible or unexplained, are suddenly possible.

Animation also privileges a number of distinct linguistic conventions that can help writers create interesting concepts and explore different directions as the content unfolds. These conventions include the important and subject-specific elements of metamorphosis, condensation, anthropomorphism, fabrication, penetration, symbolism and the illusion of sound (see box below). Each can be used individually or in combination, as a single occurrence or as a repeating cycle, the variance depending on the project being considered.

Animated language

Metamorphosis – the ability to enact some type of change from one property to another. The versatility of such changes can positively affect scenes, transitions, characters and stories. For example, changes may be sudden or prolonged. It is entirely possible for one property to become multiple properties, or for one or more aspects of the original form to morph into new aspects but using the original form as a base, or to illustrate particular attributes in morphed form that were somehow hidden in the previous form.

Condensation – involves the economical use of narrative material to suggest or imply information, creating symbolic or metaphorical icons to trigger ideas or possible directions for the audience. Used in conjunction with visual material, this is an effective linguistic tool for exploring characters, scenes and storylines.

Anthropomorphism – imbues inanimate objects, animals and settings with human characteristics, giving them the ability to inhabit stories, display their personalities and, crucially, to interact with each other using human communication attributes. For example, an old chair takes on the characteristics of an old man, his back bent, his joints creaking and his voice breaking from years of wear.

Fabrication – alternative environments and figures can be constructed to facilitate the idea that a story or event is happening in a believable world.

Penetration – the ability to investigate subjects that are in some way prevented or excluded from being 'seen'. This approach is often used in animated projects of a scientific or industrial nature as a way of explaining a particular medical procedure or the way something functions, as it is able to employ stylistic or symbolic interpretations and replicate or change elements to help the viewer understand the principles being explained.

Symbolism – writing for animation demands that creators think about the 'visuality' of the form and how narrative motifs can have leading symbolic associations. Use of such visual motifs is important as they help an audience identify with, glean knowledge from and understand the wider context of characters and situations, thus helping them to comprehend a storyline.

Illusion created by sound – used to support an action or as interludes to accompany more abstract narrative ideas as the production develops, sound acts as a vital ingredient in bringing a complete picture to the audience. Both 'diegetic' sounds (dialogue or natural noise created by an action) and 'non-diegetic' sounds (soundtrack, effects and narration) heavily influence an audience's appreciation of the production.

Approaches to scriptwriting

Unless a specific brief has been set requiring an answer, such as an advertising campaign promoting a particular product or service, the job of the scriptwriter is first to seek inspiration for the story. This can come from a rich variety of sources, including a writer's own experience, observations and ideologies, or from responding to facets of the experiences of others. These could include recollections, interpretations, dreams or fantasies. Such starting points are known as the 'premise' or 'inciting incident' for a story, acting as a driving motivation for the production as a whole to be made.

In attempting to establish a narrative structure for the story, the scriptwriter must identify important contextual aspects, such as the history, geography, sociology and duration of the piece. It is vital to introduce immediately a sense of when the story is occurring, where it is set, who is involved and how long the story lasts, as all these factors directly affect both the following structure of the narrative and the wider context for the audience. Importantly, they also provide an early overview for the writer of the possibilities and limitations of the structure, establish 'story laws' and help define 'logic' for the production more broadly. These laws are especially significant in an imagined world that does not conform to realistic conditions since given factors, such as jeopardy, need permission from the scriptwriter to exist. Allowing certain situations to occur, while refusing others, helps embed a conditionally defined

140 bpm

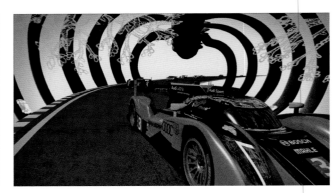

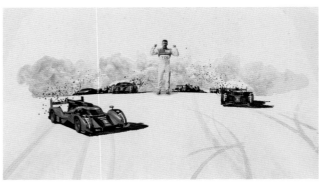

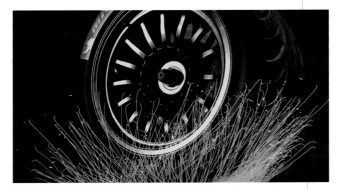

logic that the audience can understand and relate to. These conditions serve to signal occasions where, for example, danger might lurk or fortunes could be sought, and have a pivotal role in developing a deep structural narrative because they permit the connected ideas of anticipation, suspense and release that are crucial to storytelling and which ensure the audience is emotionally invested in the story.

Premise

A premise manifests itself as a simple description of an outline for a story in literal form. Through a combination of the scriptwriter's research, deliberation and play around the broad subject or focused inciting incident, a collection of words and phrases becomes a more refined description, simply structured into the beginning, middle and end of a story, which allows the formation of an animated narrative structure to emerge.

In his book *Story: Substance, Structure, Style and the Principles of Screenwriting* (1999), Robert McKee suggests that narrative can be identified by some key structural components. For example, a story that explores a coming of age or a rite of passage can be identified as 'maturation', while one that follows the journey of how a central character or characters go from bad to good is classified as 'redemption'. A story depicting how a central character, or characters, go from good to bad may be described as 'punitive', while a work that examines the struggle between knowing right from wrong and acting on those impulses can be regarded as 'testing'. 'Education' describes those stories that explore how characters 'learn' to see a new direction, while 'disillusionment' represents stories that explore how a character might be turned to having a very negative worldview.

Opposite Animation is often used in television advertising as a way of seeing how something works 'inside', penetrating the surface to reveal the inner life of the subject.

These early drawings for *Animal Farm* (1954) not only help visualize scenes, but also allow a sense of mood and atmosphere to be evoked that underlines the sentiment of the story.

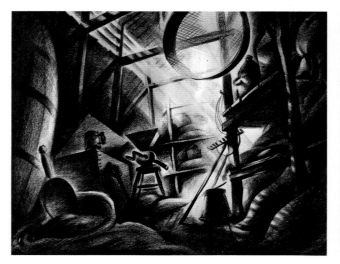

Story ladders and friezes

There are simple visual and textual mechanisms, such as storyboards (see pages 75–81), to help writers quickly review and test the premise of a story. As animation is a highly visual medium, it makes sense for the writer to get used to seeing his or her ideas in rough visualized pre-production format. For example, a story ladder can be employed to review the main aspects of the plot before subplots or additional storytelling information is considered. Here, single panels are roughly drawn and contain brief written descriptions of plot developments. A story frieze performs much the same purpose, but is often displayed in a horizontal line or grid format.

Grant Orchard employs a story frieze to lay out his animated exhibition design for the 'Live Science' exhibit in London's Science Museum.

1.

Plot

Once a story has been decided, it then needs to be carefully constructed and tested so that all of the informative events link structurally towards a conclusion. This is known as a 'plot'. In animation, the plot is often designed in tandem with the narrative structure, which is known as a 'storyline' or 'story arc'. Storylines allow the textual depiction of several characters involved in the story to be accommodated in parallel with plot events, while story arcs usually describe extended or ongoing storytelling in animated television series that may run over several episodes. Both storylines and story arcs offer a framework that supports the continuity and accuracy of the story, the latter helping the audience understand where the story was left and where it picks up in a subsequent episode as part of a bigger series of programmes.

A plot is generally made up of a simple structure involving some or all aspects of exposition, rising action, conflict, climax, falling action and resolution. The beginning of a plot opens with an exposition that introduces the key characters and settings necessary to tell the story for an audience. The plot develops through a rising action in which events occur that help the audience understand both the passing of time and the way in which the events are interlinked together. These events inevitably precede some kind of conflict, where problems between a character and other characters, environments, society at large, or even with themselves, are illustrated and amplified for the audience. This leads to a climax where these agitating factors combine to 'peak', perhaps exposing secrets or signalling struggles and conflicts, before receding through the falling action where the impact of the climax is reflected through characters or situations. A resolution can be achieved when a conclusion to the plot is attained, although some plots deliberately prevent this in order to keep a story open or alive. Resolutions allow an audience to release their tension or anxiety, whereas a non-resolution deliberately keeps an audience in a state of suspense.

British animator Joanna Quinn begins to outline a plot, using quick sketches to capture her ideas for framing scenes and also thinking about how to animate the unfolding story through transitions and camera moves.

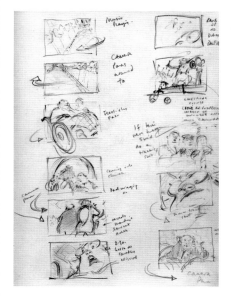 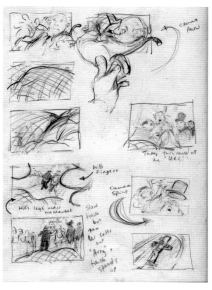 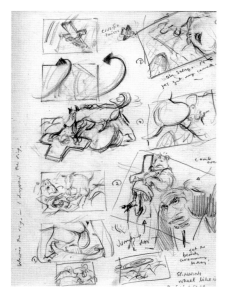

Animation plot themes

Writers might consider using the following plot themes as useful starting points for creating their own animated material, or categorizing the work of others. Here are some examples of animated productions, or productions that use animated special effects, that illustrate the themes described:

Adventure – *Alice in Wonderland*
Ascension – *Mulan*
Descension – *Avatar*
Discovery – *Magnetic Movie*
Escape – *Chicken Run*
Excess – *101 Dalmatians*
Forbidden love – *The Hunchback of Notre Dame*
Love – *Beauty and the Beast*
Maturation – *The Jungle Book*
Metamorphosis – *While Darwin Sleeps*
Pursuit – *Beep, Beep* (Wile E. Coyote and Road Runner)
Quest – *Jason and the Argonauts*
Rescue – *Belleville Rendez-Vous*
Revenge – *Coraline*
Rivalry – *Prince of Egypt*
Riddle – *2001: A Space Odyssey*
Sacrifice – *The Lion King*
Transformation – *Toy Story*
Temptation – *Snow White and the Seven Dwarfs*
Underdog – *Cinderella*

Genre in animation

We are used to going to see 'action', 'horror' or 'romantic comedy' films at the cinema. These are examples of 'genres', which embody typical codes and conditions of a particular narrative structure that allow such a story to be told. For example, a film classed as belonging to a 'science fiction' genre has visually 'coded' objects, environments and plots that help an audience identify key components and make vital associations. In this example, coded clues such as hostile aliens, weapons and spacecraft, or environmental or motivational conditions such as travellers venturing into space or saving our world from calamity, are all established markers of the genre.

Scriptwriters often make use of an audience's pre-existing knowledge of genres, and many animated feature films pay homage to film history through certain scene enactments, or by parodying visual gags and jokes. Many of the films from Aardman Animations rely heavily on such structural traits from well-known live-action films. An example is *Chicken Run* (2000), which heavily

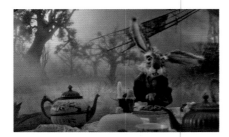

Adapted from Lewis Carroll's book of the same name, *Alice in Wonderland* (2010), directed by Tim Burton, is a lavish adaptation of this childhood adventure, complete with resplendent sets, unworldly characters and a magical score composed by Burton's long-time collaborator, Danny Elfman. © Disney

borrows scenes, situations and even visual escape devices from *The Great Escape* (1963).

On a wider level it should be noted that some film critics have mistakenly categorized animation simply as a genre of film because of its strong association with children's cartoons. Animation is a form in its own right that supports its own framework of genres that are being developed and redefined continually. They fall into seven distinct categories, known as 'deep structures', including Abstract, Deconstructive, Formal, Political, Paradigmatic, Primal and Re-narration.

Categories of animated genres

Abstract – includes animated productions where a non-linear or non-objective approach is adopted for subjects or themes, often connected with expressionistic attempts by the creator to explore outside traditional storytelling conventions. Works are often biased towards investigating the form of animation rather than using text as a foundation. The work of Norman McLaren neatly fits the abstract genre of animation.

Deconstructive – productions fitting this description involve displaying the reasons and methods of their construction for comic or critical effect. Animated cartoon works often fit this category as they openly portray narrative and visual methods derived from cartoon conventions of interpreting representational drawing.

Formal – works included in this category display a linear set of conditions and values that are consistent, enabling representative interpretations of a particular world to be imagined.

Political – these animated productions have the facility to incite and empower through the communication of a moral or ideological political agenda, expressed through a core or combined narrative and/or aesthetic direction.

Paradigmatic – animated productions that use pre-existing visual or literary sources as a foundation, such as adaptations of literary classics, children's stories or graphic novels. Such productions are often governed by rules that remain consistent throughout episodes and series.

Primal – includes animated features that explore such states as consciousness, dreams and the 'unknown'.

Re-narration – works that in some way reinterpret an established story or chapter of events from a different perspective, giving them a different viewpoint and possibly altering the emphasis placed on key moments.

Script development

Scriptwriters must balance the educational, informative or entertainment demands of the premise of a story against the need to strike the right tone with the target audience. Using key principles and characteristics of the animated form is crucial to delivering this through the lifetime of the story, ensuring that the writing allows for the mixing of visuals, sounds and motion to create the necessary desired dramatic, stylistic and structural effects that convince the viewer. To do this effectively, a series of steps is taken by the scriptwriter as he or she attempts to build the framework for a story from the original inciting incident. These steps include a prose brief, a step outline, event analysis and synopsis of the story.

Guilherme Marcondes' stop-motion film *Tyger* (2006) actively involves puppeteers in the frame as a way of emphasizing the construction of the film.

Prose brief

With the beginning, the middle and the end of the story agreed and written in note form, a 'prose brief' can be established. This develops ideas for thematic topics to be covered in particular scenes and suggests where these ideas might occur in the overall telling of the story. A prose brief textually outlines key components of the story and provides a foundation for the writing team to build other related layers of narrative, decide where and how they want characters to be introduced, establish the viewpoint the story is written from and so on.

Step outline

This is a useful device that breaks down a story factually into detailed chronologically numbered scenes. Each scene has a descriptive commentary that explains the main action that will occur and provides clear instruction about what effect this action has both on subsequent scenes and on the story at large. The outline is created by the scriptwriter or writing team and acts as an important guide for the pre-production team to signal and understand key actions in the story.

Event analysis

Using the step outline as an overall guide, the production of an event analysis provides a comprehensive checklist for the script supervisor or editor to spot gaps or inaccuracies in the script. The event analysis matches essential movements of action against specific plot developments and characters. This analysis in turn highlights pivotal movements of individual characters through the development of the narrative, signifying the desired outcomes and emotional responses required or expected from the audience.

The script supervisor or editor first checks the event analysis to ensure that a scene's details – including locations, characters and action – are adequately described and, if necessary, that they are consistent with other episodes in the series. Consideration is then given to how the scene helps develop the plot as part of the overall story. The script supervisor or editor

1.

Grant Orchard's animated shorts for LoveSport premise actions around simple story events that trigger resulting actions, using simple visual and aural motifs with carefully chosen and custom-recorded sound effects.

looks for evidence that demonstrates how the central characters develop their involvement with the plot, creating the desired emotional feeling and providing sufficient information for the audience to understand how the events contribute to their comprehension of the main storyline. At this point, the script supervisor should signal any inaccuracies, including stylistic deviations or descriptive omissions. He or she should also be mindful of suggesting ways to simplify the story if ideas are too complicated, or if they do not utilize the animation production possibilities open to the writer. For example, rather than writing overly descriptive dialogue, it is often easier for an audience to understand symbolic or metaphorical visual devices coupled with shorter narratives, as these resonate more immediately with a viewer.

Synopsis

Written as an overview of the story, a synopsis aims to establish all of the necessary information about the intended production from a more distanced and objective perspective. In essence, it is written to provide clarity for the pre-production team, but is also useful in either attracting or reassuring creative partners or investors. The synopsis usually introduces the location or environment for the story, summarizes the plot, includes information concerning the central characters and their connection to each other, and illustrates the key events that help develop the story towards a conclusion for the audience. A typical synopsis is normally between six and eight paragraphs long.

Treatment

With the premise of the story set, the prose brief, story outline, event analysis and synopsis completed and agreed, a 'treatment' can be finally constructed. This will detail the story's theme, plot, structure and characters in a complete textual and possibly visual form. By this stage, the story will have been scrutinized several times by the script development team, editor and writer(s)

and will have undergone structural, thematic and stylistic changes that better support the telling of the narrative. The treatment will explain the reasons behind the story and how it will unfold dramatically for an audience, and it will also incorporate elements such as key moments of action where the plot changes direction and pace. It is likely that the treatment will also have elements of sample dialogue to provide a feel for how the story will be told.

Analysing a script

The finished script now holds core information about the project and needs to be checked and cross-referenced. It contains details of the storyline or story arc, settings and environments, scenes, characters, dialogue, sound effects and points of action that will be visually rich, as descriptions will be written in such a way as to provide instructions for key details of the production to be interpreted by the pre-production team. This core information directly affects the next stage of the pre-production process for designers, animators and voice-over artists. It is the director's responsibility to ensure that meetings are conducted to read through the script, highlighting key areas that different crew members in the pre-production and production process need to take account of and prepare for. These might include specific technical requirements for the set to be able to adapt to scenic changes, or where emphasis will need to be placed when recording dialogue.

An important aspect that requires checking, regardless of the type of animated production, is running time. If a script has been written for a commercial, it must be aligned with the air time the commercial is to occupy. Similarly, an episode of a television documentary will have stipulations from the commissioners of the project regarding the running time of the piece. Inevitably, this means that the script must allow suitable 'lead-in' time to the content and sufficient space to reflect on the material at the conclusion of the production.

Conclusion

With a script complete, the process can begin of originating visual material around the story and collecting the necessary research material (see pages 55–71) to support the delivery of the story or idea to an audience. The director also begins to look for voice-over actors who can convincingly carry off their interpretations of the dialogue required to help bring the animated production to life. In addition, the director must consider who to approach and brief to provide a musical score, act on discussions with members of the crew relating to sound and lighting effects, and approach special-effects studios as necessary (see pages 106–25).

2.

Animation can be used as a vehicle for telling stories, expressing ideas, explaining principles and selling products and services. With commissioners, creators and audiences alike becoming aware of its possibilities to reach out and engage with different demographics, so the popularity of animation in different forms has grown. Whatever purpose the medium is being used for, its content is significant. Not all content, however, is drawn from a script. Other visual, aural or literary starting points may be equally valid, depending on the type of animated production being considered. In other instances, starting points are briefed rather than originated by the creators themselves, again from numerous possible starting points.

This chapter looks at the ways in which animators originate and develop their concepts and ideas and communicate them to the crew, how these are developed and prepared for a pitch, and how the corresponding research is undertaken and used in the creation of the animation.

Elizabeth Hobbs' touching film, *The Old, Old, Very Old Man* (2007), tells the story of Thomas Parr, who reached the age of 152.

Concepts and ideas

The content of an animated film, regardless of its end use, has not been simply conjured out of thin air. Content may have been introduced through a script, a brief, an adaptation of a previous work of literature, or from an individual's imagination, so the origination and development of concepts and ideas may vary.

Concepts have often been thought about, mulled over and debated long before an idea for an animated project goes into production, or before a series or an advert has been commissioned. Concepts are abstract ideas that need time, research and structural development to become concrete ideas having form and foundation. In pre-production, the animation team experiment and test countless initial concepts, discarding them or redeveloping them from their original inception to working ideas. However these ideas are ultimately arrived at, they are absolutely vital. They ensure

that stories have solid foundations that can be communicated in telling ways or that enable an audience to identify a product or service ahead of its nearest rivals. Perhaps most pivotal of all, these ideas can make the final animated outcome original, distinctive and memorable. Ideas are the very lifeblood of animation, on which every other ingredient depends, validating and authenticating content for the audience.

The significance of ideas

As human beings, we are extraordinarily complex and sophisticated receivers of information. Our body's sensory stimuli are charged from earliest infancy through a mixture of intuition and learned and acquired experiences. We are informed by our ability to observe the world around us. This information is processed, synthesized and recorded by our brains every second of our waking day and can be recalled later through other experiences that act as triggers to engage our memory. An important part of our collective make-up is our ability to interact and communicate by sharing these stimuli with each other. Human social abilities are very advanced and are perhaps something we often take for granted in our everyday lives, but they are fundamentally important to the way in which humans co-exist in a fully functioning, inquisitive and progressive society.

Animation uses two critical sensory functions – sight and sound – as primary drivers to communicate what the creator wants us, as an audience, to perceive, fusing them together to create an emotional experience. In simple terms, this might be best illustrated by imagining a script as a series of words on paper voiced by an actor and a sequence and series of lines on paper drawn by an animator. The important connection is made by a director, who encourages these forms in parallel with each other and blends them together as one, giving the production its shape, life and function. The audience sees a synchronized and coherent form that is imbued with emotions directly connected to their own experience as individuals and which encourages parts of their brains to validate, authenticate and believe the content.

Investing in ideas

Core narrative or conceptual animated ideas can have a sensory effect on other parts of our human psyche. They allow us to become emotionally attached to characters, stories and events, sharing in celebrations and achievements as well as commiserating with failures or recognizing weaknesses. The very nature of the dynamism, vibrancy and clarity of ideas demonstrates that they can make us feel something for the subject being portrayed. In turn, this ability for animators to touch our lives through their work makes an audience feel intrinsically connected, helping them feel valued as participators in the animation process, rather than merely acting as recipients. It is this reciprocal arrangement that has endeared animation to many fans from childhood, and which creates the opportunity for the medium

Studio AKA has enjoyed commercial and critical acclaim for their output of highly engaging and memorable productions, from independent short films to commercials.

to be used outside of 'traditional cartoon' territories by expanding into more adventurous realms, such as the animated documentary or information graphics.

Indeed, animation relies heavily on the power of individual and collective memory. On the one hand, an animator's ability to call on the power of recall means that connections can be established, frameworks built and foundations set for the introduction and development of ideas. On the other, an audience's ability to recall some memories and not others, or to remember sequences or orders differently, enables animators to play with our recollection. Such reconstitutions and reconstructions of events scramble our memory, allowing a 'suspension of disbelief' to become possible and trick our minds into seeing something that seems plausible. It is possible for these shared memories and events to have the same basis in reality for everyone, but for individuals the experiences, knowledge and expectation that contextualize how they recall such occurrences can mean that memories differ considerably. This permits the creator a licence to play, be liberal or economical with the truth, and blur the boundaries between fact and fiction. Examples in animation history are numerous but are well illustrated by many of the visual gags that appear in the Tom and Jerry shorts, where visual metaphors illustrate punch lines that happen to one or other of the characters at the end of each visual joke. For example, Jerry placing an iron into the chasing Tom's path inevitably means Tom collides with that object and is portrayed with a face shaped like the footplate of the steaming iron.

Nick Park's *The Wrong Trousers* (1993) sees the villain, Feathers McGraw, captured and imprisoned in a zoo as his punishment for attempting to commit a diamond robbery.

Starting points

Animation does not exist in a vacuum, but borrows inspiration from real world events, contemporary culture and different aspects of our lives, much as other art forms do. Successful animation acknowledges that it co-exists with and contributes to a world of visual culture and popular entertainment, and that these are vitally important and culturally rich parts of our human existence. It also adds to, as well as learns from, parallel art forms and often uses influences as important core strands of new projects and initiatives. Good ideas stem from keen observation coupled with a need to communicate these observations to others. The ideas need to be exhibited in ways that can be understood by both the production team who will create them, and by the audience who will receive them. The animator's job at this point in the project is to make these ideas a visual reality.

The starting point for an animated project can grow from a variety of interests – including commercial, industrial, educational, informational or personal – informed by both creators and commissioners. As it is a form that draws interest from such a broad spectrum of participants, the decision to use animation as a form of expression originates from one or more of these points. Consequently, there is no one single way in which an animated project is born but, broadly speaking, some of the more traditional starting

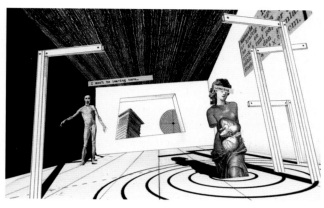

points include scripts, pilot episodes or commissioned briefs that require specific animation treatments. It is equally possible, however, to create a production based on artistic responses to observations and found visual and sonic material. Any of these starting points triggers conceptual thoughts of how to address subjective, structural and technical concerns and requires some thought at first about how to approach the project.

Early conceptual interests can be supported and enhanced by scouring newspapers, magazines, reference books and online blogs, forums and podcasts, at home, in the studio, at the library or out on location. Collected material needs careful reviewing, editing and storing to make sure that historical and contemporary information has a currency that is both valuable and accurate. This supporting evidence helps to firm up concepts and rationalize them into more formed ideas that can be visually explained to others in the crew who will be working on the project during the pre-production phase.

At the same time, conceptual material must be checked to ensure it is sufficiently accessible for further study and not bound by legal or moral restrictions. For example, it may well be possible to use actual existing factual or fictional tales as a starting point, but then to alter certain events to change the story according to the creator's wishes. Animation as a form is historically able to weave a rich and varied tapestry in regard to adapted stories,

Swedish director Jonas Odell's striking video for the band Franz Ferdinand actively acknowledges cultural references from historical Constructivist posters and propaganda.

for example the Walt Disney Studios' 1937 adaptation of the classic fairytale *Snow White and the Seven Dwarfs*, Halas & Batchelor's 1954 adaptation of George Orwell's novel *Animal Farm*, and Jimmy Murakami's 1986 adaptation of the Raymond Briggs graphic novel *When the Wind Blows*. All three examples are written in a way that exudes a visual richness, and the animator's task in each was to preserve the spirit of the original text while adapting the story to an animated context that articulates the plot (and associated subplots) through artificial sequential vision and sound.

Ultimately, successful starting points should strike a chord with the creator, depending on the project in hand, and allow the audience to sense it quickly. For example, nostalgia and familiarity are signals to which audiences naturally respond favourably, regardless of their racial, cultural, linguistic or religious differences. Given the global nature of animation as a form, it is sometimes necessary for creators to strike a balance in creating work that acknowledges differences and at the same time makes audiences feel included and valued. This requires that ideas are tested and adapted to counter criticism that they favour one section of an audience by marginalizing another.

Nonetheless, it may not always be possible to satisfy all audiences all of the time, and many critics and fans of animation argue that there are good reasons not to homogenize animation content, but rather to celebrate our individuality and differences. Indeed, region-specific work such as Ari Folman's universally acclaimed *Waltz with Bashir* (2008) can help us better understand the culture and customs of different parts of the world that may be unfamiliar, even though we might not agree with some of the actions being shown.

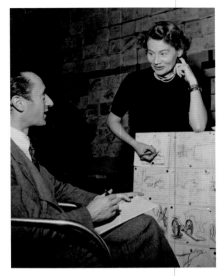

John Halas and Joy Batchelor review early *Animal Farm* layouts.

Ari Folman's absorbing feature film, *Waltz with Bashir* (2008), serves as a timely reminder of the power of animation to traverse boundaries of race, religion, culture and language, presenting a difficult subject matter through a deceptively simple technique.

Developing a conceptual framework

Animators use conceptual frameworks to contextualize the script, brief or imagined starting point of the project. A conceptual framework encourages, informs and permits the shape, definition and progression of each phase of the production. It allows the crew involved to measure their progress and

evaluate their individual and collective achievements, and also enables them to bring ideas to the table and to test, evaluate and revise the project effectively.

The conceptual framework should establish a series of parameters that are understood as being guiding principles by which the project is defined and then conducted through the pre-production and production phases. It should include answers to the following ideological and practical considerations:

- What is the starting point for the project?
- What media format is the work likely to take?
- What style or animated treatment is required for the project?
- What is the role of the audience in the production?
- What is 'possible' or 'impossible' in the story?
- What restrictions are there in terms of subject matter, handling, association and/or implication?
- Are there any moral, ethical or ideological restrictions to the subject or the intended depiction of the subject?

This is not meant as an exhaustive list, but instead an illustration of contextual guidance that might permit the subject to be considered objectively and freely.

Pixar's purpose-built studio in Emeryville, California, offers a dynamic and stable environment to create animated feature films, with creative studio environments housed under the same roof as huge render farms processing the computer-generated imagery. © Pixar

The studio environment

A good studio environment is important in supporting the schedule, workflow and conceptual framework of an animated project. Any studio must have consistent and reliable conditions that will support the changing needs of the project. It must be able to be secured, but equally should be easily accessible to those who need continual access. Ideally, the studio will provide a solid base for extended working practices, as the process of animation is time-consuming and meticulous.

A flexible studio space should be conveniently located for both the animator and visitors to the studio. It needs to be well-resourced, spacious, temperature controlled and capable of being adapted to provide different lighting conditions. The studio must be insured and should also conform to health, safety and fire requirements, especially where it is part of a bigger building, and occupants are responsible for ensuring that published local guidelines are followed. Working conditions are checked regularly, and it is helpful to have an inventory of equipment and materials that can easily be checked by inspectors looking for assurance of compliance. Many studios also have a register to prove who is working at particular times and visitors are also closely monitored.

A welcoming and inviting environment, encouraging playful thought and the exchange of ideas around the animated project, is the ultimate goal. It should be remembered that the space is considered a home from home by

many of the crew. An inviting studio is a place where animators will be happy to spend long passages of time producing quality work; the layout should enable the team to work closely as a group in a shared space, but have enough flexibility for partitioning off the space when members of the crew need to work independently.

The success of the layout, the maintenance of the studio and the lively atmosphere of the space can also actively encourage other supporting activities. For example, the ability to identify, develop and enable acting to occur to inform animation is a fundamental expression. This can be achieved through a variety of non-verbal activities, including the depiction of exaggerated or understated movement, body language and figurative gesture. Many animators come from a background that is steeped in the understanding of the art, science and even politics of movement, through drama, music and dance, and use this knowledge and experience widely and frequently in their work. The studio environment needs to have sufficient space and resources to allow such actions to occur.

The ability to act is often employed by animators to explain their concepts and principles to other members of the crew in the studio environment. These structured or impromptu sessions are useful in helping the team to identify common ideas, explain concepts where other forms of communication are not appropriate, and share a vision of how problems concerning the depiction of characters, environments and situations might be solved. Very often they also save time and give a clearer picture of the overall essence of a visual idea.

Toronto-based animation production company Head Gear have created welcoming, conducive working environments to allow their animators to work in comfort.

Capturing ideas

It is important to turn abstract concepts into visible ideas. Animators keep a mixture of journals, sketchbooks and notebooks to record their observations and thoughts, processing this information through drawn or noted ideas. This documenting process is highly personalized and individual, helping to articulate and place events into understandable visual interpretations.

The value of drawing

The immediacy and interpretive nature of drawing allows the playful exploration of ideas and can lead to some surprising discoveries. In turn, these events can formulate new directions for subject matter to take that audiences might not expect. Visual documenting is often highly engaging, and can range from expressive depictions of scenes or situations, right through to detailed working out of figurative poses or explanations of mechanical devices. It can be representational, exaggerated or abstracted. It can also be conscious or subconscious – depending on the creator's need or desire. Animators such as Joanna Quinn, Caroline Leaf and Elizabeth Hobbs all prolifically document discoveries through drawing and this ability to explain and define movement through drawn statements extends as a central identifying theme in their work.

A bewildering array of mark-making materials, processes and techniques, at different scales and on numerous surfaces, can be employed to capture thoughts and observations, depending on the type of activity the animator wishes to record. For example, the fine point of a pencil might be better to explain details in a sketchbook, while the broad sweep of a chalk pastel perhaps better enables the animator to capture a sense of movement on loose sheets of paper. Whatever is being recorded, bringing tools that are fit for purpose is essential and prior preparation is key.

The fluidity of Elizabeth Hobbs' drawing aids figurative and gestural interpretation with an economy of visual marks, encouraging the audience to 'see' the story unfold.

Animator's tools are highly specialized, depending on the task in hand.

Drawing and visualizing tools

A typical treasure trove of drawing materials for animation pre-production might include:

- various grades of graphite pencil
- sharpeners and files (nail files are good for getting very fine points)
- selection of erasers (including putty, which can be shaped)
- graphite sticks
- charcoal (various grades, including compressed)
- fixative
- compass
- scissors and cutting blades/handles
- coloured pencils
- felt-tip pens and markers
- watercolour and/or gouache paints
- coloured waterproof inks
- pastels (oil, wax and/or chalk)
- brushes (a broad selection might include flat and round heads, hog- and sable-haired, long- and short-handled and possibly specialist variants, including Japanese calligraphic brushes, to suit specialist work as required)
- dip pen with selection of different nibs
- selection of fine liners
- ruling pens
- measuring aids (set squares, rulers, protractors, French curves and so on)

With the increased use of digital technology, it has become commonplace to mix recording tools to capture specific observations. For example, a sketchbook can be used to note specific details as drawn information – perhaps to understand how something works – while supplementary digital photographs can provide a consistent contextual overview of the subject in question. Sometimes digital photographs allow an instantaneous moment to be captured that would be difficult to report through a detailed drawing. This versatility simply gives the animator greater tools on location to be able to consider observations and capture the necessary recordings. This enables informed judgements to be made in a detached environment, where it is possible to be objective about the quality of collected information.

2.

The animator's toolkit

The following suggested toolkit can be supplemented by your own particular requirements, depending on the specific area of animation you are working in:

- sketchbooks (various sizes, types of paper and bindings to enable the animator to record observations)
- notebooks (again, of various sizes, as preferred)
- elastic bands or clips – useful for securing pages against prevailing weather conditions
- large sheets of paper – to draw expressive movements or to expand ideas where a sketchbook is inappropriate
- digital camera(s) – a compact camera is essential, but an SLR camera with manual focus is probably more desirable as it can be customized with different lenses and filters; choose the best picture resolution capability you can afford; the option of shooting movie frames is also extremely useful; a memory card with good storage capacity is a must
- removable hard drive (again, buy the most storage space you can afford)
- tripod
- drawing stool
- sturdy bag
- travel umbrella
- waterproofs (can save time and allow you to work uninterrupted)
- freezer bags – useful for keeping collected material or equipment dry and with a zip seal that can be reused
- a digital sound recorder
- external microphone
- headphones
- watch or stopwatch
- duct tape – waterproof and reliable
- repositioning tape

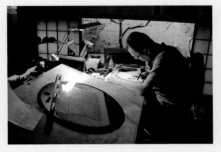

Influential Japanese animator Koji Yamamura at work in his studio uses a mixture of analogue and digital processes to make his independent films.

The central issue is to be methodical and to have a structure and order to the information being collected first-hand. For example, some animators use a personalized wall planner to record events and store associated material. Others prefer to collate material digitally, using tools such as digital data-tagging technology to pinpoint related observations and group them together. For example, Apple's iOS software uses face recognition technology to group photos of people together, borrowing the digital profile of where the photo was taken to create a visual footprint of this information as a pin in a map. This allows a hierarchy of information to be developed, at the same time ensuring that all the information is kept in a versatile format that can be viewed according to the creator's preferences.

The value of the doodle

Doodling in particular, while seen as trivial and banal by some professions, is highly prized by animators as a way of potentially unlocking closed mindsets and encouraging playful intercourse between images and sounds. The word 'doodle' is thought to originate from the verb 'to dawdle', implying a lazy, haphazard approach. Doodles in this context can be read as unfocused drawings, often made while doing other tasks. Various scientific investigations indicate that while the brain is concentrating on one function, it also has the capacity to allow additional motor skills to occur, such as drawing or scribbling, without the creator being fully aware of his or her actions.

Doodles can be representational, abstract or symbolic and can be created anywhere, at any time and with limited materials. Their universality is part of their appeal and disarming nature, turning some who express reservations about creativity into creators. The ability to express oneself without the fear of failure makes the doodle a priceless commodity, instantly able to illustrate random thoughts that might lead to a string of sequential images that ultimately could form the basis for a plot. Doodling marginalizes risk, throws out conventional representational rules and encourages the impossible to become realized – echoing the ability of animation itself.

In the very early stages, doodling ideas is a very productive way of allowing the flow of ideas to develop.

Idea development

As a form that privileges motion, animation is able to explain, articulate and celebrate artificial passages of time. Some ideas can use time to alter appearances, suggest events or change meanings, and this quality is used by animators to progress the development of plots, characters and scenes. The working up of initial thoughts through a sequence of associated or related images allows scope for expansion or condensation, introducing possibilities and raising issues that need to be addressed for the project to continue to flourish. Several leads can be pursued at the same time to find the best solutions. Connected sequential visuals also start to suggest main points of actions for ideas that could later become key frames in the project. Some animators work quite loosely in this regard, while others, typified by Johnny Hardstaff, work intensively, meticulously working through the best ways to squeeze meaning out of every element of the project.

Ideas in motion through the figure

One of the most important aspects uncovered in ideas development is that of depicting the movement of the figure, where certain poses can communicate powerful symbolic statements and act as signals that the plot is developing in a particular direction. In order to fully understand, appreciate and articulate motion, a thorough understanding of the construction of the human figure is important. This is fundamentally achieved through observing and recording figures from life, through drawing, exploring the anatomy of the human form in both static and moving poses, whether nude or clothed, male or female, young or old. Animators place great store in their ability to understand how

Opposite Johnny Hardstaff's obsessive sketchbooks show a microscopic attention to detail as he works through ideas.

the human body moves, balances and rests. This ability to comprehend the body's capabilities and restrictions has a direct impact on characters they go on to create. Physically imitating motion through acting or miming is also often employed to help understand the complexities of movement.

Characters need to move in ways that audiences will believe and accept. For example, the main character in Peter Docter and Bob Peterson's *Up* (2009), Carl Fredricksen, is an unlikely seventy-eight-year-old lead. His restricted movement is painstakingly captured by the team of animators from the Disney•Pixar studio – who drew countless elderly men in an attempt to understand how the ageing process affects the general properties of movement and posture of the human form – right the way through to how the character wears his clothes, how his skin ages and generally how his body language differs from that of a growing boy or young man.

Aids to developing ideas

Animators need to test and evaluate ideas in motion to gauge how successful they are. Several devices are available to showcase convincingly idea development through movement. On a basic level, flipbooks, character study sheets, simple armatures and line tests can be employed to depict and test basic movement. As ideas for characters or sets get more involved, working on a bigger scale, with the option of being able to trace or overlay drawn image elements, is useful. This bigger scale promotes the choice of scale and gesture and also allows work to be pinned to boards, creating an opportunity for ideas to be shared. Building quick models, often very roughly, allows ideas to be realized and developed and has the added advantage of allowing the animator to start thinking three-dimensionally, especially if the production method is going to follow this process. Sequential images can also be scanned or photographed in order, and played back at different speeds to give an indication of the 'start' and 'end' of an idea.

British independent animator Joanna Quinn is known for her sensitive and acute portrayal of the human form, demonstrated here through drawn studies for *Elles* (1992), which pays homage to Toulouse-Lautrec.

Flipbooks to test ideas

The flipbook was invented by John Barnes Linnett in 1868, and has become a relatively quick and simple sequential device for transferring two-dimensional static images into short moving sequences at relatively little cost. Like the zoetrope and the praxinoscope, they are very useful to test out ideas on others but, unlike those cylindrical devices for viewing images in motion, flipbooks have the advantage of being linear in format. This allows animators the opportunity to take doodles and sketches of ideas and develop them as a linear narrative. The 'movement' is created by flipping the pages quickly so that the single images appear to move as they are pieced together by the brain to make a sequence.

Flipbooks should be no bigger than 10 x 15 cm (4 x 6 in.) and no smaller than 5 x 7.5 cm (2 x 3 in.) and should contain at least fifty pages, allowing the page to be seen as one whole entity, but also offering sufficient workspace for the drawings. Each page becomes a blank canvas and, using the previous drawing as reference, the animator has the freedom to explore the properties of the page by making subjects morph from one scene to another, playing with spatial and composition elements to speed up and slow down the story.

The size restrictions mean the pages of the book can be flipped quickly but consistently and this is key to smooth transitional movement. The outer two-thirds of each page are visible (the inner third is consumed by the binding and the operator's thumb securing the book in place). The separate sheets of paper are bound together tightly, allowing the pages to be flipped. The story can run in either direction, but pages have a tendency to 'arch' running front to back and make the story harder for the viewer to follow.

These gestural studies reveal both Joanna Quinn's knowledge of the human form, and the possibilities for using the character as a vehicle for introducing ideas and establishing mood.

The arrival and abundance of digital technology has revolutionized idea development and testing. Digital cameras, camcorders, mobile phones, motion-capture technology and even some PDA devices all have the facility to record movement and to allow instantaneous playback. They have the benefit of allowing animators to examine footage repeatedly at different speeds and resolutions to understand how motion occurs. This knowledge can then be applied to thinking about how the production could use specialist animation processes and techniques to communicate these ideas to the audience.

These visual ideas can take on an extra dimension with the introduction of sound. If ideas are being produced in response to a script or brief, it is possible to read and record passages of spoken word to provide a framework or backdrop to test ideas against. Even odd sound effects recorded on location, or found from other sources, can be helpful in bringing visual ideas to life. Marrying sound to image is important and many animators argue that the sooner this occurs the more seamless and natural the final result appears (see page 124).

The ability to express initial ideas clearly is very important. As animation is artificial, it is entirely possible to create imagined worlds that are unfettered by the limitations of our own physical one. Provided that such imaginary conditions are credible to the audience, animators aim to achieve a harmonious and balanced overall feel, even if certain components are fantastically imagined or seemingly unbelievable. This requires that the animator has a full knowledge and grasp of the synchronicity between the structural elements of colour, composition, design lighting and movement that make up the single frame, in order to communicate a consistent and collected statement of intent. At this phase of pre-production, the most important requirement is to ensure that ideas are strong and flexible enough to act as a foundation to build these other elements from. The essence and flavour of the overall body of work is critically important, allowing characters, scenes and events to work in harmony, aiding believability for the audience. Time spent working ideas through is important and should not be overlooked.

Evaluating ideas

Good ideas are not set in stone, but instead need challenges to test their authenticity, believability and currency. Sadly, there is no magic formula for a good idea. One might argue that good ideas stand more chance of materializing from a process that encourages thorough research, excellent preparation and an ability to construct interesting, dynamic and thought-provoking content. Ultimately, however, there is a strong element of chance involved in animation, which reveals its experimental properties and perhaps is part of its charm for creators and audiences alike.

While the element of chance equals risk in some quarters, the animation process at least enables some degree of certainty and reassurance by its

nature of being an artificially constructed medium. In the pre-production stages, where changes can be more significantly made and cause least disruption, ideas are tested and developed. They can also be shelved or rekindled. Changes made outside of the pre-production or production phases are inevitably more time-consuming and expensive and may prevent the work being completed.

An honest and open review of ideas is essential to iron out weaknesses in pre-production. It is important to seek balanced but insightful reviews at opportune moments. These vary, depending on the nature of the project, but might include:

- initial ideas generation process
- a rough storyboard introducing the core key frames of the production
- an overview of the central characters
- ideas about locations and sets
- the visual breakdown of scenes
- completion of the rough animatic where the project is seen sequentially for the first time

Many larger studios have the luxury of screening developing ideas to selected audiences (often their own staff), who have often had to sign agreements preventing them from talking about work being undertaken. Ideas can be explained and measured and comments noted, digested and acted on. If the work is commissioned, there will be an agreed process of review that has already been built into a schedule, so that key individuals, such as marketing and account handlers, can satisfy themselves that the company is being profiled in the correct way and the budget is being run efficiently. For more personal projects, an ideal review team might consist of individuals who have an interest in the project – perhaps as other animators or as keen watchers of animated productions – whose opinions are valued, based on previous knowledge, experience and expertise. Receiving friendly criticism is not helpful when trying to produce the best possible work and should be avoided.

Honest criticism can sometimes be painful, especially where a project has been nurtured over a long period of time or if the subject matter is highly personal. It is important to remember that the evaluation process is there precisely to allow ideas to be tested. If a reviewer does not understand something, it is likely that a cinema full of people will not either, so it is better to deal with any issues at the beginning. The important point to take from the review is what does not work and why, and then to ascertain whether issues are conceptual, structural or to do with poor explanation. Understanding the faults allows the animator to take stock of ideas or sections of the project and reconfigure them.

Learning to pitch ideas is a necessity and is regularly practiced through college critiques as a way of building confidence and sharpening students' presentation skills.

Below are some likely issues that animators may have to face when developing ideas:

Problem	Issues	Potential solution
'I don't get the idea.'	Poor choice of idea. No contextual clues to help. Confusing angles.	Consider changing angle or viewpoint of subject, or incorporating supporting pictorial elements.
'I can't see what is going on.'	Indecipherable visual elements.	Economize on the number, variety or intensity of drawn marks.
'It happened too quickly!'	Too much information being shown in too short a space of time.	Try changing the start and end points of an action. Emphasize the most important movements and sacrifice filler information.
'How did it do that?'	Subject changes through metamorphosis from one thing to another.	Consider the context of the change. In the greater story, can this change exist? Does it need contextualizing sound, narration or description?
'It couldn't do that!'	Unbelievable changes occur that have no apparent justification or reason.	The idea may be too far-fetched to be credible. Time to revise the idea.

Pitching concepts

Unless the animated project is self-funded or is an independent production, ideas will usually need to be communicated to an outside agency through a 'pitch'. A pitch is an overview of the planned production and will clearly vary depending on the scope, format and outcome of the work. A feature film will require a series of pitches, as will an advertising campaign, while a short feature will normally be pitched only once. Traditionally, pitching has involved the meeting of constituent stakeholders of the production in the same place to hear about potential ideas and directions for the project. In recent years,

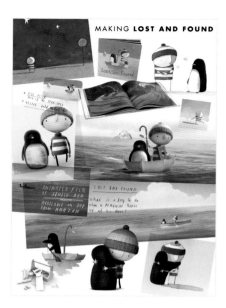

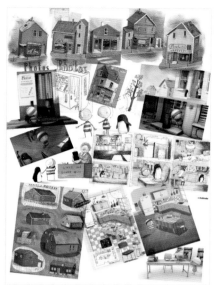

These images show the background research required to adapt a children's book to screen, including ideas for possible environments, creating scenes for action to occur and planning compositions to heighten a sense of drama.

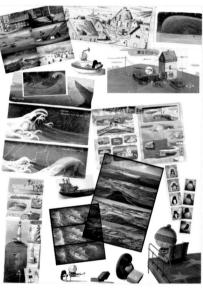

such meetings have also been conducted virtually if required, with the improved reliability of online and mobile technology better able to connect parties in different venues and countries.

As a summary of the project, the pitch should easily and quickly identify the core idea of the production and indicate the target audience. The pitch should clearly mark the beginning, middle and conclusion of a story and might seek to do this through a written treatment, a series of visuals, a short sequential piece or a mixture of these formats. Whatever the format the animator decides to employ, the critical point is to establish the idea clearly, concisely and memorably, taking into account that individuals who make up the group might not be fully visually literate or may not have direct

understanding of the possibilities of the animated form, but they may have full control over future funding of projects.

The individual or team involved in introducing the idea should plan the pitch in advance, consolidating the body of material into digestible and memorable pockets of information that directly address what they have been briefed to do. If necessary, such material as supporting folios of visuals, examples of treatments and display maquettes can be expanded upon through further questioning, where answers might employ these examples to persuade or validate previous information given in the original pitch. A practice pitch establishes what combination of materials the pitch is using and the length of time the presentation will take, and allows the team to prepare for likely questions by working out potential answers in advance.

Research

If ideas are the lifeblood of animation, then research is the crucial oxygen by which those ideas have the chance to come to life. The importance of research in pre-production cannot be stressed enough, though it is occasionally overlooked as its outcomes cannot be immediately tangibly identified when an animated project is released. However, if we begin to unravel the gloss of the final product, it soon becomes apparent that research is wholly evident in every work and exhibited in the quality of content in a film or series. To examine animation further, we must begin by asking what exactly constitutes research, how it is collected, recorded and measured, and how it can be employed to create content that is believable and compelling and that provides a solid foundation on which to build other convincing aspects of the production.

What is research?

For animation purposes, research embodies the process that identifies, collects, sorts and processes reference material that has been gathered by direct and indirect sources so as to fully understand the concepts behind a story or factual event. In the field of animation, this span can range enormously: from the enthusiastic individual animator who often goes to extraordinary lengths to collect material to convince a commissioning body, the rest of a production team and the audience about the merits of a particular idea, through to the teams of researchers working on particular aspects of a studio feature film.

Inevitably, there is a particular set of skills associated with this kind of activity. Some people entering the field find themselves drawn to researching projects as they naturally have these specialist skills. Such skills include:
- a love of finding out about subjects that you may not have a direct interest in
- a tenacity and rigour of approach

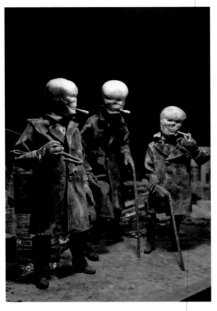

Good character design is cemented through rigorous and painstaking attention to detail, as demonstrated by Clyde Henry's extraordinary stop-motion film, *Madame Tutli-Putli* (2007).

- an ability to frame questions likely to get informative answers
- an orderly and methodical procedure for deciphering findings
- an ability to catalogue outcomes in ways that enable others to access material from different points and for a range of uses

Clearly, an individual researcher needs to have or develop these skills in abundance, together with an ability to manage these activities to a set timescale.

Research is used at different stages of the animation process, and can be returned to at any time for greater clarity, reassurance or accuracy. This is especially important when dealing with factual subjects, or adaptations of other people's work. It may also encompass more widespread factors, including researching potential film locations, specialist animators who may be required to perform specialist tasks, or potential distribution regions. Specifically though, research in pre-production is centred around the following areas:

- the pre-production cycle of story research
- historical and factual accuracy
- costume details
- location details
- accents
- mannerisms and colloquialisms
- character interaction
- environments
- audience
- how material is likely to play to different geographical, racial, cultural or religious audiences

In order to make this process meaningful and relevant, it is vital that the research team share the plan of how best to acquire this information and how the findings of the research process can aid the production overall.

Collecting accurate reference material

Quality reference material is crucial to the origination, development, portrayal and acceptance of an animated production. Many animators cite the importance of content and will go to extraordinary lengths to satisfy their own curiosity, knowing that well-researched material is the cornerstone of their production and that it might be relied upon by others in the creative process. For example, for their Clyde Henry Productions short film *Madame Tutli-Putli* (2007), creators Chris Lavis and Maciek Szczerbowski spent months investigating how to simulate the ageing process of clothing by first researching the costumes required for their villainous characters, constructing the clothes accurately to scale, and then burying them in mud for several months so that they would take on the patina of aged distressed material.

Accuracy is paramount to the success of any piece of animated work. Researchers and animators diligently trawl for large amounts of information and sift this down gradually into identifiable and usable material that has relevance and practical benefit for others accessing it. Clearly, the need for different levels of accuracy fluctuates with the kind of animated project being undertaken. Material that has been poorly referenced often manifests itself in unconvincing and badly conceived ideas that reveal a lack of fundamental preliminary detail when the work is screened.

A lack of preparation can have the potential to mar good scripts, characters, plot lines and other constituent parts of a project by suggesting a lack of accuracy, rigour and even belief in the project. To prevent these unfortunate occurrences, a team needs to ensure that the research process involves checking that material has been cross-referenced against other reliable sources to verify key facts, dates and other immovable information. This can often best be achieved by presenting the collected research in an understandable format to trusted external experts, such as educators, psychologists and health workers, who can offer helpful and knowledgeable advice.

Identifying and formulating a research methodology

Before embarking on a research agenda for the project, it is important to ask some meaningful questions in order to identify and plan an appropriate method to collect useful material. Each project may require different research methods to explore, unearth and discover vital information, but it may be helpful to ask the following general questions:

- What findings are likely to be required and what is the best possible way to achieve them?
- How much time is available in the proposed project schedule?
- How physically close and accessible is the research field that has been identified as needing investigation?
- What monetary and/or physical resources are available to the project to collect and compile material into a recognizable format that will positively benefit the team?
- What proportion of available time will need to be designated to collating, sifting, documenting and archiving the information?

Answering these questions enables researchers to formulate an outline research methodology and plan how the collected material will be assembled as a tangible and usable body of evidence for the creative team to utilize efficiently.

Opposite Jonathan Hodgson's drawn sequences for the BBC documentary, *The Trouble with Love and Sex* (2011), produced and directed by Zac Beattie, uses a mixture of video recordings, interviews and video diaries that had been specifically researched to collect audio clips capable of being interpreted into an animated documentary.

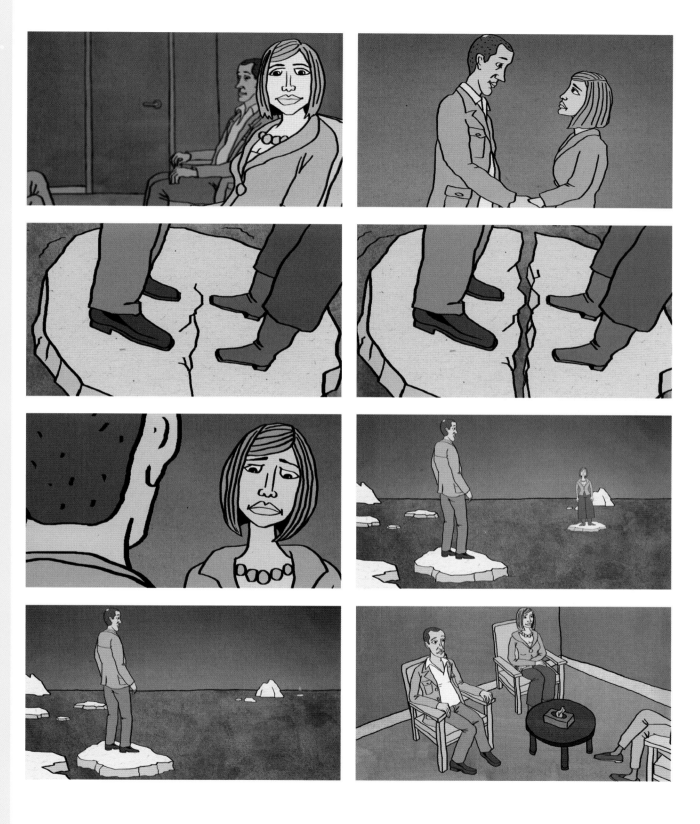

A sample research methodology

Primary research trawl
- visit locations
- establish contact with local experts in the subject
- advertise your presence and explain to people why you are researching the subject and what you are hoping to find (if allowed)
- visit libraries, museums, archives and collections to check reliability of and access to source material
- make connections with people able to offer personal insights, experiences or recollections that constitute first-hand research
- keep a diary of meetings, events and locations visited
- ask to be kept informed of developments in the subject being researched via email or telephone
- collect, tag and record where research material was collected
- establish any factors that would prevent the use of certain materials in the project
- inform the research team of your findings and prepare them for the amount and location(s) of material to be inspected

Secondary research trawl
- revisit locations if appropriate
- check local contacts for updates on information
- meet contacts and record their observations or recollections
- borrow, read and record specific information from established sources
- revisit diary notes and look to organize second meetings with interested and informative parties
- check on developments in the subject
- revisit collections of materials and apply questions formulated from the primary research evaluation meeting
- check that permissions have been granted for material you wish to use, including any rights releases, and ask contributors to sign to confirm they understand the full implications of this material being used in the project
- keep connected with the research team and ensure that news is communicated in good time

Tertiary research trawl
- check local contacts for final updates on information
- check clarity of factual information with contacts and record their revised observations or recollections
- revisit diary notes and check that meetings with interested and informative parties have been completed
- check permissions status of research material
- thank those who have helped the process and remain in touch with key providers

Collecting and appropriating research

Wherever possible, it is highly desirable to collect first-hand research material as this greatly improves both the accuracy and the legitimacy of the research. First-hand research might include such activities as site visits, trips to visit local or foreign locations and places of note, interviews with knowledgeable parties and the canvassing of opinions from individuals or groups who have had immediate dealings with the subject. Time spent preparing for research visits should be built into the project. Researching, locating and communicating with foreign contacts who know the local conditions inevitably saves valuable time and money on the ground. For international visits, translators are well worth investing in as they will save a good deal of time and effort, and may be able to ask questions of subjects that can turn up further important discoveries.

Of course, it is not always possible to get detailed factual accounts, either because they do not exist in a format that can be relied upon, or because they have been affected by forces such as time, loss of memory and other developments. In this instance, the collection of relevant second-hand material becomes important and will include archived static media, such as newspapers, magazines, journals, periodicals and transcripts, as well as broadcast media including old television and radio programmes, plays, documentaries and so on. Successful research involves getting a sense of the context of a story or event, as well as the correct facts about the story itself. This context will add to the atmosphere in which the assembled collection of material will be viewed back in the studio and will also imbue the subject with a sense of authenticity.

Since animators use a great number of starting points in their work – ranging from working from a script or storyboard through to responding to a piece of music or a chance observation – the breadth and depth of research material is essential. To get such scope requires several phases to identify which pockets of material are valuable and which should be discarded. This process is, of course, affected by the time permitted. It may also be appropriate to return to a research field to collect other kinds of material to further consolidate and support material collected on a previous expedition, in line with the research plan set out in the project's conceptual framework.

Reviewing the research

Research should be collected and collated principally for the rest of the team to understand and use in their work. In pre-production, it is quite common for idea development to overlap with the collection of research material. It is, therefore, crucial that shared information is presented clearly and concisely. This will differ depending on the format of research material collected, but can include pinning drawings, photographs and collected samples to studio walls, creating a specially designated space within the studio for materials and artefacts to be seen and shared, and using appropriate sound or projection equipment to share recordings or footage with the rest of the team in a screening room.

Julia Pott uses drawing as a way of recording the research around her subject matter for the film *Belly* (2011), working her findings into the development of characters and situations to create depth and complexity.

Key information is considered at different stages of the pre-production and production phases, but it is important that research reviews are regularly conducted to ensure that collected material is historically, factually or fictionally accurate. This should be built into the conceptual framework for the project so that everyone is aware of how the material has been collected, sifted and made available for use. Additionally, studios may employ 'focus groups' consisting of people chosen deliberately to reflect the target market of the intended audience for the project. These groups sit and watch production test shots, giving feedback to questions set by the crew. It is also possible to ask specific questions relating to the presentation of factual information, should the project demand that level of scrutiny. Animated campaigns for advertising will also have to go through consecutive stages of approval, including target audience tests, detailed client scrutiny and, in some cases, statutory regulatory bodies to ensure compliance with certain industry standards.

Animation students in a critique explaining their formative ideas at the Royal College of Art, London.

Conclusion

With a script written and the central ideas developed, considered and tested, and any resulting problems corrected, the project is ready to move from the pre-production into the production phase, subject to developments concerning visuals and sound being agreed by the director. The project takes a step closer to becoming a reality, with final structural decisions made by managing members of the crew – usually the director and producer on larger productions – that will impact on the project work schedule. Revisions are made where necessary to help support the project, often in consultation with its commissioners.

In the next part of this book we will see how the project is developed by breaking down the specific elements of the production of an animated project, including creating artwork through different animation processes and techniques, and capturing these expressions through set design, camera moves and lighting techniques. We will also introduce and establish ideas for applying and integrating sound design into the project. These specialist tasks require skill, knowledge and awareness of other members of the crew, and the next chapters outline the often absorbing and intricate work that turns a project into a production.

3.

This chapter explores the development of an animation project in the transition through the pre-production phase into production. As we have seen, the project concept has been introduced and scripted and a series of resulting ideas explored, researched and developed. The material has been consolidated through discussion and visually presented by the pre-production team as an agreed rough draft of the final project. It has then been delivered through a pitch to the client. Now the project needs to take on a more detailed physical shape, putting those initial ideas into practice, finding out where there are likely to be production problems and attempting to resolve them. This development stage will take a good proportion of the overall project timeline to complete, since decisions made in this process are integral to its success.

In the development stage, the material collected during pre-production needs to be explained in a visually succinct way to the production team. For example, the overall scripted and pre-visualized story should suggest how the plot or idea unfolds for an audience, including how directed camera angles and movements will add increased drama, altering the narrative or conceptual pace of the content. With animation being employed widely in projects, the order of tasks in the production process may vary. As a general rule, a storyboard needs to be originated and developed first to help inform layout designs. Considered layouts need producing, testing and developing to communicate the content with cinematic impact, acknowledging the ability of an animated product to squash or stretch the passage of time convincingly. Characters then need to be originated, developed and tested to check they are credible for an audience to identify with and understand. These characters will be required to possess and exhibit characteristics capable of delivering the actions outlined in the script and storyboard through an appropriate production process, or combination of processes if multiple animation techniques are being employed.

Thoughtfully planning a storyboard can help formulate a framework for a production by laying out the key action points of the story, providing a coherent structure to commission voice talent, composing the score and collecting sound effects.

Animation pipeline

Storyboard: A storyboard is developed to illustrate the emerging narrative, setting the scene, introducing characters, establishing where dialogue fits with action, suggesting camera shots and angles and determining sound effects. This is tested as an animatic, merging vision and sound to start to make sense of pacing and timing of the material for the audience. As the production develops, so does the quality of information held on the storyboard.

Development: Sets, scenes, and characters are visually developed in tandem with the collected research material as the crew work out how to animate the information contained in the storyboard. This involves detailed analysis of how the production is constructed (how to move items on set, how characters walk, talk and interact, how lighting will be set and cameras will capture each frame) so that any production issues are resolved prior to filming. The production schedule is established and published for the crew.

Storyboarding

A storyboard comprises a collection of numbered static visualized images that represent pivotal film frames. They illustrate the important points, known as 'key stages', of an animated script or story in chronological running order. These key stages are largely determined by the type of animated project being undertaken and the availability of such components as the script, the soundtrack and any necessary dialogue. Some independent animators and studios create storyboards as a way of originating or informing a provisional script, while in other instances the storyboard is created in response to a written treatment. Regardless of how they are conceived, storyboards are an important shorthand visual aid in helping the crew understand the basic production information involved in animating the story.

Storyboarding was first employed on a major industrial scale by the Walt Disney Studios in the early 1930s, although there is evidence that the practice of drawing and posting images was pioneered at the studio some years before. Animator and historian John Canemaker suggests that 'story sketches' were employed in the planning of Disney's *Steamboat Willie* (1928) and *Plane Crazy* (1928), films that introduced the cartoon phenomenon of Mickey Mouse to the world. These sketches were pinned to the walls of the studio to help communicate story ideas to the team of animators, and were certainly in place in the production of the 1933 short *The Three Little Pigs*.

Storyboarding has successfully continued to traverse moving-image production in subsequent decades, being an important process in the development of big-budget live-action features, in documentary film-making and, most recently, in designing the order and navigation of animated websites and applications for personal mobile devices.

Storyboarding: from single to serial imagery

Typically a storyboard comprises visualized and noted information in individual boxed panels known as 'frames'. These correspond to the proportions of the final production format, which depends on the selected broadcast format. Broadcast formats differ depending on the source of output, geographical region and recognized broadcast standards of different countries or regions.

Storyboard frames are usually grouped in collections of 12, 24 or 36 boxes and may run over multiple boards to show the key frames from the beginning to the end of the production. Each panel is supported by some, or all, of the following information:

- a chronological scene and corresponding shot number
- a brief narrative description, or a collection of symbols such as arrows to illustrate how the camera will 'move' in the scene
- a description of whether the shot will be created using long, medium, close-up, extreme close-up or wide-angle camera positions

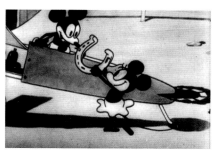

Storyboarding became prominent as part of animation production as animated feature films became more popular, as studio animators needed to communicate their ideas efficiently through quick visual storytelling. © Disney

- additional information such as script inserts, director's notes and narrative ideas
- provisional passages of narration or dialogue to supplement the visual information

The process of constructing a storyboard has three basic phases. First, a rough thumbnail storyboard, produced in either black and white or limited colour, is created by one or more animators to rapidly establish the important core actions that visually suggest how the events work as key frames of the story. Second, the agreed rough thumbnails are worked up into larger drawings that include more applied visual reference material and give more detailed information about possible camera moves. Third, a final version or presentation board is created with additional frames to fill in the gaps between key frames. This acts as a strong referential visual framework for the animatic or story reel and allows for temporary dialogue and a rough version of the soundtrack to be seen alongside, creating a rough draft of the project.

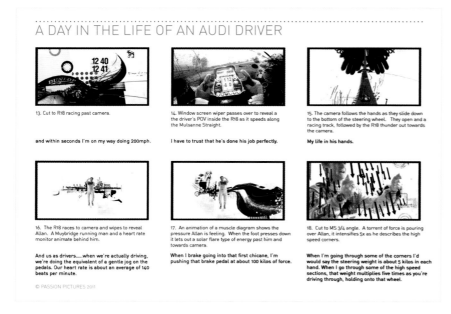

Presentation boards for Chris Curtis' *A Day in the Life of an Audi Driver* advertisement provide essential information about synchronizing the timing of the visual story development, narration and action occurring in frames.

The art of storyboarding

On a basic level, storyboarding is a technically cost-effective and readily available process employed to solve visual and aural problems ahead of starting to animate a project. More fundamentally, in inspired hands, storyboarding has also proved to be an arena where animators can visually express themselves through the act of interpretation – moving away from routine treatments to present something compelling, original and inventive. Such artistic expression often gives animated work an immediate visual

impact, although it will have taken the creator a significant period of time to develop his or her skill.

Some studios actively look for this personal style when hiring directors. Studio AKA's Marc Craste is a good example of an in-demand director with an immediately recognizable visual style. Through short films such as *Varmints* (2008) and clever commercial work created for the British bank Lloyds TSB – designed to portray personal banking and finance in a more user-friendly light – his stylized characterization of figures and environments retain a whimsical, naïve quality and evoke emotional responses from the audience. However, individual flair is not a recent quality but something rather more symbolic of how animation has pervaded mass popular culture by giving us instantly recognizable icons.

Masters of their art

The visual characteristics of an animated production are rooted in a personal but collective aesthetic vision at the storyboard stage, where a script or series of visual ideas is brought to life. There are good historical examples that support this idea. The Walt Disney Studios' development of storyboarding techniques in the early 1930s was, in some part, a response to the industrial type of delivery expected from Walt Disney. His vision for creating entertainment through storytelling extended to creating theme parks to embody his ideas about entertainment and mass popular culture more widely. In this era, storyboards not only were employed as a vital communication tool to inform animation teams working in the studio or to plan schedules for productions, but increasingly were used to test out Disney's adventurous ideas for stories that potentially could go into production, without fear of committing large amounts of money for little return.

The surreal and poetic animated short, *Varmints* (2008), demonstrates director Marc Craste's ability to develop character-driven narratives that are engaging, thought-provoking and memorable.

Consequently, it would be easy to marginalize Disney's storyboards as a largely soulless technical device without any artistic or design merits. But these animators were artists in their own right and inevitably were responsible for forging the studio's signature style. This is especially recognized in films such as *Pinocchio* and *Fantasia* (1940). Similarities started to emerge in the visual signifying of characters in particular, with oversized facial features that could more immediately and expressively display gestures and poses.

Through the storyboards, animators could communicate how the character felt about a certain situation directly to the audience, using the graphically interpretive language of the cartoon. This form of telling a story sequentially enabled the artists to become acutely aware of the simplification possibilities of the medium of animation. They believed it was able to focus the audience on a particular message in a more succinct way than live-action film. This view was shared by public bodies, governments and private companies, which commissioned studios to make everything from animated commercials for household goods through to war propaganda films, typified in the United Kingdom by the renowned work of the Halas & Batchelor studio.

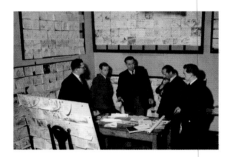

While conforming to a recognizable aesthetic, animators working on *Fantasia* (1940) were artists in their own right, including Oskar Fischinger, who expressed themselves by marrying the animated sequences to the music, helping to create the Disney aesthetic of that time. © Disney

The development of visual narrative in animation

The simplified visual language of the cartoon through sequential panels and strips is heavily connected to the art of framed storyboarding. Other cartoon conventions, including exaggerated figurative features and the placement of iconographic symbols, were increasingly used to illustrate actions and anticipate approaching movements. The Walt Disney Studios strike in 1941 came at a time when animated films had captured the American public imagination. The loss of production allowed other studios such as Fleischer and Warner Bros. to gain a priceless toehold through important figurehead cartoon characters such as the racy Betty Boop and the irrepressible Bugs Bunny respectively. These characters brought more sophisticated content to the animated feature, and with it demanded a visual styling that was more immediate and less artistically homogenized than the Disney offering.

The Halas & Batchelor studio was responsible for a significant number of propaganda films produced for the Second World War effort, including *Dustbin Parade* (1941).

The way was open for such animators as Chuck Jones and Tex Avery to take the cartoon art form to dizzy new heights, experimenting with movement and exploring the pace of narrative through the storyboards by varying the composition and placement of characters and scenes. They imbued their designs with deeper ideological references drawn from everyday life, including status in society, tolerance and sexuality. They recognized that the storyboard was the place to test how characters could engage with the audience by drawing extreme close-up key frames and allowing the character to 'know' that the audience was watching by depicting narrative asides to the camera. As a result, such films as *Duck Amuck* (1953) and *What's Opera, Doc?* (1957) have rightly become regarded as masterpieces of their genre.

In subsequent decades, major art and cultural movements inevitably pervaded the art of storyboarding, an example being Disney's *Tron* (1982), which pays visual homage to the American home video games revolution of

Steven Lisberger's *Tron* (1982) heralded the arrival of computer-generated imagery (CGI) in major studio productions, complete with the dynamic spatial qualities and aesthetic appreciation of the video game. © Disney

the late 1970s. The present day sees many books published that specifically examine 'the art of' a particular film through storyboards, early visualizations and development towards finished imagery seen in the final release. Pertinent examples of these include Brad Bird's *The Incredibles* (2004) and Henry Selick's *Coraline* (2009).

Creating a storyboard with a visual narrative

A coherent visual narrative style is necessary to bind ideas together into meaningful animated statements. This is also sometimes described as a 'treatment'. The visual narrative or treatment will usually be informed by the director, who may have been selected because he or she has a deep conviction of how the project will look and feel stylistically to the audience. An example of this is Peter Docter's treatment of Pixar's *Monsters, Inc.* (2001). On other occasions, the visual narrative is governed by taking the stylistic lead from particular adapted works or from a treatment as directed by the brief. Good examples exist in the realm of children's feature animation, including Dianne Jackson's interpretation of the Raymond Briggs classic *The Snowman* (1982), Philip Hunt's adaptation of the Oliver Jeffers story *Lost and Found* (2008), and Jakob Schuh and Max Lang's rendition of Julia Donaldson and Axel Scheffler's *The Gruffalo* (2009). The visual narrative can be immediately identified in every frame, resulting from a storyboard that has a consistent and informed filmic language for the crew to constantly refer to throughout the life of the production.

Each storyboard frame represents a 'picture field', that is, a depiction in two dimensions of a three-dimensional space. It is worth investing time in organizing the picture field to create an environment where the illusion of space and the considerations of reality can be juxtaposed into a believable visual narrative. Individual frames have the ability to communicate different emotions depending on the placement of characters and props in the picture field. Such placements create spatial relationships that can be harmonious, cohesive, reflective or dramatic. These spatial relationships effectively act as controls for the level of drama that can be contained in the story, giving

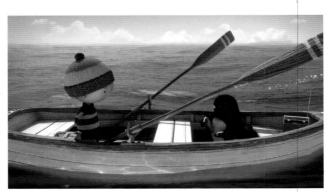

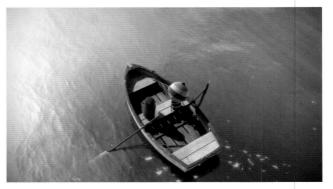

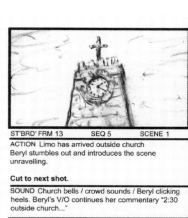

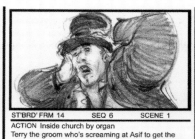

ST'BRD' FRM 13 SEQ 5 SCENE 1

ACTION Limo has arrived outside church
Beryl stumbles out and introduces the scene
unravelling.

Cut to next shot.

SOUND Church bells / crowd sounds / Beryl clicking
heels. Beryl's V/O continues her commentary "2:30
outside church..."

ST'BRD' FRM 14 SEQ 6 SCENE 1

ACTION Inside church by organ
Terry the groom who's screaming at Asif to get the
organ music right for the entrance. He's also on his
mobile to someone who is supposed to be providing
the booze for the reception. **Cut to next shot.**

SOUND Terry's V/O yelling at Asif and his mobile phone
"No no faster! Different beat! Come on it'll work..." /
Beryl's V/O continues her commentary "2:35 whaa..."

ST'BRD' FRM 15 SEQ 6 SCENE 2

ACTION Inside back of church
Beryl runs to back of church. Mandy and Dad walk
down the aisle. Dad continues to moan.

Cut to next shot.

SOUND Ragga rendition of the wedding march played
badly on an organ / barking dog / Dad's V/O "I told
you it's a fucking shambles..."

ST'BRD' FRM 16 SEQ 6 SCENE 3

ACTION Back of church
Beryl tries to imagine what she can do to make the
shot more interesting.

SOUND Continuing racket of organ and Mandy's Dad /
Beryl V/O "2:40 back of church. I think I'll try something
different here..."

Beryl 'Dreams & Desires' © 2004 Beryl Productions LTD.

ST'BRD' FRM 17 SEQ 6 SCENE 4

ACTION She remembers Triumph of the Will. Beryl sees
herself mounted on a tracking camera with a whip in
her hand. She is goading a group of Nazi's into
pulling the tracking dolly at the Berlin Sports Palatz in
30's Germany.

SOUND Nazi rally sounds / Beryl's V/O continues "Will
you don't mind holding the camera do you...?"

ST'BRD' FRM 18 SEQ 6 SCENE 5

ACTION Back of church
Beryl has an idea and asks Will in his wheelchair to
hold the camera.

SOUND Continueing organ music and Will's surprised
mumblings "But Beryl my leg..."

'Dreams & Desires: Beryl's Video Diary' - "Family Ties" storyboard page 3

the director a greater choice of tools to determine the function and flow of the content.

The effectiveness of compositions can be controlled through the exploration of viewing and interpreting the visual material in the picture field. For example, lowering the horizon line creates a sense of impending drama, further intensified by a character's being placed in the foreground above the natural eyeline of the viewer. Conversely, seeing shots from a raised position reduces this impact and makes the viewer seem more in control of a situation. These adjustments not only change the position of the camera, thereby giving the story different levels of impact at necessary points, but also have the added effect of making an audience concentrate on the story and become engrossed in the action taking place. This visual engagement is crucial in selling the idea to the audience, allowing them to feel empathy for the characters and providing them with a sense of purpose to see how the production will develop and ultimately conclude.

This storyboard, from Joanna Quinn's film *Family Ties* (2006), depicts the key frame of action taking place in the scene, together with annotations concerning forthcoming actions, camera moves and sound direction.

Opposite Studio AKA director Philip Hunt skilfully retains Oliver Jeffers' wistful lyricism in his adaptation of *Lost and Found* (2008), incorporating beautiful narration by Jim Broadbent and a memorable score by composer Max Richter.

Style guides

A style guide acts as a collective production bible for the animated project. Style guides are created to inform a coherent overall design strategy, to provide art-directed reference points for the crew and also to include key information on the visual styling of characters, props and environments. Practical design concerns, including scale, patterns and colour palettes of these key components, can be resolved by checking creative decisions against the style guide. Information contained in the guide has been informed by the research process, but manifests itself collectively through the storyboard, where creative decisions are taken about camera positions, settings and necessary moves. Style guides are usually created by different members of the production crew and finalized by the director.

Much of the specific information gives crucial visual information that constantly needs to be referenced. For example, characters might be profiled in a series of drawn elevations from different sides to provide consistent and reliable reference points. Additionally, there may be model characters, perhaps sculpted as maquettes – effectively try-outs or practice models built to explore three-dimensional constructions. These can be created in various scales to provide three-dimensional reference for stop-motion characters.

Style guides will also include information about the way in which jointed or articulated versions of characters, known as 'armatures', are constructed. An armature is a framework that effectively provides the skeleton of the three-dimensional character with working engineered joints that can be posed to create different dramatic gestures. In this context, the possibilities and limitations of the armature must be demonstrated in the style guide to ensure

Style guides serve as a central collection and reference point, informing the art direction for a production.

Working on an exhibit for London's Science Museum, Grant Orchard used molecular structures to inform his character development as part of an overall design strategy with Casson Mann's exhibition design.

consistency and clarity with the director's vision for the production, but also to consider the limitations of the armature itself.

Layouts and scenes

The job of the layout artist is to design and construct environments for animated sequences to occur in, with each layout technically creating a 'scene'. The layout artist translates information from the storyboard and works out the field space necessary to allow content to flow. This can include enabling characters to interact with other characters and props, and capturing any exaggerated movements the shot requires. Within the frame, the layout artist is responsible for technically enabling actions illustrated in the storyboard to happen, by creating a sense of time and place. He or she is also able to suggest a sense of atmosphere through the layout design in the use of negative space and spatial relationships between different visual elements. Significantly, the layout artist needs to have the ability to control the dynamics of the frame itself, but also to possess sufficient awareness for the imagined world of the production beyond the visualized frame. This allows sequential layouts to run seamlessly, creating a sense of natural cohesion and synergy between the scenes for the audience.

In traditional two-dimensional (2D) cel animation, layouts provided a backdrop for action to happen against. Animators would position individual animation cels over painted layout designs. These animation cels were made of clear cellulose or acetate that had been drawn, inked and cel-painted with a design. Photographing each cel independently would then create a frame. The illusion of movement occurred when the sequence of individually photographed frames was played back, typically at a rate of twenty-four frames per second, and the images appeared to move before the viewer's eye. In traditional three-dimensional (3D) stop-motion animation, members of the production crew involved with layout face the additional hurdle of working in a modelled three-dimensional space. They need to design with consideration for both spatial awareness and the requirements of animators, who must be able to access the set easily without disturbing props or characters. They also need to consider carefully the use of materials in an environment prone to dust, heat and changes in humidity.

Layout artists clearly need to have a sound knowledge of fundamental drawing skills, including an understanding of the principles of perspective. They need to understand how these principles marry with the cinematic concerns of staging, lighting, framing and achieving suitably dramatic camera angles. This enables the dramatization of the narrative to be explored in action and allows the capabilities of the layout design in relation to the planned storyboard to be tested out.

A fully jointed armature is a miniature engineering feat in its own right, often needing to be precision machined to withstand the rigours of continual manipulation on set, aptly demonstrated here by Barry Purves' central character in *Plume* (2011).

This behind-the-scenes image from director Suzie Templeton shows the level of detail required to construct sets with correctly scaled props that can stand up to the rigours of being continually manipulated by animators on set.

Planning and formulation

The translation of the storyboard into practical layouts means that both visual and narrative problems can be identified and resolved before progress can be made. Some technical problems can be foreseen in 3D stop-motion animation, for example, where certain shots are impossible to capture because the camera cannot physically be fixed into a particular position, or where the scale of certain props prevents desired movements from being engineered. In other instances, the layout artist's quick-wittedness combined with an ability to change or consolidate a scene with minimum distraction is required, occasionally leading to some 'happy accidents' that could not have been predicted by the storyboard. Wherever possible, planning technical resolutions to problems highlighted by visualizing the story helps to keep the project on track and on budget by predicting problems early, and there are some specific tools and techniques that can aid production.

Field guides

A 'field guide' is used widely in two-dimensional animation to help layout artists imagine and construct the picture field while working on the layout. It has the immediate effect of visualizing what the camera will crop. For example, if the director wants to move from an establishing shot to a close-up, holding the field guide between the eye and the layout enables the layout artist to see instantly what that camera shot will look like for the audience.

The design and layout of any set must necessarily include technical considerations, including the placement of lights and cameras to permit the shot selection deemed necessary by the director.

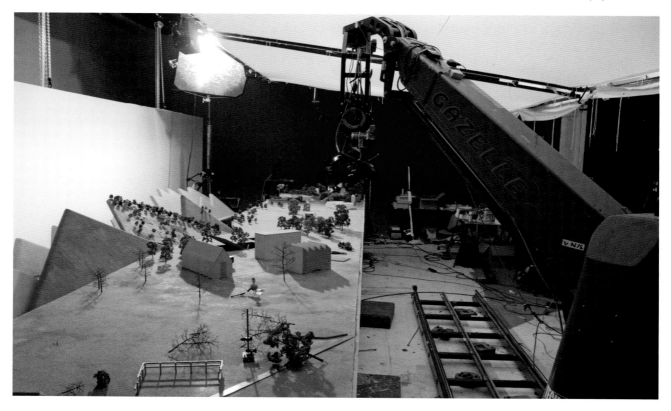

The field guide typically consists of a clear sheet in a lightweight frame, marked with a faint static grid of rectangles. These act as an immovable framework. Bigger rectangular windows are placed or marked on the grid corresponding to the aspect ratio the production is going to be shot at.

Field guides conform to common production aspect ratios used by different broadcasting platforms:

- Academy ratio is 1:33:1
- Widescreen ratio is 1:85:1
- CinemaScope ratio is 2:35:1
- Letterboxing involves placing a black slip above and below the frame

Layers

Creating artwork in layers allows layout artists flexibility with their designs. In traditional cel animation, clear acetate sheets are applied over each other to ensure movement flexibility of key components, while other elements of the design can remain static, saving production time and unnecessary expense. The advent and application of digital media accelerates these principles, and has the added benefit that layers are virtual rather than physical. This is a distinct advantage for the layout artist, where the problem of layering traditional physical cels would eventually lead to parts of the overall artwork appearing to fade or lose focus. Every layer can be controlled individually so that it is seen at the same intensity if necessary. Technical flexibility aside, the layout artist still needs to factor in how many layers are required for the scene to be conclusive and readable, rather than overly complex and confusing.

Cinematic thinking

The ability to think cinematically is a principal requirement for anyone interested in making an animated project. It is a key skill that studios and partners look for when seeking potential support for a production. Cinematic thinking encompasses the conceptual and physical process of determining and visualizing camera angles and choosing shot selections. These decisions to represent the content of the project can shape the production dramatically. They allow rhythmic changes of narrative pace to reflect action in the plot, or to create visual pauses while the audience absorb and understand information being imparted. The ability to think cinematically gives productions a unique identity of interpretation, and also ensures that particular elements can be framed so that they remain as memorable markers in the audience's mind.

Essentially, the camera acts as the eye on the production and the captured information is described as a 'shot'. This imparts ordered information on a basic level, but can also stir emotional responses from the audience if used imaginatively. The camera can be employed in fixed or variable positions and further cameras can be added to create different shot options – of the same frame if required – that will allow directorial choices in

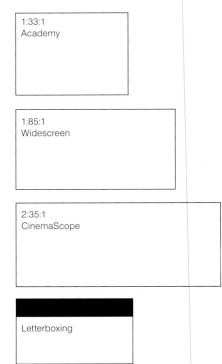

1:33:1
Academy

1:85:1
Widescreen

2:35:1
CinemaScope

Letterboxing

Different aspect ratios are required for formatting to different viewing platforms.

the editing phase. There are several possible types of basic camera move that give creative freedom for the director to mix moves to achieve a desired shot:

Barry Purves' *Tchaikovsky* (2011) is a poignant and touching account of the composer, meticulously captured using a variety of shots by Justin Noe and Joe Clarke.

- panning – the camera creates level horizontal movement from side to side
- tilting – the camera achieves level vertical movement up and down
- dollying – allows the camera to move into or out of a scene
- tracking – allows the camera to run with the action by the aid of a moving position as it travels through a scene
- craning – enables the camera to be attached to a device that can swing, dip and travel through three-dimensional space, effectively anticipating, following or reacting to action in a scene

Variable positions can be achieved by removing the camera from its fixed position and hand-holding it, or by attaching it to a device where it can capture information from unexpected sources, such as a balloon. Such camera techniques are often employed in documentary and independent animation, where they are often used to convey the effect that the camera was hidden in a location that was not visible to the subject being filmed.

Types of camera shots

Establishing shot – used to introduce a scene and explain the context to the audience by acknowledging external factors. For example, we might see the scene of a street, but recognize from other information in the shot that the street is in a seaside town.

Medium shot – enables a character or object to be seen against the context of his/her/its immediate location, for instance a security guard outside a bank on a high street.

Close-up shot – directs the viewer's gaze to a particular aspect of the shot, for example, a soldier squinting down the barrel of a rifle.

Extreme close-up shot – examines in detail a focal point, for example, using the illustration above, the soldier's eye taking up the whole frame.

Bird's eye – focuses on the subject from an overhead position and gives a sense of place and purpose to a scene from an unexpected position, which the subject may not be aware of, for example, the enemy moving into position on a battlefield.

Dutch angle – an unusual but dramatic shot, where the camera is placed at an oblique angle, making the horizon line dip or lift from one corner of the frame to the other, conveying tension.

Follow shot – as the description suggests, this shot pursues a character or subject through a scene.

Forced perspective – the camera is used to capture optical illusions of subjects in a scene by placing them together but, for example, exaggerating or minimalizing scale to give them unusual values and properties.

Freeze-frame – the camera captures a precise moment in time.

High-angle shot – the camera is fixed above the eyeline of the character, allowing the audience to look down and suggesting a superiority to or power over the subject.

Low-angle shot – the camera is fixed below the eyeline of the character, allowing the audience to look up and suggesting an inferiority to or fear of the subject.

Point-of-view shot – the camera intimately sees what the audience perceive the character or subject sees directly, although this may also include the character or subject in the frame if the camera is looking over the character's shoulder, for example.

Reaction shot – the camera records the reaction to a scene or event being showcased. For example, if a soldier is wounded, the reaction shot reflects the immediate reaction of his fellow soldiers.

Sequence shot – also known by the French term *plan-séquence*, this shot allows events happening in the mid-ground and background to take precedence over what might be happening in the focal point of the scene among the main characters.

Zoom – an extremely versatile and popular action: keeping the camera still but adjusting the lens takes the subject closer to or further away from the audience.

Using a variety of cameras in different positions allows variable shots and options for a director that are crucial when scrutinizing a scene for maximum impact, as demonstrated here in *Madame Tutli-Putli* (2007).

With careful direction and selection of shots, and the support of equally considered and applied sound design, the audience should not notice key technical production processes, concentrating instead on being transported into a make-believe world through the development of the content. A variety of carefully considered shots is essential to ensure that content transfers smoothly from camera to screen, aiding audience appreciation and understanding of the production.

Development drawings

The importance of drawing to animation development has been highlighted previously as a skill that requires aptitude, practice and time to master. As the project develops, drawing takes on a more considered and detailed role.

Historically, the drawn animated image was central to determining and defining animation's legitimacy as a recognizable art form. In the contemporary era, some of the immediate resonance of drawing may have been partially hidden by advancing technical production processes. However, much of the underlying success of productions is still owed to an invested sense of drawn activity and language. Drawing both encourages and rewards observation and imagination – two of the basic ingredients defined and celebrated by animation. It is a vastly adaptable and expressive skill, easily able to encapsulate and merge exaggerated movement and description.

Imagination and observation

A basic element that animators need to have in abundance, and expect to develop, is imagination. The creative flair, passion and drive of a given project are drawn from an individual's capacity to bring vision, excitement and appetite for the project to the wider team and to encourage that vision and belief among others. Whether we look to innovative pioneers such as Peter Lord, visionary directors like Tim Burton, or the wit and charm of animators such as Joanna Quinn, imagination fuelled by the desire to observe and record the wider world is a skill that is greatly applauded by fellow creators and audiences alike.

In practical terms, observation is something often marginalized and overlooked by students. Looking is something we are routinely accustomed to doing, our brains continually taking on board information and processing responses to stimuli set out before us. Seeing, in the context of the arts more broadly and animation in particular, involves far more focused and concentrated study. Here, seeing is akin to decoding and understanding subjects, compartmentalizing captured information to make sense of the bigger picture being presented. In animation, such activity can be taken to extreme measures through the artificially constructed nature of the form. Creators experiment liberally with visual, aural and structural components

Joanna Quinn's human studies reveal an animator who places great emphasis on her ability to observe, but also to interpret those recordings systematically to explore the developing character's nuances more accurately.

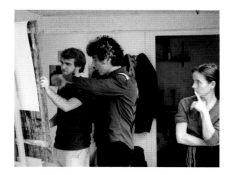

Students undertaking a life-drawing class at the Royal College of Art, London, learn to see 'through' the figure to the transformative possibilities of the human form as a storytelling device.

of a production to illustrate observations in varying degrees of detail and complexity. More specifically, the structural elements of drawing, such as composition, placement and emphasis, can have a profound effect on the delivery of content if imaginatively employed.

Fundamental aspects of composition, placement and emphasis

While the storyboard provides an overview of the production, it is widely understood that development inevitably leads to changes in how particular aspects of the project are interpreted. The ability to alter the composition of frames is necessary to ensure that the information and the central theme of the content are organized and edited, ensuring clear explanation. Within the frame itself, the placement of visual elements, and the resulting relationship they have with one another, allows the audience to understand and interpret information based on the emphasis given compositionally to those subjects.

Animators use design elements such as line, shape, colour, texture, form, tone and space to explore composition. Each of these elements can be employed singly or collectively to act as visual signposts that will attract the viewer's eye and direct it towards vital information. In determining composition, it is important to understand who or what the focus, or centre of interest, of the frame will be. Having established this, other clues are provided in the composition to establish a unity of information and a harmonious, balanced frame. Organizing the composition effectively involves making critical decisions about the shape and proportion of key elements and how they balance themselves against each other. This might involve using geometric or natural forms to explore such aspects as perspective, negative space, colour contrasts and lighting. Controlling these aspects alters the visual rhythm or beat of a sequence of frames making up a scene, effectively controlling the pace of how visual clues are illustrated for the viewer.

Dividing up the frame compositionally can have a profound effect on how images are understood. For example, the 'rule of thirds' uses the idea that the frame is divided by three vertical and horizontal lines, and that elements are placed on or close to where these imaginary lines intersect to create a harmonious and balanced composition. A similarly pleasing compositional aesthetic device is the triangle, its implied shape within an image acting as the foundation for a face, for example, where the corners of the mouth line up with the corners of the triangle, while the point lies between the eyes. Frames that have an odd number of elements appear more informal owing to their lack of symmetry than those made of an even number of components.

To create emphasis in a frame, the animator must position elements in a visual order that will be read correctly by the audience. For example, the introduction of a character usually involves using a close-up composition or shot in the first few frames to allow the audience a chance to identify certain characteristics or personality traits. Emphasizing key elements involves editing. To be a good editor, an animator must be able to identify which are the key components of a frame and to see these in the context of

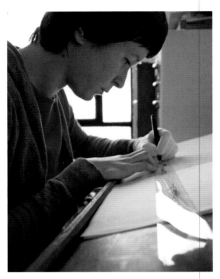

Understanding the visual dynamics of the frame allows the animator to control the order that specific pictorial elements are seen by the audience, creating opportunities to emphasize or hide clues through careful placement.

supporting narration, dialogue or soundtrack. It is important to consider all aspects of the production, as having multiple visual and aural effects can clash, confusing the audience. At all times, it is important to use a certain economy of scale when considering visual elements, or vital aspects of a scene may be lost under superfluous detail. This requires careful planning and animators use a number of tools, processes and techniques – dope sheets, key movements, key frames, line tests, the story reel – to help in this regard.

Dope sheets

A 'dope sheet', or exposure sheet, is effectively a blueprint plan of the production. It shows the production crew at a glance how elements of visual and aural material are to be pieced together in the production with correct timings. The dope sheet is used to break down individual technical elements into units of information, such as annotating which layers of artwork are being used in a particular shot, the camera moves required, the part of the script being animated, a guide to the supporting soundtrack and any additional sound effects needed. This information is held on the spreadsheet, clearly indicating how many frames each of the components explained above will last, and projecting what is about to follow in the production.

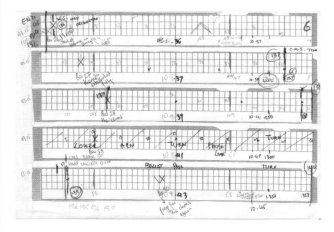

An exposure or 'dope sheet' allows visual and aural components of the production to be broken down in timed segments to maintain consistency of flow.

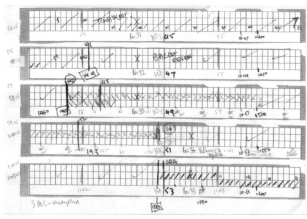

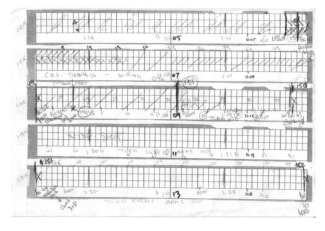

Key movements

Animation occurs through the movement of objects between frames. The frequency with which objects move can alter, but the consistency of movement of the object itself varies depending on its function or purpose. In a movement, there are points that explain the magnitude and frequency of the action and these are known as 'key movements'. For example, imagine that a ball bounces in front of you. The two key movements of that particular bouncing action are the impact as the ball hits the ground and the highest point of the arc of the bounce, signifying that the ball is bouncing from one point to another.

Key frames

In traditional animation, 'key frames' are identified as being the start and end points of a sequence of smooth transitional animated movement. These key frames represent pivotal points where the greatest degree of the move occurs, with the remaining frames in the sequence known as 'in-betweens'. Animators establish and create key frames, and while traditionally animators known as 'in-betweeners' would develop, 'clean up' and execute the adjoining frames, today this process is for the most part digitally constructed using software such as ActionScript.

With other digital platforms, such as Adobe Flash, the animator creates key frames but relies on the process of software to fill in the spaces smoothly through a technique known as 'tweening', whereby images are seamlessly interpolated into the sequence. The versatility of tweening software enables changes to a movement to be easily accommodated. The predictability of such a mechanical technique can be overcome by essentially 'keyframing' each and every frame, enabling the creator to digitally manipulate and have complete control over the whole creative process.

Line tests

In traditional cel animation, a 'line test' (or 'pencil test' as it is sometimes known) can quickly and efficiently enable an animator to flip consecutive drawings by hand to see incremental movements created by a sequence of drawings. Drawings are created on separate sheets with a fixed point of registration illustrating a piece of action from a start to an end point. The drawings are then held tightly and flipped in the chronological order they have been created in, producing a linear sequence that moves between a beginning and ending frame of action. It is also possible to scan or photograph these individual drawings and play them back on screen if necessary. The process allows animators to ascertain if some drawn movements between one frame and the next are too pronounced and movement appears to jar or jolt as a result. Many programs now offer this facility for animators working in a digital environment.

One of Koji Yamamura's key frames for the animated short, *Muybridge's Strings* (2011), produced for the National Film Board of Canada (NFB), is ready for scanning.

Using a registration or peg-bar, frames are drawn consecutively here on a light box before being scanned and played back in the corresponding order to create a line test to check animated movement through the frames.

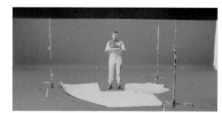

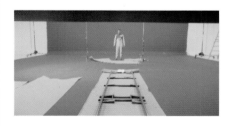

The animatic or story reel

An 'animatic' or 'story reel' is created when individual frames from the storyboard are recorded and played back sequentially with sound. It is created to show the production crew what the finished project could look like. Sound can be a rough recorded voice-over taken from a first reading by an actor, clips of recorded dialogue or suggestions of how an instrumental or vocal soundtrack might contextualize the imagery. Projects can have any number of animatic sequences and it is quite common for animated content to be routinely tested in this way as it allows changes to be implemented without major cost revisions.

An excellent example of an early animatic, with elements of live-action footage and illustrated stills bound together by a recorded script read through by racing driver Allan McNish.

Character design

Characters play a crucial role in animated productions. They must be designed for various uses, from acting as key defining tools for explaining the developing plot, through to establishing a recognizable presence audiences can identify with and attach an emotional response to. Characters have even adopted the role of brand ambassador for the film, television series or product being advertised, an example being Homer Simpson. A character's versatility of function is a core requirement of his or her design and needs important consideration when the character is being created. Time invested in this stage of the process often reaps rewards later in production. It is a common occurrence to check early development of character development using a simple line test (see page 92) or a walk cycle (see page 99) to better understand the form, function and versatility of the character.

The bones of character design

Character design goes beyond the simple outward visual appearance of a character and instead considers the potential overall embodiment and flexibility of the form. This includes rudimentary inner facets such as stature, posture and gesture, movement and expression. Historically, a technique known as 'rubber hose' movement was used to animate characters, so called because it tended to elasticize a character's movement and was considered more efficient. The approach was developed by the Walt Disney Studios in the 1930s as preparations for industrialized animation production on a far greater scale gathered momentum.

Walt Disney's decision to hire artists had a massive influence on the form, and their influence served to bring artistic principles of anatomy and movement to mass industrial practice. These artists looked adventurously at the way animation techniques could potentially illustrate the diversity and complexity of articulation of the human form. Such approaches led to examples of 'full animation' in feature films. Here, every frame was hand-drawn, ensuring the character's movement could be completely manipulated, resulting in visual fluidity and greater options to explore a character in motion, classically illustrated by *The Three Little Pigs* (1933).

By contrast, other studios such as UPA used a technique known as 'limited animation'. This relied on sequences of drawn animated material being used in cycles or holds as a way of economizing, and depended instead on supporting techniques, such as voice-over or a greater variety of camera shots, to complete the production. The technique has the advantage of being quicker, more efficient and cheaper than full animation, and is used today in many animated television series, Japanese anime such as Pokémon, and animation for the Internet. Far from being 'limited', the true test for limited animation is that it forces the animator to be inventive about where and how to show movement.

The legendary Walt Disney Studios animator, Frank Thomas, was one of Walt Disney's early recruits. One of the affectionately nicknamed "Nine Old Men," Thomas inspired generations to work as animators. © Disney

Experimental animator Max Hattler's film *Collision* (2005) is a good example of 'limited animation', using repetitious, geometric, symbol-laden shapes in quick succession to play on deeper political and ideological differences between contrasting nationalities and states.

The art of character design

In recent years, historians of animation have made connections between the art of animation and the major art movements, serving to highlight parallel concerns and centralizing the view that animation was very much contextualized by developments in the wider world. More recently, animation has begun to have a profound impact on the definition of the arts more generally as it pervades feature films such as James Cameron's *Avatar* (2009), video games such as *Gran Turismo* and *Call of Duty* (both 2010), and even the opening ceremony performance at the 2010 Winter Olympics in Vancouver, where animated diving whales were projected on the centre field of the stadium. If Chuck Jones and Tex Avery championed 'art' through their now infamous characters, such as Bugs Bunny and Daffy Duck, the mantle has certainly been picked up and carried in the contemporary era by the likes of Nick Park, Philip Hunt and Matt Groening.

Characters need to be easily recognizable, able to be identified through their appearance, voice, abilities and actions, and also capable of carrying and enacting the story to the viewer clearly and functionally. Their increasing visual prominence and recognition as forms that exist beyond the world of an animated production has inspired leading Hollywood actors, including Tom Hanks, Tim Allen and Dakota Fanning, to voice household names – in these examples, Woody, Buzz Lightyear and Coraline respectively.

The role and function of character

A character is not a solitary object that exists in isolation, but rather a vital component that works in tandem with other aspects to bring life, action and explanation to a production. In this context, his or her role is to provide the audience with a sense of anticipation. The director's inclusion of a character signals that he or she is in some way important to the development of the plot and has the ability to deliver information, whether this is factual, entertaining or informative.

The animator's ability to understand movement, and its visual depiction, is key when considering the design of any character. The audience need to believe the capability of a character to move, communicate, act and respond to the world around him. Animators often look to the performing arts – typified by dance, mime, theatre and street arts – where movement is often exaggerated and staged. In this way an action can be amplified and overstated, emphasizing a particular movement more efficiently and directly than if it was naturally conducted.

This is an important facet of animation, because these heightened actions enable conceptual and physical conventions to be removed from presented characters. This allows the audience to begin to invest in and understand the characters for what they are being presented as, rather than what they might be thought to be. An example is a character such as Astro Boy who, as his name suggests, is in some way linked to outer space but whose characteristics need to be understood and approved by the audience in

Keen to evoke a sense of national pride and passion, the Canadian organizers of the 2010 Winter Olympics in Vancouver chose to commission special animated effects to illustrate the cultural and spiritual identity of the host nation to the watching world.

order to validate his supernatural ability. Permitting these actions to occur requires an understanding of key technical skills – timing, lip-synching and movement – combined with a confidence in making the unbelievable seemingly come alive through the suspension of disbelief. These skills are largely invisible as the character is not seen in isolation, but without a mastery of such techniques characters can appear unconvincing.

Timing

In all forms of animation production, the ability to understand and control time is a central issue. In character design, an understanding of time allows the audience to engage with and have empathy for the character, mapping their movement as it is synchronized against the other production elements of voice-over, dialogue and supporting sound effects. Mastering the techniques of timing allows the sense of time to be constructed, manipulated and exaggerated through controlled movement.

In principle, a character functions on an invisible axis or line of movement. Horizontal movements are conducted along a simple 'x' axis, while vertical movements take place on the 'y' axis. In three-dimensional animation, where the properties of the character in space can be explored, depth is represented by the 'z' axis and can often produce some startling and unexpected results. Similar possibilities occur in two-dimensional animation, where an understanding of the rules and applications of perspective can produce scenes exploiting optical illusions with characters, especially where exaggerated scale is used between the depiction of character traits and environments, as illustrated by Gerald Scarfe's drawings for the Pink Floyd film *The Wall* (1982).

Once a character is given licence to move, it needs to display these motion qualities openly to the viewer, mimicking and exaggerating our own understanding of the timing of movements. For example, characters can be

The Brothers Quay film, *Street of Crocodiles* (1986), is an excellent example of the suspension of disbelief principle in animation, where the tension between stasis and flux is palpable.

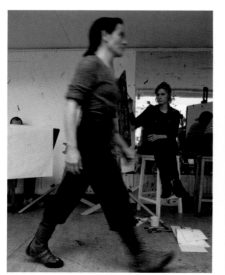
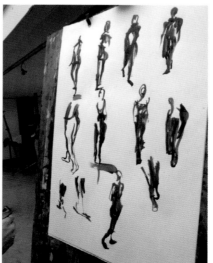

These illustrations ably demonstrate the challenge of visually interpreting the complexities of human movement, including anticipation, follow-through and holds.

imbued with the sense of 'anticipation' that a movement is going to occur. Anticipation signals that a movement is going to happen and is directly linked to previous and future movements. At the end of the movement, an action known as 'follow-through' occurs, where the body is allowed to come to a natural rest rather than freezing still. Anticipation and follow-through can be considered forms of animated punctuation and their use can make movement seem more natural and less artificial.

Equally, absorbing and promoting this understanding of timing allows instances such as pauses, which help the audience to identify characters and signify moments where action can take a different course, or plot direction can change. Such pauses may not be immediately noticeable directly to an audience, because they are masked by other production effects, but they serve to create visually grammatical 'holds' where the audience can focus on an upcoming event or regroup after an intense period of action. It may require many years of practise to understand and develop this skill, but its application can undoubtedly make a substantial difference to a production.

Other effects such as gravity and physical possibilities and limitations also present timing possibilities and obstacles. Even if characters are not firmly rooted stylistically in a realistic approach, the audience is conditioned to expect that certain events will 'naturally' occur. Changing such elements often leads to synthetic-looking results. Examples include when an object appears to float because it lacks an expected mass signified by its scale and depiction; or when the impact of a collision fails to refer to the travelling mass of a colliding object, such as a train hitting a station platform and the resulting devastation being proportionally smaller than anticipated. Adopting a 'slow in' and 'slow out' approach demonstrates that the animator understands that movements are not continuous, but have natural rhythmical interludes that accelerate and decelerate to reflect the nature of a complete action.

Lip-synching

A way of convincing the audience that a character has come to life, expressing the ability to breathe and talk, is through the technique of lip-synching. This is a complex and tricky technique, conducted on an almost frame-by-frame basis, and requires continual intervention by the animator not only to render the mouth in the right position for every frame, but also to anticipate end movements as naturally as possible. For English-speaking characters, there are nine basic types of mouth shape (see drawing opposite) to signify and imply recognizable speech and suggestion. For example, many people do not close their mouth immediately after speaking a word. It is this sense of naturalistic behaviour that the animator is looking to impose on his or her character. Equally, the sense of responding to a question through the anticipation of sound, movement and concurrent breathing is hard to reproduce faithfully. Slight movements to the mouth shape signify a change between vowel and consonant sounds within a word, and it is

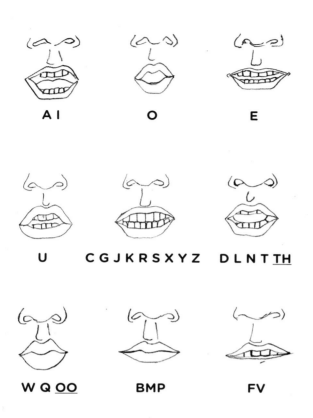

U C G J K R S X Y Z D L N T T<u>H</u>

W Q <u>OO</u> BMP FV

The nine basic mouth shapes employed by animators to imply speech. Groups of letters create specific sounds that must be linked together frame-by-frame to achieve consistency and aid believability.

important to see these as linked shaped sounds, rather than concentrating on the noise of the individual letter itself.

Clearly, any form of lip-synching is closely linked to secondary actions such as facial expressions. Economizing on lip-synching to allow other features, such as eyebrows and eyes, to convincingly amplify emotions should be considered. A good example is Nick Park's animal creations from the animated short series *Creature Comforts* produced by Aardman Animations. These films source voice recordings of the general public talking about a given topic, and are interpreted as different animals, who mimic human gestures and behaviour. Created in stop motion, the models are made of Plasticine modelling clay, which can be manipulated and sculpted to form different expressions to support economical mouth movements. While lip-synching in production means that the animator concentrates on a particular aspect of the face, it is worth remembering that the audience will be able to see the character as a whole and that other facial features, limb movements and the overall posture of the character can also support the story.

Originally commissioned by British Gas as commercials, these short films by British studio Aardman Animations became so popular that the Creature Comforts series was created. Their acute observation of mundane everyday happenings, adapted into extraordinary situations through stop-motion animation, is their key to success.

The walk cycle

Producing a 'walk cycle' allows the animator to better understand the possibilities and limitations of a character's movement. Still linear drawings of a figure in isolated walking movements are sequentially created, scanned

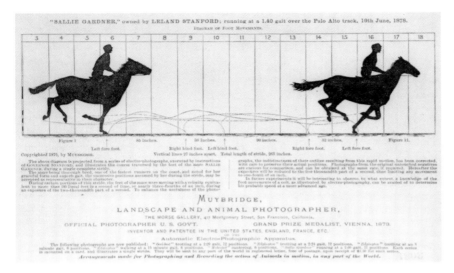

and played back, indicating how potential movements might occur. While it is predominantly centred on the articulation of movements of crossing and stretching in the lower body and legs, a walk cycle fundamentally introduces the principles of related movement to the body as a whole, as it is connected and therefore creates secondary movements.

Since the work of early motion-capture pioneers such as Eadweard Muybridge (1830–1904), whose *The Horse in Motion* successfully proved to doubters through the use of stop-frame photography that a horse lifts all four feet in the air when it gallops, animators have continually strived to prove that characters they have designed have the ability to freely anticipate and respond to movement. In short, they respond to the laws of physics that govern them, whether real or imagined.

The walk cycle confirms vital and necessary connections that can inform aspects of the character's physical appearance, having a profound effect on an audience's understanding of the character. For example, producing a walk cycle allows exploration of different facets of movement, from shuffling and ambling through to leaping and bounding. This will include the 'rise' and 'fall' of the body as it naturally and rhythmically contends with deliberate directional movements.

Suspension of disbelief

The 'suspension of disbelief' is achieved when an animated sequence succeeds in appearing to make an impossible act happen, like a character lifting up a car over his head. This is achieved using a balance of accepted and reassuring elements on screen and allowing the impossible character or act to operate within the confines of the scene. Animators need to balance the audience's established views and beliefs, but introduce and embed objects or situations in a position where the impossible can, seemingly, become not only possible but also believable.

Given that animation is a form based on artifice and illusion, it offers extraordinarily broad and free licence to indulge in creating characters that challenge assumptions and suggest new and exciting directions. It is nearly impossible to create something entirely original since animation, like all disciplines, borrows ideas, practices and purposes from a multitude of quarters. It is, however, right to suggest that some approaches, whether conceptual, practical or technical, will be new to animation.

Character as protagonist

Animation has been likened to the art of metaphor, reflecting perceptions of the culture surrounding us and projecting them into imaginary captured worlds. Central to this idea is that the character becomes symbolic as a figurehead or protagonist, helping to carry the plot, expressing the director's ideas and authenticating the content of the production at large. This might include the moral, ethical or political standpoints the director wishes to portray and with which he or she wants the audience to empathize. Protagonists can be heroic or villainous, and there may be more than one protagonist, especially if the story contains subplots.

Many examples exist in animation, from feature films to animated commercials, where the character often becomes the 'hook' that the viewer responds to. A good example is Jack Skellington from *The Nightmare Before Christmas* (1993).

Jack Skellington from Tim Burton's *The Nightmare Before Christmas* (1993) displays many of the hallmarks of Tim Burton's richly imaginative view of the world. © Touchstone Pictures

Developing characteristics

Your character is a shell until defined by its characteristics. These properties give your character its identity, personality and purpose. Characteristics establish a set of beliefs, justifications and contradictions. Working through these questions as you think about your character will help shape your design process, allowing you to test your ideas before developing the character so far that changes become difficult to accommodate later.

- What is the target market for the production?
- Who does your character need to appeal to and why?
- What do they need to achieve?
- What is their history?
- Where have they come from and what have they previously experienced?
- What is their perception of themselves?
- What are other characters' perceptions of them?
- What are their capabilities in relation to communication and movement?

In order to believe in a character, the audience must be drawn into believing the overall look and feel of the wider production. It is absolutely vital not to look at the idea of developing characteristics in isolation. Animation is the sum of all of its parts and any element that jars will make the audience suspicious of the production overall. It is important that the context of the assumed environment beyond the screen is considered in order to ground the character. For example, when we see a character in a production, we naturally assume that he or she (or it) will have come from somewhere, will have had a previous life or experience, and will effectively be bringing these experiences to the screen. He or she will belong to a direct (seen) or indirect (implied) family tree and a wider world context and will have been shaped by conditions that may still be prevalent in the scenes and locations of the production as it unfolds.

While countless examples of heroes and villains exist in animation, the Warner Bros. characters have a enduring appeal, typified here by Wile E. Coyote.

Heroes and villains

Successful characteristics can instil a belief system in the audience that can identify characters as being good or bad. In animation, such feelings towards a character can be enabled through single or combined visual, aural, narrative and ideological constructions of the form, capable of taking extreme directions and giving rise to the idea of the creation and expression of the hero and villain. In animation, as in comic books, the functions of heroes and villains vary according to the project being produced, but need to be considered in relation to one another – the one often requires the other to illustrate just how super or devious they really are. Animation history is littered with famous heroes and villains, especially in cartoons – for example, Tom and Jerry, and Wile E. Coyote and Road Runner – their extreme characteristics both embodied and projected by the nature of animation as a form.

The introduction of heroes and villains gives an audience a chance to intensively question, understand and potentially align themselves individually with characters, giving rise to the idea that heroes and villains are actually animated 'projections of self'. They embody our wants and desires, our fears, hopes and aspirations. Like cinema, animation has the ability to propel heroes to the status of superhero by giving them extraordinary and unexpected powers beyond the standard comprehension of their supporting cast, location or apparent ability. In an animated context, these additional virtues can be heavily exaggerated to suggest power and prominence, but they should also be treated carefully to ensure that characters retain some degree of vulnerability.

A point of view about the character might be introduced by the character's appearance, personality, actions or reactions to other characters or plot events. Development of characteristics might mean that the audience see these traits from the outset, as a result of action as the plot unfolds, or even at the conclusion of the production when they reflect back on what has been witnessed.

Metamorphosis

Movement is central to animation, but is not confined to shifting objects or characters from one point to another. More fundamentally, objects or characters can change through a process called 'metamorphosis' into something completely different. This idea is crucial to animation as a form and represents myriad possibilities for the animator. It manifests itself regardless of the kind of process of animation employed and offers a wealth of options for the animator looking to move from one scene to another, or to shift the audience's perceptions of a character. A good example occurs in Disney's *Alice in Wonderland* (2010), directed by Tim Burton, where the character of the Cheshire Cat morphs from a cat into a swirl of smoke. Anthropomorphism is used widely in character design and is the imposition of human traits on animals, objects and environments.

Objects or characters can change through 'metamorphosis' into something completely different. In Tim Burton's *Alice in Wonderland* (2010), the mysterious character of the Cheshire Cat freely morphs from a cat into a swirl of smoke, playing with the senses of illusion and reality. © Disney

Narrative construction

All animated projects that encompass characters, regardless of their genre, need a structure to operate effectively. Here are some examples:

Compilation – various creators produce animated responses to a set theme or topic.

Cyclical – a story runs full circle back to its original starting point.

Effect – animation is used to provide extra dynamism to a situation, such as a rollover or a special effect.

Episodic – most commonly seen in television series where a wider story is told in separate components.

Gag – many jokes are visually told in quick succession that would be impossible to achieve in the same timescale through live action.

Linear – might typically consist of an introduction, a situation or drama, and a resolution.

Multi-linear – several stories are told simultaneously using a mixture of techniques, including edits or splitting the screen into different sections.

Non-linear – a story has inbuilt permissions to change each time it is seen, and is commonly used in games design where gamers can decide to go different ways.

Thematic – a story that does not move round or along, but instead invites viewers to investigate what is there in front of them.

Conclusion

Visual pre-production is complete only when the storyboards are signed off by the director, the layouts created and the characters designed. The project now awaits approval from the commissioners and clients to move into full production. At this point, all aspects of the production should have been checked against the schedule and the budget. It is imperative that any issues concerning the projected schedule are brought to the attention of the director so that decisions can be made to help maintain workflow continuity, as many more crew members are now going to become involved in the animation pipeline.

In the next chapter, we will examine the importance of sound, and look at the role it plays in animation and how it is constructed and used to emphasize actions and movement in a production. We will investigate what considerations need to be given in the pre-production phase to ensure the form can be planned, recorded and utilized to the full.

4.

Sound is a vital component in an animated production, all too often overlooked by students approaching animation from a purely visual perspective. Like other aspects of the animation project workflow, sound features in all the phases of production: from the collection of research materials and the generation of early concepts and ideas, through the production of the animated project, to producing the animation in post-production.

As we have already seen, the visual elements of animation are constructed artificially, and sound is built in this way too. To work effectively, sound needs to be designed so that it can fully integrate with the script and the animated visual elements. Sound can spark, and certainly accompanies, the development of the narrative and helps to form and shape the production through the inclusion of dialogue and music, culminating in the addition of special effects in the production phase. The inclusion of sound gives the director a further vast array of tools to delineate and describe a production, using the design of sound to emphasize and explain the animation to the audience.

This chapter considers the inclusion of sound in animation and its many benefits. It introduces a broad overview of the physical properties of sound, and explains how it is appreciated and understood by the audience at large. Important components of sound design are established and applied to the principles of dialogue, music and special effects, through a studio environment. The chapter concludes with an illustration of the way in which sound is handled through the animated production phases.

Animation pipeline

Sound: The choice of 'sound stems', dialogue, narration, music and special effects is finalized and designed in close conjunction with the visual development taking place. Music is commissioned if a score is required, voice talent is auditioned for narrative and dialogue roles if needed, and the crew working on special effects are tasked with originating or collecting relevant material that can be first recorded on location or in the studio, before being edited back in the studio and mixed together to form a soundtrack.

Understanding sound

To understand sound, we must consider its construction. The property of sound consists of three phases: a source, a medium and a receiver. For example, the source might be the distant rumble of an avalanche that creates acoustic energy; the medium is signified by the air over which the acoustic energy travels; and the skiers' ears in the valley act as the receivers, picking up the sound. Like the visual examples we have seen previously, the aural

animation production process also relies on artificially constructed forms that are envisaged and established by a sound editor and sound designer.

To build up a picture of the sounds required for each element of the production, the sound designer imagines through mental pictures which sounds might be required, using an existing knowledge of sounds stored in the brain. This process is called 'audiation'. It is extremely helpful in mapping how sound might be applied to the production as the workflow develops and is used continually to help inform the director as he or she manages the production process.

The anatomy of sound

Below are some elements of sound crucial to understanding its structure and framework:

Sine wave – sine waves use a horizontal axis as a zero point, with waves extending above the line signifying compression (higher pressure) and those below the line signifying rarefaction (lower pressure). High points are known as 'peaks', low points as 'troughs'. A cycle is created when a wave turns through 360 degrees on itself. Waves can move in tandem, producing more energy, or can oppose each other, causing phase cancellation.

Amplitude – waves digitally recorded are referred to as a 'signal' and amplitude is the measurement of the energy emitted in this signal. After conversion to acoustic energy, amplitude exerts pressure on the listener's ear, measured in decibels (dB) and in sound pressure level (SPL), known as the 'dynamic range'.

Frequency – measured in hertz (Hz), frequency illustrates the number of occurrences of a repeating event per second, and is understood by humans in terms of musical pitch. We can hear a range of frequencies from roughly 20 Hz–20,000 Hz.

Timbre – sounds that contain sophisticated 'personalized' qualities or independent characteristics that mark them out as being unique.

Wavelength – the distance between the successive crests of a sound wave, measured from one high point of a wave to the next.

Through clever interpretation of the script in tandem with the previously visualized ideas and development work, it is possible to be highly original and inventive with sound. Much of the success of sound design in animated productions is about depicting actions without having a literal depiction on screen. Clever devices are employed to trick the audience into believing that they saw an event or an action, when in reality, they have only been given clues and will have pieced these together conceptually to envisage a scenario that was not shown. The same principle holds true in sound design,

where many sounds replace visuals, but do not exist in the events outlined in the confines of the frame.

The principles of sound

The principles of sound classification are outlined below:

Diegetic – sounds heard by both the characters and the audience.
Non-diegetic – sounds heard only by the audience.
On screen and off screen – as the term implies, on-screen sound refers to the source being present on screen whereas off-screen sounds can be created by an absent source.
Establishing sound – a scene change or transition is preceded by creating an atmosphere or tone.
Causal sounds – a literal aural depiction of a cause and an effect, where the visual object emits the correct sound (picture: dog; sound: barking).
Semantic sounds – a sound with some literal association through translation, for example, native speech.
Reduced acousmatic – the sound generated by an object is dissociated from its original source and can be applied to another form (picture: dog; sound: barrel organ).

The importance and use of sound

The construction of sound performs a series of important functions in an animated production. As an illustration, it is useful to think of a recent cinema visit, where the audience has just entered the theatre and taken their seats. It is vital that the animation transports the viewers to a world where their belief is suspended, and the most immediate way of doing that is through sound. Audiences commonly and mistakenly refer to sound in animation as a soundtrack. In fact, animated productions consist of elements of sound, namely dialogue and narration, music and special effects, which are known as 'stems' (see page 112).

Sound creates ambience and sets a level of expectation among the audience. By establishing a pace and rhythm it can introduce, set up and showcase characters and situations, signify rises and falls in the tempo of the production, and similarly define and support transitions and conclusions, thereby bringing the audience back to the real world. Put simply, sound is designed to envelop the production, binding the narrative structure together into a coherent and believable commodity.

4.

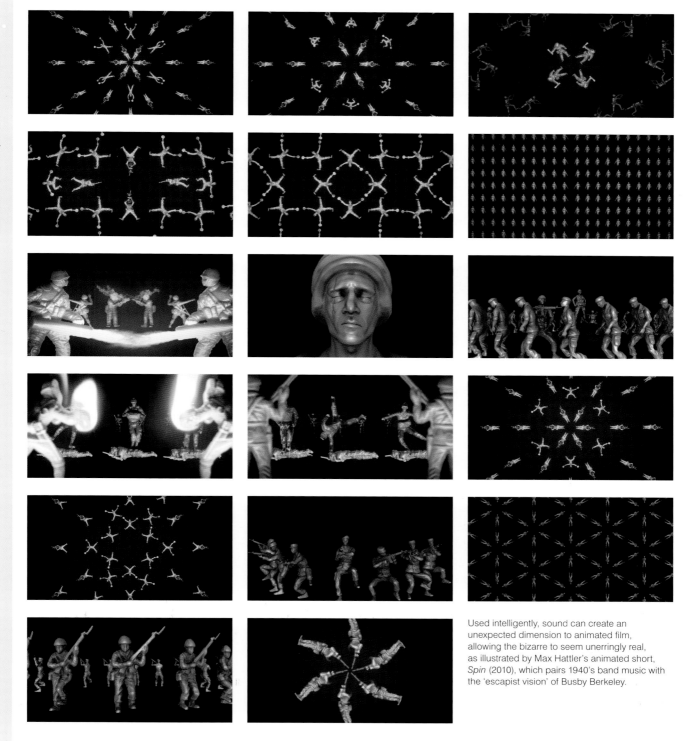

Used intelligently, sound can create an
unexpected dimension to animated film,
allowing the bizarre to seem unerringly real,
as illustrated by Max Hattler's animated short,
Spin (2010), which pairs 1940's band music with
the 'escapist vision' of Busby Berkeley.

Audience perception of sound

The audience has become very adept at understanding sound in relation to animated production. Within a century, we have moved from silent animated feature films to myriad aural possibilities. Disney's *Steamboat Willie* (1928) succeeded in helping the audience feel the emotional content in the film. Such astonishing developments have been accomplished through a mixture of directorial ambitions, production developments, technical advances and, perhaps most significantly but least appreciated of all, the highly knowledgeable understanding of the relationship between image and sound exhibited by the audience.

Some of this knowledge is part of our human make-up, as we are able to process, absorb, appreciate and understand sound more efficiently than we can visuals, thus fast-tracking our understanding of particular scenes. For example, our field of vision is physically limited to 180 degrees, whereas our experience of sound is an all-encompassing 360 degrees. Therefore, utilizing animation to appeal to both sight and hearing in unison allows potentially very complex ideas to be communicated. In animated propaganda films, the properties of vision and sound are accentuated to provide a sense of drama, but also to provoke the audience to remember what they have seen. Good examples include Jan Svankmajer's *The Death of Stalinism in Bohemia* (1990) and Piotr Dumala's *Franz Kafka* (1992).

This balance is worth investigating when watching animation. It is entirely possible to have a relatively simple visual scene illustrated for the audience, but then to manufacture a complex sound design to accompany it. The resulting scene envelops the audience in a rich and varied moving visual and aural landscape, which creates an assault on the senses, but which is largely led by the design of the sound. A good example of this occurs in Christopher Nolan's *Inception* (2010), where the street scene appears to explode, animated through a stunning mixture of visual effects, but characterized by the score and complemented by recorded and foley effects (see page 121) which combine to create an arresting and bewildering sequence for the audience. Turn the sound down while watching this sequence to understand how much of the drama comes through the sound design.

Sonic interpretations of space and time

Sound aids the audience's spatial understanding of the production using depth, height and width by means of signal processing, mixing and panning. For example, manipulating the frequency, volume or pitch of sound can achieve sonic depth, while using reverberation has the effect of creating a scene that is spatially consistent. Panning allows exaggerations of sonic width by placing sounds compositionally in a space, so they can be heard in different parts of the auditorium. For example, the rumble of tanks might be heard towards the rear of an auditorium, while the sounds of light gunfire and a soldier's breathing might be heard at the front. This will make the viewer more conscious of the immediate action, but also aware of the context of the

One of the world's foremost animators, Jan Svankmajer is famous for his surreal films that often have propagandist themes, illustrated here by *The Death of Stalinism in Bohemia* (1990).

battlefield. The development of sound design is particularly important in this regard, as animated productions move away from traditional screens, to portable transmission devices, enlarged IMAX cinemas capable of showing animated productions, and holographic projection systems capable of bringing augmented-reality environments to life.

Sound is also a significant component that directors use to play with the perception of time in an animated production. For example, while a dramatic cut to a visual close-up allows the audience to examine a depiction in greater detail, such edits can sometimes appear static. The corresponding soundtrack must, therefore, compensate for the seeming loss in movement taking place outside of the picture frame by providing a continuum and an enhanced sense of tension or suspense. The use of sound can also introduce, accompany and emphasize accelerations and decelerations in time-based narratives. This principle is creatively applied to all kinds of animated productions, using the concepts of fast-forwarding, replays, slow motion and flashbacks as devices that help the audience comprehend narrative sequential content. A very good example of the compression of time happens in the Disney•Pixar animated feature *Up* (2009), where the scenes detailing the love affair and relationship between Carl and Ellie Fredricksen are aurally developed entirely through the musical score, without the need for written dialogue. Michael Giacchino's score skilfully depicts the highs and lows of the Fredricksens' life while packaging the premise of the story emotively for viewers.

The grammar of sound

Exploiting the opportunities of sound gives further permission to the director to allow reality to exist plausibly through invention and articulation. For example, sound themes can be attributed to characters to reinforce a particular point of view. Such themes are known as motifs. Many examples exist in animated features, but perhaps the most iconic are the sound interludes that govern the continual antics of such characters as Tom and Jerry, where comedic moments are musically interpreted with high-pitched, playful interventions using wind instruments, while moments of grave danger or impending doom are illustrated by forceful interjections of vigorous piano playing.

As animation relies extensively on the artificial creation of forms, so too must the sound design have the flexibility to enable non-literal sounds to exist and flourish. For example, a scene that depicts a trapdoor slowly opening might reasonably be expected to be accompanied by a creaking, groaning sound, suggesting a nasty surprise. However, if the sound instead is a flock of birds singing a morning chorus, the sound encourages the audience to expect a more positive, uplifting discovery. Creating such aural metaphorical situations is clearly important in fostering a belief system around the characterization of objects and forms. Removing literal sounds from one plane of existence and transposing them into another imagined situation

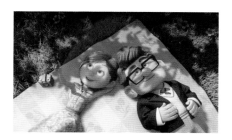

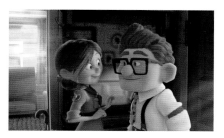

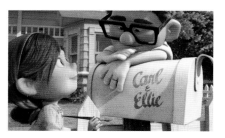

The opening sequence of Disney•Pixar's *Up* (2009), where Carl and Ellie's marital relationship is introduced and developed, offers a master class in presenting and establishing character and environment using a condensed time frame.
© 2009 Diseny/Pixar

with smooth sonic transitions can help exaggerate visual effects in a believable but uncompromising manner.

Perhaps the most significant requirement of the sound design in the production is the possible scope for enabling tension and release to mirror narrative intent. In tonal music, harmonies written with dissonant chords create tension whereas consonant chords provide a welcome release. Both instrumentation and dialogue perform these variations, where the cutting edge of a screeching electric guitar creates greater tension than the melodic dalliance of a clarinet, or where an actor's punchy delivery spikes at the heart of a subject but a lilting soft accent skims the very edge of the piece. Further support can be provided by accompanying sound effects, so the scream of a bullet immediately awakens the audience, while waves breaking against the shore provide an altogether more refined air.

Stems of sound

This section highlights the key components of the three characteristic stems of sound design: dialogue and narration, music, and special effects.

Dialogue and narration

The reliance on the roles of dialogue and narration has evolved continually since the middle of the last century and can be attributed to the rise in popularity of television. Televisual modes of storytelling could be readily applied to animation, allowing the form to evolve away from cartoon conventions and embrace more impactful fields, such as documentary and propaganda. Such familiarity now ensures that dialogue and narration are more immediately recognized than a soundtrack or special effects.

Historically, silent films compensated for the lack of sound by relying on pantomime-style exaggeration of characters and actions, and were often accompanied musically in cinemas by piano or organ. It is hard to imagine the impact that *Steamboat Willie* must have had in 1928, given how familiar with and expectant of sound we are in animation today. It is equally impossible to consider voice actors in animation without mentioning Mel Blanc. A gifted artist and performer, Blanc is remembered for delivering the the vocal signature for a variety of characters from the Warner Bros. studio, including Bugs Bunny, Tweety Bird, Speedy Gonzales, and Porky Pig, before later moving to the Hanna-Barbera studio to voice Barney Rubble in *The Flintstones*.

Dialogue involves the exchange of sonic information and can take various forms. For example, on-screen dialogue can exist through the process of lip-synching (see pages 98–99), whereas off-screen dialogue contains no visual point of reference in the frame. The key principle is that both forms happen in the sequence being viewed, and can carry the story or describe actions or responses to those actions witnessed by other parties.

Whether specially written or adapted, musical scores need to be played back in real time to allow the director and music editor the opportunity to time sections that will be blocked as sequences to animate.

Opposite Mel Blanc is arguably the most famous voice artist in animation, responsible for the unmistakable tones of Bugs Bunny, Speedy Gonzales and Porky Pig.

Dialogue clearly has an important defining role to play in the nuanced development of characters, establishing their age, sex and ethnicity, together with their 'place' as part of the production. Casting an actor to deliver dialogue is crucial to the success of the production, not just for the believability of the character, but in the requirement to 'click' with the other characters supporting them.

Meanwhile, narration identifies and supports events happening on screen from a distance, with the narrator being excluded from interaction with the characters, and delivering material in either the first or the third person. Many examples of narration exist in animated film, a good example being Les Orton's *Under Milk Wood* (1992), which features narration by the actor Richard Burton. Narration is also a good vehicle for explaining and informing the audience about subjects that are fact-laden, an example being the short film *Branching Out for a Green Economy* (2011), which is narrated by the naturalist and broadcaster David Attenborough. His authoritative tone, combined with the freshness of the visual imagery, works well in dispensing environmental advice without prejudice or persuasion. Some productions, such as

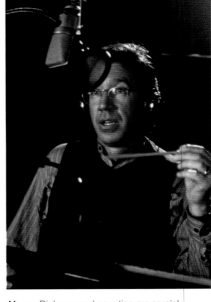

Above Dialogue and narration are crucial components of an animated production. Some actors, such as Tom Hanks and Tim Allen, have demonstrated that their understanding of comic timing has informed not only the chemistry between their characters, but the director's vision of the feature film itself. © Disney

Left Employing narration to add gravitas and solemnity to a production requires specific casting – such as choosing Richard Burton to narrate Dylan Thomas' *Under Milk Wood* (1992).

Opposite Casting a voice artist who brings familiarity to a subject is an excellent way of imbuing the production with integrity, illustrated by Sir David Attenborough's contribution to the animated short, *Branching Out for a Green Economy* (2011).

Disney•Pixar's *Wall-E* (2008), required dialogue in deliberately nonsensical tongues, known as a 'synthetic language', to plausibly demonstrate that creatures or objects are able to communicate with one another.

Casting voice talent for animation is a complex process, as artists will invariably need to immerse themselves in a character over the timeline of the production in order to perform with sincerity. Directors hiring voice artists must look beyond necessary essentials, such as the clarity of the recorded voice, to acting ability and the ability to interpret from the imagined. The process of finding voice talent is conducted in larger productions by the casting consultant, whose job is to interpret the voice talent needs of the director and act as a negotiator between the studio and casting agents. The casting agents' role is to represent their voice talent artists, promote and suggest particular artists for special voiced parts, negotiate the terms and conditions of contracts between the artist and the studio and to manage the artist while they are signed to a production.

Voice talent artists come in many guises, including individuals who have very defined voices and others who revel in mimicking a range of accents and styles. Agencies represent artists capable of voicing dialogue or narrative parts in a wide range of genres, from independent documentary through to science fiction. Regardless of the size of the part, a voice talent artist is usually presented with the whole animation script in order that he or she can understand the story and the atmospheric conditions in which it is set, as well as the physical and emotional connections between the characters. 'Read-throughs' of the script are conducted between the director, voice talent artist and casting consultant, and 'takes' are recorded many times to achieve exactly the right tone and speed of delivery of lines corresponding to the actions of the character being portrayed. Of course, this level of preparation is seldom witnessed by the audience, but will often guarantee that the believability of character depth and plausibility of emotion is coherent.

Tools for recording

Recording studios are home to audio engineers, whose principal job is to ensure that voice recordings are perfectly recorded for production. Major recording studios offer professional recording facilities, complete with excellent acoustics, sound-proofing and permanent, tested microphone positions, while independent creators improvise by converting a laptop into a digital audio workstation. However vocal elements are recorded, planning resources and creating a sympathetic environment are key ingredients to creating good-quality vocal passages.

Microphones

In a similar way to how the human ear processes sound, a microphone simply converts acoustic energy into an electrical signal. The outer face of the microphone collects sounds, while the inner diaphragm vibrates to produce a signal as an acoustic wave. Animation production uses two basic types of microphone: dynamic and condenser. Dynamic microphones capture loud sounds in close proximity, while condenser microphones are popular in vocal settings as they can be more versatile, can be placed further away from the source and are considerably lighter. Each type of microphone conforms to a particular 'polar pattern', which picks up certain sounds dependent on the direction of the source sound. For example, universal sound is captured through omni-directional microphones, while more directional microphones are known as 'cardioids'. Microphones capturing voices are positioned between 20 and 30 cm (8 and 12 in.) from the actor delivering the lines, and a pop shield is used to prevent unwanted air hitting the diaphragm inside the microphone and distorting the sound. For this reason, the script is broken down into segments that can be recorded incrementally, before being edited and imported into the animation production program.

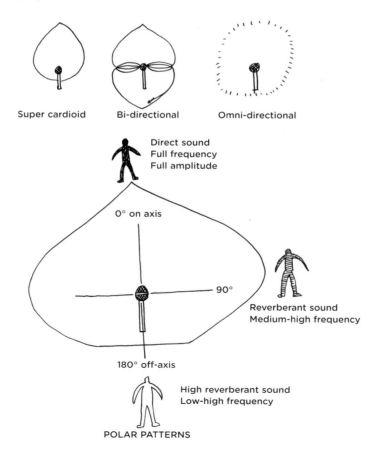

Super cardioid Bi-directional Omni-directional

Direct sound
Full frequency
Full amplitude

0° on axis

90°

Reverberant sound
Medium-high frequency

180° off-axis

High reverberant sound
Low-high frequency

POLAR PATTERNS

This illustration shows how microphones pick up sound depending on the direction of the sound source. Setting up microphones to record in studio settings permits many subtle variations to be captured, altering the pitch and frequency of delivered lines for dialogue or narration.

Troubleshooting voice recordings

Sibilance – some spoken words have an emphasis on certain letters to create their sound, which can mask other sounds that make up the entirety of the word. Actors can be encouraged to change the emphasis on the letter sounds in words to help balance and better articulate the sound. For example, the word 'stop' emphasizes the 's' to sound like 'ssstop'. Changing the emphasis away from the 's' makes the word sound like 'sTtop', reinforcing the articulation of the word.

Plosive – certain consonants (b, p, k, d and t) produce a sharp blast of air that is picked up by the microphone as wind distortion. A pop shield placed between the actor and the microphone can help, as can re-recording.

Proximity – an actor standing too close to the microphone will often have the bass tone overemphasized.

Anxiety – reading parts can produce feelings of stress, loss of self confidence and glottal shocks on the part of the actor, resulting in unnatural reading and heightened breathing, which can usually be edited out.

Unwanted sounds – microphones may inadvertently pick up clothing rubbing, ticking watches or headphone waste sounds, which will need to be edited out.

Music

Designed sympathetically, music acts as an important tool for the animation director. It opens up decisions about economizing on visual production methods and techniques in favour of aural ones, thus achieving a better result while successfully managing budgets and production schedules. In animated productions, the musical score is deliberately commissioned and composed to heighten our enjoyment and appreciation of the emotional content. It also allows us to envisage settings, helps us to appreciate scale and complexity, and provides a symbolic motif for the production. For example, full orchestras are charged with playing epic introductions to feature films that require high drama and a sense of grandeur, as in the case of Disney's *Fantasia* (1940) or more recently *Lord of the Rings: Fellowship of the Ring* (2001), whereas more private moments are often more successfully handled by solo or smaller groups of instruments, such as Grant Orchard's *A Morning Stroll* (2011).

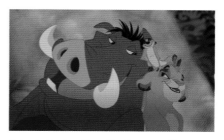

Animated feature films often have specific musical scores originated for them, with songs written and performed to help amplify the story and create a distinctive feel, typified here by Sir Tim Rice's lyrics for *The Lion King* (1994). © Disney

What's the score?

Scores are defined by musical selections known as 'cues'. It is important to understand the role of these cues as introductions to underscores or sources. Cues allow subtle introductions to a character's state of mind without the need for dialogue or narration. For example, an underscore can be seen as the musical equivalent of narration, whereby ambient music accompanies the production to enable the audience to appreciate the way the narrative or subtexts develop through the character's innermost thoughts and feelings. By contrast, source music is central to the production, and is experienced by both characters and audience. In this case, this might involve indirect music that is being performed on screen, or narrative lyrics of songs that the characters in the production either perform or respond to directly. Tim Rice is an obvious example of a lyricist who has written for animated productions, perhaps most famously for Hans Zimmer's score *The Lion King* (1994).

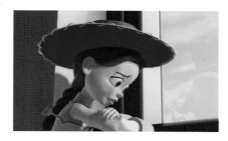

The character of Jessie is central to *Toy Story 2* (1999), and is particularly remembered for the captivating flashback sequence of her being loved, discarded and eventually abandoned by her owner. The sequence featured the song 'When She Loved me', beautifully scored by Randy Newman and performed by Sarah McLachlan. © 1999 Disney/Pixar

Musical delivery

Different aspects of music are used in animation to drive and deliver convincing productions. Melodic sections are devised to explore or accompany linear developments, while harmony provides intrinsic emotional support for a narrative. Rhythm allows the pace of a production to be defined and supported. Music can be positioned to allow sounds to follow visual movements, much like a writer uses punctuation in language to emphasize particular events and circumstances. This process is known as 'dynamic panning'. Music can also be interpreted stylistically by a conductor and orchestra to highlight particular aspects of a character, including genre and national identity. Historically, such figures as Scott Bradley and Carl Stalling played a major part in defining the sonic success of the 'sight gag' cartoons, typified by Tom and Jerry, where visual jokes were anticipated, played out and enjoyed by musical accompaniment. But as television production

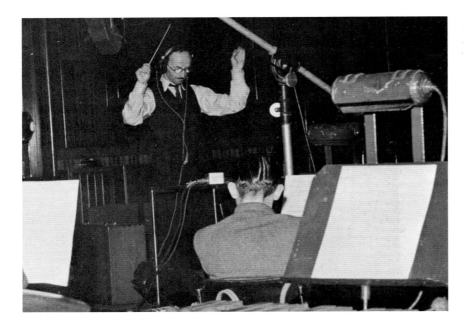

Hungarian-born composer, Mátyás Seiber, conducts the orchestral recording of his score written for Halas & Batchelor's *Animal Farm* (1954).

methods demanded greater efficiency in the way animation was constructed, so too came the need to have defined sounds that could create instant recognition and enhance marketing. The composer Henry Mancini is a useful example here, with his compositions for the *Pink Panther* series influencing later work by Randy Newman for Pixar.

Scoring

To develop a score, the director discusses his or her ideas with the music production supervisor, together with the music editor and the orchestral contractor, depending on the scale of the animated project. The music editor is in charge of compiling, editing and synchronizing the musical score in production, and may look to a film composer to create an original score for the animation. Meanwhile, the music production supervisor develops the relationship between musical and visual parts of the production by selecting and licensing any prerecorded music used. The orchestral contractor will select orchestras that are able to perform musical scores, interludes and anecdotes as directed by the composer or music production supervisor.

If a composer is commissioned to create a score, it is essential from the outset to supply an agreed timing detail. This may be achieved by bringing in the composer to work alongside pre-production artists as they shape and define the storyboards, or may be put into action through a developed animatic that contains sufficient clarity to allow accurate musical interpretation. The briefing between director, composer, music production supervisor and music editor should highlight the importance of music in the scene(s) discussed, the incremental points where significant action happens, the use of dialogue or narration and the moods or atmospheric conditions prevalent in the visual production of the scene(s). From here, the discussion

might consider where underscore can be used to add continuity, or where it needs to make dramatic effect or to act as musical paraphrasing for the audience.

This discussion forms the basic foundation for a cue sheet to be completed, enabling the composer to sketch out key themes that can be played, with the help of instrumentation, to the director in the studio. This is known as a 'temporary' (temp) track. Once approved, each cue is orchestrated and recorded in the studio environment. It is worth noting that where budgets are small, directors often turn to production music libraries to source rights-free music, which can be a cheaper and labour-saving alternative. Examples include LicenseMusic, DeWolfe and KPM.

Sound effects

Sound effects are used to emphasize narrative components of the production. In animation, the idea that inanimate objects may have their own 'sounds' is as comprehensible as their having an inner logic controlling their actions and appearance, and this concept needs to be factored into any sound design. Sound effects are seldom heard in isolation, but rather as part of the bigger soundscape, often to highlight elements that can be linked and to draw meanings for the audience. They can be used in establishing a character, setting a scene and framing the wider production. For example, the roar of a jet engine, or the screech of tyres on tarmac, might signify an airport setting. Equally, sound effects can be used off screen to imply or subvert meaning, adding a sense of mystery and sophistication.

The sound-effects editor works with sound-effects designers and foley artists to produce the sound-effect stem. Typically, sound-effects designers work on designing and building specific recorded effects in a studio setting.

Soft effects add texture to animated film, and are beautifully underplayed in Robert Seidel's film, *Black Mirror* (2011), here on display at Young Projects in Los Angeles.

These are categorized as 'hard effects' and are linked to directed actions or objects occurring on the screen. In contrast, foley artists make, find and record sound from often surprising sources, borrowing incongruous sounds that can be reapplied to other situations. An example might be a recording of a water droplet landing in a half-filled bottle, which could be used to make a sound effect to represent water dripping in a damp cave. These sounds are known as 'soft effects' and are often blended to provide sounds to off-screen occurrences. Background sound effects create depth in the overall ambience of a scene or situation, while foley effects provide a 'performative' series of sounds that catch and embody the action on screen.

Marc Craste and Jon Klassen's dramatic Winter Olympics 2010 animated sequences draw on the Innuit legend of rescuing light and peace from a world of impending darkness, aided by an imposing and climactic musical score.

Spotting sound effects

As with music, the process of 'spotting' helps identify the possibilities and requirements for special-effects production or acquisition. Spotting effectively involves the director and sound editor sitting together to review visual and aural recordings played in tandem and agreeing where sound special effects are required to emphasize certain actions or events. The discussion paves the way for the effects cue sheet, which synchronizes the placement of special effects throughout the production. It also signifies where special effects need to be created or purchased, considers how many of them are required and how long each sound is, and provides an overview for the production and collection of material to take place. Some studios build up a library of their own recorded sounds, but this takes time, effort and resources. It is also possible to buy specific effects in varying delivery formats from commercial libraries, such as Sound Ideas or Sound Dogs.

Thinking about and recording sound effects

Inventively conceptualizing sound effects requires intuition and creativity to imagine everyday sounds out of their ordinary context. It is also important to try to harness the imagining of these sounds to the practical act of being able to record them, since our knowledge of them may not necessarily equate to being able to acquire them. Many sound effects can be collected in the same source environments as those being depicted on screen, but the music editor must be careful to ensure that sound effects are not too literal, as this will undermine the scene being developed.

It is important to restate that the best sound effects are not heard alone. Instead, they work within a conducted mix of sounds, with each sound and image element contributing to the overall experience. That said, recording special effects is an exacting challenge and one that can be undertaken both in the studio environment and out on location. Key to the success of the recording is the clarity and precision of the recording, and although editing equipment can clean sound, having a reliable original is preferable to having to clean a recording later in editing.

On location, it is commonplace to use multichannel digital field recorders to collect sound on disk. They are easily accustomed to supporting high bit-depths and will support surround-sound recording through a multitude of placed microphones. A selection of microphones will deliver different directional effects. For example, a shotgun microphone pushes sound away from the side and bottom to fully capture everything in front of it, while an adaptive microphone is used to capture directional sound far away, and hydrophones are used to catch liquid sounds. All microphones should be protected with a windsock to prevent buffeting from the wind on location and may be fitted to a boom to allow directionality.

In a studio setting, patience and testing are the two keys to ensuring successful recordings. The permanence of the studio environment, and its ability to be controlled without adverse exterior effects, are helpful when working under pressure. The biggest issue in this environment is making sure microphones are not placed too close to the sound-emitting source or the microphone will pick up the reflected sound bouncing back. Background sounds are normally recorded using a stereo microphone, which houses two transducers to balance and distribute the collected sound.

Effect editing

All sound effects captured on location and in the studio require signal processing to maintain consistency. Sound-effect editing removes unwanted sounds from a recording, but can also be usefully employed to change the duration of recordings and the effects by adjusting their frequency. It is possible to adjust the length of audio files without damaging their pitch, through a process known as 'sound shaping'. This is achieved either by using time compression or by looping the sound, and then playing with levels of volume, pitch-shifting and compositing to consider variation and conditions.

It is also possible, and desirable, to remove unwanted sound using digital noise-reduction software, which 'cleans' the sound without radically disturbing the original recording. Other options include reversing and reverb, which reinvent sounds by shifting their pitch, and Doppler (named after Austrian physicist Christian Doppler), which alters the audience's perception of sound perspective. This is often used to encourage the establishment of a point of view in a sequence, and is best illustrated by the way an emergency vehicle siren sounds higher pitched as it races towards us and lower pitched as it speeds away.

Synchronizing sound

The layering of sound effects to enhance music, dialogue and narration should be carefully handled to provide the correct weight and nuance to animated content. Synchronizing the sound effects against other aural forms allows instances of recognition and confirmation of actions or events to be achieved, as well as creating dramatic points or periods of delay and tension. The decision about the placement and panning of the sound effects is taken in the final mix, where the sounds can be considered alongside final cuts of narrative, dialogue and music.

The working sound studio

The advent and availability of sound-recording, production, mixing and editing technology to create professional-quality soundscapes has developed significantly in the past two decades. By using a computer with audio software, supplemented with synchronized hardware such as video

Independent productions often work on small budgets and so need to creatively improvise sound design. *Madame Tutli-Putli*'s sound design is cleverly crafted to complement the art direction of the animated film.

monitors and mixing desks, it has been possible to achieve high levels of production at a fraction of the cost charged by professional studios. Through a mixture of the sound designer's creativity and technological knowledge, professional recording possibilities are now available for independent animators and students at a competitive price.

Collecting and processing data

There is now a host of powerful software applications capable of working across Mac and PC platforms using advanced authoring formats, including Pro Tools, Logic Audio, Audition and Nuendo. The ability to store, copy and edit files means that far more can be done with them without disturbing or damaging the original recording, using dual processors for speed of working and stability of stored data. Working with digital audio systems also has the advantage of creating detailed visual data in the form of waves that 'illustrate' the audio files, allowing the sense of sight to help in making accurate edits, rather than the analogue tradition of using hearing alone. These edited audio files can be checked using QuickTime Player (Mac) or Microsoft Windows Media Player (PC).

Most audio software also includes MIDI technology, which is able to recognize data being emitted from electronic sound sources, such as keyboards and drum machines. This data can be captured, edited and recycled by both composers and sound designers building effects. In other cases, synthesizers and samplers can be synchronized directly to the computer to provide bespoke sounds and yet more options for sound-effect generation. Then the files are encoded using systems such as Nuendo Dolby Digital or SmartCode DTS-DVD. Software and hardware are connected through an audio interface using FireWire or USB technology, providing both input and output options.

Mixing desks

Given the complexity of the sound component of an animated production, it is desirable to build any soundscape with as much real-time 'hands-on' control as possible. The modern studio mixing desk allows the sound engineer to work with source visuals, editing and mixing sound stems in tandem to create the overall aural feel of the scene in question. These mixing desks allow for stereo panning of individual sounds by seemingly placing sounds around the audience, or by surrounding the audience in a cloak of sound. Additionally, the panel allows sounds to be faded and checked using parallel audio and video playback monitors.

Conclusion

Sound performs a vital role in animation but, because the visual action on screen is constantly moving and evolving, it is often marginalized. In many

respects, successful sound design should accompany the visual action, in certain circumstances introducing, developing and signalling aspects of the plot or characters, while in other parts providing a more emotive or evocative background, encouraging the audience to ponder and reflect on the story or anticipate what might follow. By default, audiences will, therefore, be more aware of a score, musical cues or special effects at certain points.

The success of the sound design hinges on careful planning and good execution by the members of the crew responsible for interpreting the script and story ideas, designing the sound to include music, dialogue, narration and special effects where appropriate, and preparing for these recordings to take place in the production phase. Now the project is gathering pace, with the consolidation of visual and sound planning material providing momentum for the crew. The different components of the production are still very much working in tandem, marshalled by the director, and it will soon be time to finally review the pre-production material for agreement and sign-off, signalling that the project can now move into full production.

5.

The real advantage of animation as an artificially constructed medium is the variety of ways that projects can be realized. This flexibility ensures that traditional and digital processes can co-exist, enabling traditionalists and purists to continue producing work in the field, but opening up the possibility that new participants can use animation also for communication, information, education and entertainment productions. From simple projection devices, such as the zoetrope and praxinoscope, through traditional hand-drawn and painted cels, stop motion and jointed puppets, to advanced computer-generated virtual animation, the continuing experimental possibilities of animation are central to its extraordinary success as a pervasive and progressive art form. A great idea, a burning ambition to tell a particular story, or a compulsion to deliver a particular set of facts, coupled with a thorough understanding of previous, current and potential future techniques of animation are the raw ingredients needed to produce exciting work.

This chapter examines the variety of production methods used to create animated content – traditional cel animation, stop motion, 3D computer-generated imagery (CGI) and unorthodox processes. Consideration is given to the history and development of these forms, illustrating successful exponents of each and providing detail about the benefits and limitations that students can expect to contend with when producing their own work. Attention is also given to the development of sound in the production phase and the signing off of the final work by the director.

Choosing animation as a preferred communication vehicle has been commercially very successful for the British bank Lloyds TSB, with spin-off merchandising following public awareness and brand recognition.

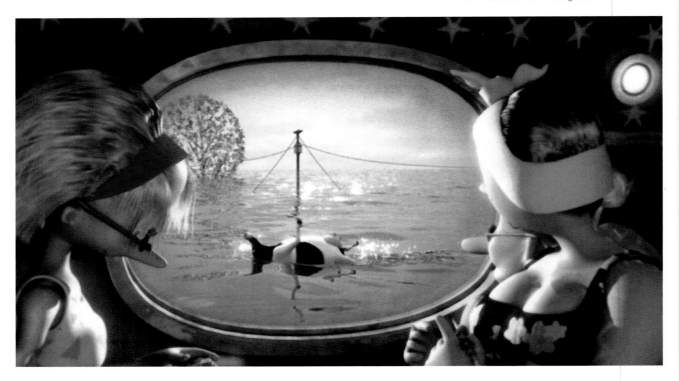

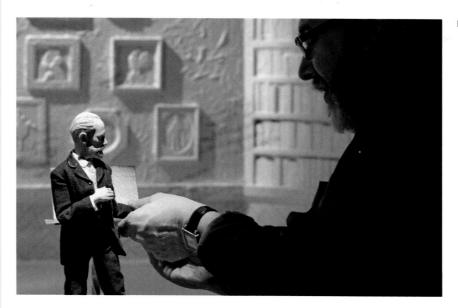

Barry Purves animating on set.

The animation pipeline in production

The animation pipeline in the production phase varies slightly according to the processes and techniques used. As a general rule, two-dimensional work is key-framed, with drawings or images created identifying the main actions in the scene in tandem with the pencil tests made for each character to enable them to move convincingly. Background and scenes are created, and the in-between frames are generated to link the key frames together, smoothing the movements of the characters and objects in the scenes. Frames that have been drawn or scanned are tidied in 'clean-up' ready for inking and painting. The process of compositing layers can then begin, developing the level of detail that may be required for each frame before picture editing and rendering complete the process and create a final workprint of the animation.

Three-dimensional production differs inasmuch as the image-making process is largely achieved through modelling the form, either as a whole or as a physical or virtual skeletal framework. The model will usually need to have its articulation engineered; in a virtual production process the technique of 'rigging' creates data-mapped 'points' that the crew can use to manipulate the model by dragging a cursor to a desired position on screen. The model is then animated by enacting movement with the body, limbs and lips to make the character walk, gesticulate and talk. Once the basic moves have been established, the model is lit to heighten its sense of presence, drama and intensity. The captured film or data is composited together to bring all the animated shots together as one combined frame and rendered or blended together to achieve a final workprint.

Dad's Dead (2002) is noteworthy for Chris Shepherd's decision to use a variety of animation production processes to challenge the viewer's perception of mediated images.

Introduction to basic techniques

In essence, all animation is made using the principle of creating a still frame, recording it and playing it back with corresponding frames to give the illusion of movement. The variation comes through the creator's choice of materials, dimensions and method of capture and is not simply confined necessarily to one form or technique. Indeed, the dynamism and versatility of animation are repeatedly expressed through productions that use multiple techniques and processes to convey meaning. A good example is the award-winning short film *Dad's Dead* (2002) directed by Chris Shepherd, which cleverly uses multiple animated techniques mixed with live action to engagingly tell the story of childhood experiences through a boy who has lost his father. The innocence of the animated techniques is juxtaposed against the often dark and subversive content, providing an uneasy viewing experience.

For those new to animation, it is helpful to have some understanding of the history and significance of the moving image. This not only requires a theoretical and critical knowledge and comprehension of the history of the subject but also an appreciation of how different practical devices such as zoetropes and praxinoscopes were invented, enabling the illusion of movement to be illustrated. These simple motion devices played an important historical part in creating the illusion of movement on which many of today's production processes are based. They all play on the idea of the illusion of movement by using moving parts themselves.

Simple motion devices

A phenakistoscope disc.

Magic lantern – records detailing the existence of magic lanterns date back to 1660, but it was really in mid-eighteenth-century France that the device became well known to the public, being used as a popular form of entertainment. Early versions back-projected an image on to a screen and operators created intriguing shapes with their hands. As lighting developed, shows became more sophisticated and slides were introduced depicting black-painted silhouettes.

Slides – early slides were made of glass surrounded by a wooden frame, which was drawn or painted on and slotted into a magic lantern. The introduction of accompanying smoke created by lighting small fires and sounds made by musicians playing live at the venue gave further life to these projected still images. Limited colour could also be applied using the process of 'decalcomania', which transferred pictures as decals (a low-tack transparent adhesive sheet printed with the image) on to the glass surface. Slides developed greatly with the arrival of photographic processes in the mid-1850s, allowing a background slide to have a foreground slide placed over it which could be moved by hand, thus 'animating' the scene.

Thaumatrope – an example of a two-state animation device where two images are alternated in quick succession, tricking the eye into believing that both are appearing together. The two images are displayed on opposite sides of a circular or rectangular surface suspended by strings. The surface is then spun and the two images alternate rapidly, merging into one. If a goldfish is drawn on one side, and a bowl on the other, spinning the surface seems to show the goldfish inside its bowl.

Kaleidoscope – a tubular container, the inside of which has been inlaid with mirrors and an object, or picture, placed at the far end. By looking through the spy hole at the near end of the tube and rotating it, myriad patterns, colours and shapes are created for the viewer.

Phenakistoscope – invented by Joseph Plateau in 1832, this device creates an animated loop for the viewer. A series of images is drawn on a disc, interspersed by a series of slits. The disc is attached to a vertical handle, and is held facing a mirror. The viewer spins the disc and looks through the slits to view the animated loop.

Zoetrope – similar to the phenakistoscope in principle, the zoetrope is a drum with a series of equidistant slits cut into its side. A long strip covered in incremental drawings is placed on the inside wall of the drum and, when rotated, the viewer sees the drawings appear to move.

Praxinoscope – instead of using slits like the zoetrope, a series of mirrors positioned centrally inside the drum reflects the drawings resting on the drum's inner wall.

Cel animation and traditional 2D processes

A common way to understand the basic principles of animation is through the process of simple cel animation. The technique has been used extensively, from full-length animated feature films right through to animated television commercials. Cel animation represents the majority of people's understanding about what constitutes the form, as it is often encountered for the first time as a child through animated cartoons.

Drawn cel animation

The process of drawn cel animation gives an animator great artistic freedom and an intimate sense of engagement with the creation of animated work. Two-dimensional drawings are created on separate surfaces that are calibrated by fixing them to the same registered position, photographed and then played back in order, so as to create a simple linear animated sequence.

Patented by Earl Hurd in 1915, cel animation traditionally consisted of rough drawings created in light-blue pencil (invisible to photographic processes), which were then drawn over in pencil or ink to finalize the design. The individually inked line drawings were crafted onto single pre-punched acetate cels (or animation paper) by the animator at the animation table. The table was tilted at an angle towards the animator, lit from underneath, with the cel fixed on a peg-bar (a piece of wood or plastic fixed to the desk, with notches to register the punched holes) directly over the light source, which illuminated a movable frosted glass or plastic disc in the centre of the table. The illuminated disc allowed the animator to draw the new image onto a cel using the previous cel as a guide underneath, ensuring that moves previously drawn were incremental and consistently in keeping with the intended action.

The inked cels were turned over and painted on the back using acrylic paint on a factory line and, once dry, were turned right side up for filming. In the heyday of this kind of production during the 1930s and 1940s, many women were employed by the animation-producing Hollywood studios to ink and paint the cels. The results of this process are known by millions around the world through the seminal works of the Walt Disney Studios. It remains the method of choice for many animators today, including Koji Yamamura, Joanna Quinn, Bill Plympton, Igor Kovalyov and Frédéric Back, who have each explored the medium with different expressive dry and wet media to exciting effect.

Two-dimensional drawn animation has expanded beyond these early 'industrial' methods and can imaginatively encompass drawing on paper using a variety of wet and dry media and textural and tonal surfaces. The further possibilities of using creative digital media, such as Adobe Photoshop and Illustrator, allow artists to create digital frames as separate files or to layer frames over one another to control more effects.

A glimpse into Japanese animator Koji Yamamura's studio reveals shelves of individually hand-drawn images that have been scanned to create sequences.

A student reviews his scanned drawn cel on screen.

Rotoscoping

The rotoscope was invented and championed by the Fleischer brothers in 1915. The writer Mark Langer describes the rotoscope as 'a device that allowed the rear projection of a live-action film frame-by-frame on to a translucent surface set into a drawing board. An animator could simply trace each live-action image on to a piece of paper, advance the film by another frame and repeat the process. By these means, the live-action images became a guide to detailed and lifelike animation.' Rotoscoping was used specifically to great effect in the Cab Calloway 'dance-walks' in a number of Betty Boop cartoons, and as reference to help animate the sequences where Snow White appeared in *Snow White and the Seven Dwarfs* (1937).

While the instrument has been superseded by more efficient digital technology, the term 'rotoscoping' is still in evidence today. It is arguably the closest form of technique linking live-action film to a two-dimensionally animated process. Rotoscoping has the potential to give the animator freedom to make content and stylistic editing decisions, making it useful for showing technically accurate, but non-specific information. For example, it could be used to show particular figurative actions or situations without revealing the individual, by masking his or her identity.

However, as a technique that enables a form of translation to occur, it is worth noting that visual differences between 'reality' in cinema and in animation mean that investing solely in such techniques can produce visual results that can appear wooden. Avoiding such unnatural depictions of form and movement requires careful checking and tweaking by the animator.

2D computer-generated images

Two-dimensional computer-generated animation is created, produced and edited exclusively using digital technology. The animator commands the computer to store and act on creative instructions, processing them into a form of mathematical data that translates how each frame of animation is constructed, rendered and pieced together in a corresponding sequence. While some may consider digital technology a relatively young phenomenon, in animation it has existed for a significant period. Highlighted by independent pioneers such as Larry Cuba, Ed Emshwiller and John Stehura, who embraced, experimented and shaped digital production possibilities during the early 1960s, computer-generated imagery has informed and developed an important strand of animation production through larger studios and smaller production companies. Much of that early experimentation and research with primitive digital technology has informed software production. Today, there is a significant variety of production, editing and compositing software available for a fraction of the cost once associated with this kind of production. Such availability and affordability opens new doors of possibility for animators, and has also encouraged other creatives to explore computer-generated animation.

Rotoscoping was used as reference to great effect in *Snow White and the Seven Dwarfs* (1937), where Snow White's character came alive through pioneering use of the technique, combined with the skilful art direction of Webb Smith. © Disney

Thanks to digital animation pioneer John Stehura's film, *Cibernetik 5.3* (1964), the possibilities of merging art and science through animation became a possibility for exploration and output.

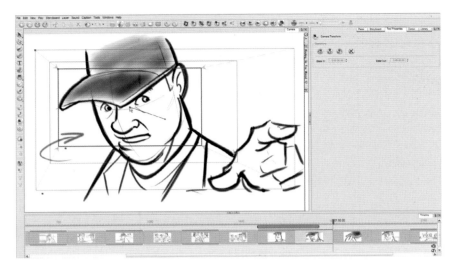

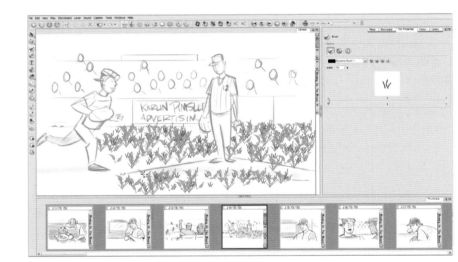

Toon Boom Animate Pro allows animators the opportunity to create content, animate and composite all in one program.

CGI platforms

While acknowledging that computer-generated imagery has revolutionized the production of animated projects, especially for independent producers and small studios, it is worth remembering that this revolution has also affected the editing, compositing and distribution of digitally made work. A platform for creating work is generally dependent on the software used. For simple core designing, processing and editing of images, the Adobe programs Photoshop and Illustrator, together with Corel Painter, are good examples of versatile and user-friendly 'off-the-shelf' packages available to buy at competitive prices.

Animators wanting to scan, line test, ink and paint cels and animate movements use programs such as Cambridge System's Animo, Toon Boom and Bauhaus Mirage, with Cel Action and After Effects popular among independent producers. On larger-scale productions, several studios have in-house developers responsible for creating specific software programs.

Often these developers are highly qualified computer scientists who work closely with their creative counterparts to seek solutions to difficult production problems and these products are then offered to the wider market to fund future projects. A good example of such a program is Pixar's Renderman.

Adobe Flash

A program primarily directed at helping animators create work for the Web, Flash is cheap and easy to learn and has proved to be an extremely versatile product. It is a good example of a transitional program: written originally to work as a drawing tool, it was reincarnated as an animation package to respond to the rapid growth of new technology. Flash has gone on to be the tool of choice to create simple, effective pieces of animation online where bandwidth is limited and large and complex image files would clog a user's system unnecessarily. Increasingly, it is also used for creating limited animation, with several studios, including Studio AKA and Robber's Dog, creating successful productions using Flash that showcase a creator's economical conceptual, development and articulation prowess.

Stop-motion animation

As the term implies, a simple 'motion' can be created between 'stops' by manipulating elements incrementally in front of, or under, the camera and then shooting the result as an individual frame. The finer the move in each frame, the smoother the transition when played back in sequence. This is what makes stop motion so time-consuming, but equally so rewarding. For a second's worth of animation, twenty-four frames will need to be manipulated, anchored, lit and shot. Stop motion can be two-dimensional or three-dimensional in format, and includes techniques such as oil- or sand-on-glass animation, two-dimensional cut-out animation, puppetry using stringed or silhouette forms, and clay animation.

2D stop motion

There are several ways of working two-dimensionally in stop motion, each essentially applying the principle of incremental movement effected and recorded by the animator, creating a frame of film. Animators have experimented widely with simple malleable media to striking effect.

Sand and oil-paint animation

Applying oil paint or sand on to a glass surface allows the animator to draw with, inscribe into, or in some way manipulate the materials on a surface that is non-absorbent. Both materials are useful to animate with: dry sand can be worked endlessly and oil paint remains wet under lights that become increasingly hot, allowing the animator time to draw or paint. Shooting each movement from above using a suspended camera attached to a secured

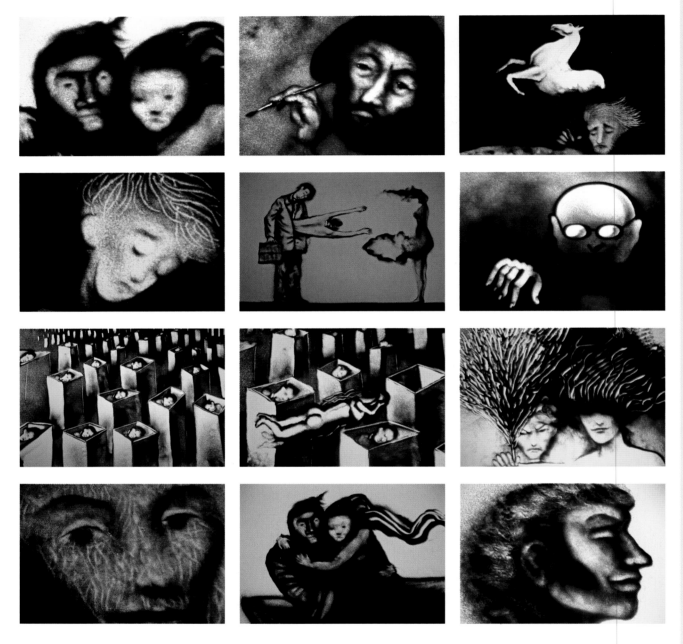

metal framework – known as a 'rig' – makes for a rewarding working method. It allows important acts such as metamorphosis to occur. It is also possible to film more than one layer at once in a single frame by adding other layers above or below the original. In this instance, the animator needs to determine which parts of the lower layers are going to be obscured. This process effectively enables limited animation to happen without the need to redraw a whole new frame. An example might be where a character's face appears in shot, but the only movement is the eyes looking left and right, so only the eyes need to be animated through the next few frames.

Working with transitory materials such as paint or sand on a non-porous surface creates interesting opportunities, illustrated here by Ferenc Cakó's film, *Érintés [Touch]* (2009).

Simple paper cut-outs

Allied to the idea of working with layers, the process of paper cut-out
animation can be used to striking effect for relatively little effort. A technique
best employed where only simple or limited incremental movements are
required, it is both a cost- and time-effective method of creating a credible
and believable animated result. Famously employed by Terry Gilliam in the
animated sequences of *Monty Python's Flying Circus*, the technique uses
pieces of paper, card or cloth that have been cut, torn or folded and placed
on a surface where they can be manipulated and recorded frame-by-frame.
To create a character using such a technique the animator must create a
series of heads, torsos and limbs that can be placed, removed and replaced
by others incrementally to create a desired move. The greater the number of
interchangeable parts, the more sophisticated the movements can become.

However, the process does require great craftsmanship and a mastery of
technique to manipulate the limited elements convincingly so that they can
be read correctly in motion. Those willing to attempt the technique must
be organized in the way that scenes are constructed and recorded and
need to pay particular attention to the way movements are planned, timed
and documented, as mistakes are difficult to correct in post-production.
The rewards of using the technique are revealed in the works of many
wonderful artists who have imaginatively and enthusiastically embraced the
process. Examples include the veteran Russian Yuri Norstein's masterpiece
Hedgehog in the Fog (1975) and British animator Oliver Postgate's collection
of children's television series such as *Ivor the Engine* and *Noggin the Nog.*

The late Oliver Postgate with fellow creator Peter
Firmin was responsible for creating some of the
most endearing children's animated television
series, including *Ivor the Engine* (above), *Noggin
the Nog* and *The Clangers.*

3D stop motion

This technique simply enables three-dimensional forms to be created,
manipulated and captured. The process is complex but is rewarded by
the potential to achieve magical results, since every element within the
frame will have been crafted to match the creator's expectation. Sets, props
and characters are imaginatively constructed from a variety of materials to
make full use of the spatial possibilities of this kind of format. Meticulous
preparation is required to dress the set for shooting, successfully manipulate
the elements within the frame to indicate movement, and also control
conditions around the set itself to ensure stability and continuity. Stop
motion as a technique encompasses areas such as puppet animation,
clay animation (also known as 'claymation'), model or object animation
and go motion.

Armatures

Where figures require manipulation to suggest movement, an armature is
needed to act as a strong skeletal framework. The armature can be made
from any material that is sturdy enough to support the weight of its body
material. Armatures can be bought or individually crafted, but much will
depend on the kind of movement the figure is anticipated to make. Small

movements may only require certain parts of the figure to move, but full-scale movement will ultimately mean the armature will need to be finely engineered.

Simple armatures can be fashioned from wood, which has the advantage of being easily shaped and joined but has limited durability. A more robust choice is an armature made from metal such as aluminium, which is light, strong and reliable – an important consideration given how many thousands of potential movements will need to be created to animate a production. These armatures are normally movable using ball-and-socket joints that allow for a variety of poses and holds to be staged.

This sequence of images from *Madame Tutli-Putli* shows the creation of the armatures and puppets used in the film, working from a twisted wire construction and using custom-moulded parts to authentically create original characters.

Puppets

A puppet is a representation of a human or animal form, or an inanimate object, that is manipulated by a puppeteer to animate movement. Animation has had a long and successful association with the puppet form, particularly in the Eastern European tradition of toy-making and puppetry through the talents of Jirí Trnka and George Pal. Trnka lived in his native Czechoslovakia all his life and created the masterpiece *Ruka* (*The Hand*) (1965) where a puppet interacts with a live hand as a tale is told of oppression and censorship using deft but hugely loaded figurative movements. Pal escaped Nazi Germany for Hollywood, where he invented the 'Puppetoon' for Paramount through a series of stop-motion short films and also created special effects for films such as *War of the Worlds* (1953).

Historically, puppets have been used as props to tell stories or explain myths and legends in many forms throughout the world. From the carved wooden Bunraku puppets developed in Japan in the seventeenth century, through to simple cut-out 'shadow' puppets that form silhouettes against lit backgrounds, to hand puppets such as Punch and Judy where the character

is worn like a glove by the puppeteer and fingers inside are used to indicate movements, puppets and marionettes have been central to an audience's understanding a creator's intentions. Animators Vladislav Starevich, Willis O'Brien and Ray Harryhausen are pertinent examples of creators who have achieved global critical acclaim for their productions featuring puppet animation, the latter two combining their artistic and technical prowess to create *Mighty Joe Young* (1949). The tradition continues today with such animators as Britain's Barry Purves, whose film characters display a remarkably complex but educated affinity with figurative movement.

As previously noted, puppets can also be object-based, enabling creators to explore surreal worlds beyond the seemingly feasible and to deal with deeper and more complex spiritual or psychic behaviour. For example, the Czech animator Jan Svankmajer has centred much of his work around interpreting the meaning of dreams and memories, often using objects as motifs to embody and crystallize wider philosophical ideas. *Street of*

The Brothers Quay film, *Street of Crocodiles* (1986), pays homage to Eastern European animation traditions.

Eastern Europe has a rich and varied tradition of puppet animation, influencing many contemporary animators in other parts of the world, such as Liz Walker's Invisible Thread company in the UK.

PLUCKED
a true fairy tale

WASHPIT
HOLMFIRTH
STUDIOS

Crocodiles (1986) by the Brothers Quay (comprising Americans Stephen and Timothy Quay), adapted from the Bruno Schulz short story, is a good example of an object-based surreal world, where a figure is trapped inside an old machine that is shared by other objects that alarmingly come to life.

Unlike conventional actors performing on a stage set, puppets are able to walk a proverbial tightrope of possibilities, projecting an air of believability while performing movements that in human form are restricted or impossible to achieve. They can be moved simply by one person who uses their skill to portray the movements of the character, or by a team of puppeteers working together to express more complicated acts. Usually, the puppeteer will remain out of shot and direct the puppet using a system of strings, rods or even remote control. However, in some cases, the puppeteer(s) can become integral to the scene, as illustrated by Guilherme Marcondes' *Tyger* (2006), which uses a mixture of live-action film of the puppet tiger being manipulated superimposed over computer-generated animated sequences and original photographs.

Guilherme Marcondes took the unusual step of employing puppeteers as actors in his film, *Tyger* (2006), who are intrinsically connected to the very fabric of the film by amplifying the movements of the puppet tiger.

Beyond the facility to articulate movement, puppets also have the great advantage of being able to be constructed to different scales depending on the 'stage' on which they will perform. Their features can be scaled up and engineered to provide movements, while other parts of the body of the puppet remain dormant. This allows key movements to be articulated that can give the greatest resonance to a character, while still maintaining a sense of believability and harmony in the overall design.

One of the most famous historical examples of innovative puppetry in animation exists in Gerry and Sylvia Anderson's original *Thunderbirds* television series, where the process of 'Supermarionation' is employed to animate characters. The term is derived from the words 'super', 'marionette' and 'animation', and the process involved an ingenious mixture of traditional marionette wired movements combined with synchronized mouth movements driven by tiny solenoid motors inside the puppets' heads. These motors were triggered from an electronic signal on the prerecorded tape of the actor's voice. However, while the heads and arms may have articulated relatively complex movements – being the most expressive parts of a puppet character – the legs and main torso appeared static and were often disguised using poses that would not showcase their deficiencies. Puppets requiring several puppeteers to manipulate them clearly require great technique and communication skills and an exemplary understanding of exaggerated continual movement.

Having a series of pre-sculpted heads that are interchangeable saves valuable production time and offers extensive creative possibilities while on set.

Clay animation (claymation)

Pioneered by the work of animator Helena Smith Dayton, who was working with clay in 1917, and illustrated to dramatic effect by the work of Bob Gardiner and Will Vinton in their Academy Award-winning film *Closed Mondays* (1974), and more recently by Aardman Animations in the United Kingdom, clay animation, or 'claymation', has been used widely from feature films to commercials. The use of modelling clay (Plasticine) provides a pertinent example of a 'hands-on' approach to animation, allowing figures, props and sets to be sculpted and manipulated to create movement at low cost and with maximum flexibility. Sculpting and modelling by hand ensures that the final production is imbued with a degree of authenticity and craft.

Simple clay animation can be created instantaneously, as the properties of the medium allow the weight of the clay to support surprising movement possibilities. For more complex productions, using an armature as a base is a necessity. Characters can be built up, modelled and remodelled in clay endlessly until the desired effects are achieved. During the process of animating itself, variations to body poses and facial gestures can be easily sculpted thanks to the pliable and forgiving nature of the medium. Animators often have a series of heads, limbs and torsos that can replace the current one, both to speed up the process and to avoid unnecessary drastic remodelling.

5.

Model and object animation

These processes are commonly used in conjunction with live-action film-making, where aspects of the scene that cannot be filmed in real time are artificially constructed, manipulated and edited into the live-action footage. A good historical example is Ray Harryhausen's *Jason and the Argonauts* (1963), where armed stop-motion animated model skeletons seemingly grow out of the ground and attack the live-action Jason, played by actor Todd Armstrong. The battle scene, which lasts four minutes, took Harryhausen nearly five months to produce.

Go motion

Go motion was invented by Phil Tippett at ILM (George Lucas's Industrial Light and Magic) originally for *The Empire Strikes Back* (1980) and was used extensively in the film *Dragonslayer* (1981). Connected to stop-motion principles, this method relies on the process of 'motion blur' created using techniques between frames of film that nullify the stops between frames. Animators move a model incrementally during the exposure of each film frame, producing a motion blur. The crucial difference between the processes is that while stop-motion frames are made up of stills taken between the small movements of the model, frames in go motion represent images of the object taken while it is moving. This approach is usually created with the help of a computer, often using rods connected to the model that the computer can manipulate to reproduce movements programmed in by the animators. It has now largely been superseded by CGI technology.

Sets and lighting

Even the most simple stop-motion sets are often elaborately designed, and their creators pay painstaking attention to detail to ensure that every aspect of the design works efficiently, showcasing scenes in ways that are convincing and often imaginatively remarkable. In a production, members of the crew will be specially chosen for their design and construction ability, both in relation to the physical materiality of the set itself and for the crucial lighting design that works hand-in-hand to achieve the desired unity of finish.

Set design

In practical terms, the set has to be stable and solid, but must also have scope for expansion and be able to be manipulated from different positions as required by the director. Understanding the scene outlined in the storyboard and masterminding a design that can incorporate all of the action that will take place within that scene are paramount. Thought needs to be given to the size, scale and proximity of the camera, or series of cameras if a more complex scene is required. Other considerations involve the placement of internal walls and dividers so that camera moves and shots are not impeded, the provision for lighting, and the placement of key props that will be used or referred to in a scene. Above all, planning needs to ensure that

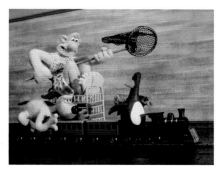

Perhaps one of the most complex stop-motion sequences ever shot, Nick Park's *The Wrong Trousers* (1993), sees Wallace and Gromit engaged in an epic pursuit of Feathers McGraw.

Stop-motion animation relies on teamwork and communication, with lots of animators working in tight, confined spaces at any one time.

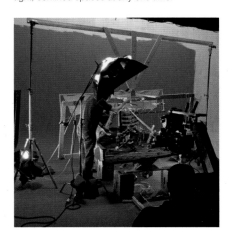

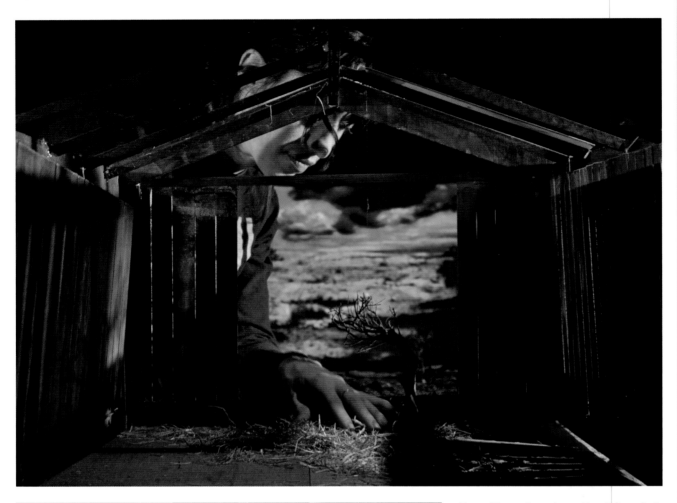

Above Stop-motion sets need to satisfy aesthetic and practical requirements, so designing entry points is important to aid accessibility, while ensuring continuity in the shooting sequences.

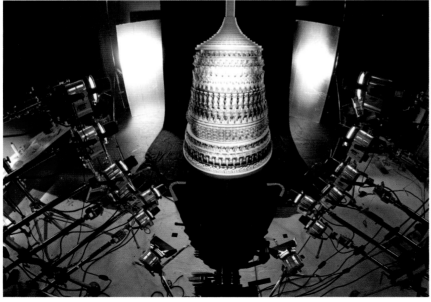

Left This image demonstrates the complexity and scale of a stop-motion set, requiring its own studio and extensive lighting rigs that can be easily manipulated and changed by the crew.

the animator is able to reach into the set and manipulate the characters without accidentally moving other aspects of the filmed frame, and that the camera can move back sufficiently to allow an establishing shot without capturing superfluous material beyond the limit of the set.

Sets can be built at a variety of heights depending on needs and conditions. Generally, it is favourable to have the set built at a height that allows maximum flexibility but that promotes comfortable working conditions for the crew, given the number of hours they are likely to be filming. This set-up also allows trap doors to be built in larger sets, giving animators more accessibility to move props. The set must be as temperature- and atmosphere-resistant as possible, usually best achieved using an indoor environment. This also allows lighting to be carefully orchestrated on set to remain consistent and reliable, and to avoid casting unnecessary shadows that could detract from the overall feature.

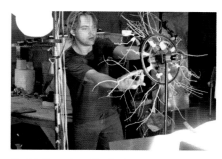

Maciek Szczerbowski adjusts a custom-created lighting rig on the set of *Madame Tutli-Putli*.

Lighting

Lighting design is frequently undervalued by the audience, but is a highly prized skill among the production crew. It requires technical prowess to think ahead and plan how lighting will best optimize a scene, but may also involve some immediate creativity to overcome structural problems. Different lights and positions create variety for the director in a single scene.

On a basic level, stop-motion sets operate using three-point lighting: a key light illuminates the core focus in the scene, usually from slightly to one side to appear natural; the fill light compensates for the shadow cast by the subject from the key light; backlights are employed to distance the subject from the background and are usually hidden between the subject and the background to minimize the possibility of unwanted shadows being cast. The intensity of lighting can also be controlled to suggest different conditions or evoke particular emotions. Sets bathed in strong light are described as having 'high-key' lighting, whereas subtle depictions are considered as being 'low-key'. Specialized variations of these core principles can be applied according to the director and lighting designer's instructions to give extra dimensions to the sets.

Construction materials for sets and props

Despite often meticulous planning, there is still an element of uncertainty involved in the construction and modelling of sets. As designs mapped out on paper are translated into three dimensions, hybrid solutions are often employed to construct sets and build supporting props. It is essential to experiment with materials, processes and techniques to best represent ideas concerning surface properties, in order to achieve believable representations of products. It should be remembered that where the production is being used in an advertising context, many clients require their products to be displayed outright and this needs to be borne in mind throughout the development process.

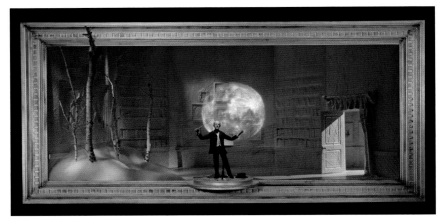

Extensive research and testing of materials goes into the construction of an animation set, to create an environment that befits the production.

Most sets are constructed around a wooden framework and glued and screwed together for strength and durability. The outer panelling of the stage set itself is often fashioned out of plywood as this is relatively light but sturdy. Plywood can also be quickly removed or applied using a system of dowel rods and holes to give flexibility to some shots where changes in camera angle might be required. Foam board and high-density core board also offer possibilities for filling and modelling surfaces, as they can be easily fixed and shaped using simple tools and mistakes are easy to rectify.

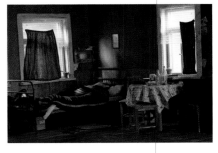

Hours of painstaking work is required to manufacture each individual prop to perfection to add believability to scenes.

Using a metal foundation, such as perforated steel, as a floor keeps a set rigid and has the added benefit of acting as a magnetized surface, which allows props and characters to be positioned accurately, holding poses without the aid of supports. The floor's surface can easily be disguised or covered to resemble other materials as required yet still allow magnetism. Other forms of 'tie-down' systems for holding characters in place on a set include wire loops or spikes that can be threaded through the floor of the set, screws for more substantial models, or low-tack adhesive agents where models are lightweight. Each requires experimentation to determine the best suitability for purpose.

Ingenious solutions are often required to create props to furnish sets. Props makers go to extraordinary lengths to source a wide variety of materials and test these out through exhaustive processes to make objects appear real. Using sculpting products such as Sculpey, Fimo or Milliput, it is possible to cut, mould, shape and texture using a variety of hand tools, and then bake the props using a household oven. They can even be painted for extra effect if necessary. A larger item, such as a flag on a pole, might have its own simple wire framework if it is to suggest movement, or if the join is load-bearing. In some cases complex props have their own armatures to allow movement where necessary. Where multiple props are required, such as a row of football boots, a simpler solution may be to use a silicon mould filled with fast-cast resin.

The central issue that is applied to all props is one of believability of scale. In a set situation, clearly each prop needs to feel like it belongs in the scene.

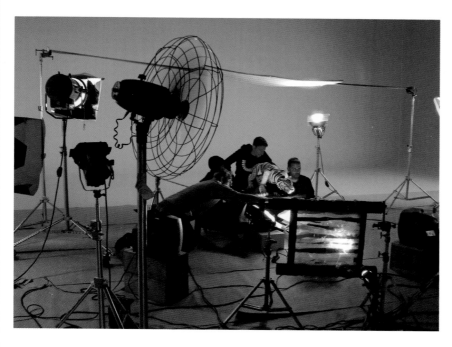

On the set of Guilherme Marcondes' *Tyger* (2006), the crew check each movement of the puppet on the facing video screen.

Nonetheless, in shots that offer a close-up of the character interacting with a prop, such as pouring tea from a teapot, it may well be more appropriate to work in a larger scale to show more details – such as labels, patterns or surface textures – and to scale up the character's hands in proportion to compensate.

Checking the filming of stop-motion animation

As 3D stop motion is a slow process requiring many separate actions to facilitate movements, it is important for the production crew to check filming as it is being recorded. Studios use a system called 'video-assist', which shows the scene being filmed on a television monitor, flattening the three-dimensional set into a two-dimensional image. A video camera is mounted on the studio camera viewfinder, at the same lens angle, ensuring that the production crew see exactly the same shot that the studio camera is seeing. Animators can then examine movements of the figures by directly tracing on to the monitor screen using a water-soluble pen, checking whether these movements flow correctly by imitating the principles of anticipation, slow ins and outs and so on.

Using a parallel computer-based video recorder, the image is viewed on the studio's digital frame store, which looks like a small video mixing desk. It stores the last shot image and compares it to the one about to be shot. A slider control allows the crew to gently mix between the two images, ensuring details are correct and spotting any mistakes, such as unexpected movements with the characters, props or set. Increasingly, digital stills cameras are employed as the technology has developed significantly in a short space of time. The recorded still images are stored on a computer

attached to the video-assist, allowing the animator to add or delete frames during production. The crew are able to employ 'onion-skinning' during shooting, checking several frames in unison using semi-opaque layers to determine the best sequence.

3D computer-generated images

Animation has enjoyed a long tradition of experimenting with emerging technologies and animators have been quick to seize on the creative possibilities that computer-generated imagery enables. As a result, there has been a significant digital shift, which has been felt in three-dimensional animation as well as its two-dimensional counterpart. Such emerging technologies have been capitalized upon both by creators already interested in animation and by users who have seen the possibility of telling stories or exploring ideas that were previously difficult because of a lack of knowledge or opportunity. Inevitably, pioneering work in the field has encouraged some to work in tandem with software and hardware industries to develop new products, such as Dragonframe, that can push the medium forward.

3D computer-generated animation merges stop-motion animation and frame-by-frame animation by allowing animators to create and manipulate worlds in which characters and environments are constructed as mathematically-rendered data. Like stop-motion animation, three-dimensional computer-generated imagery is predominantly created in an artificial state, and every aspect of what is seen on screen needs to be constructed. This primarily includes characters, props and sets, but also involves how these elements are painted, lit and positioned, and indeed, how they move. Animators working in this field, therefore, need to have not only complete knowledge of the programs they are using to create the production but also a significant awareness of cinematography, movement and narrative techniques to bring ideas to life. While different programs offer myriad approaches to designing, producing and outputting three-dimensional computer-generated creations, the basic operational sequence of production involves designing and modelling, creating a framework or rig, animating and lighting, applying surface textures and colours, adding special effects, rendering and compositing the material, checking and touching up any inaccuracies and finally outputting the material ready for distribution (see pages 173–77).

Designing and modelling
Designing and modelling a character on screen may require different kinds of physical skills, but the intellectual approach to describing, developing and testing shapes is similar to conventional means. A basic shape on screen can be created by establishing a point, known as a 'vertex', and then plotting another vertex in a different location. The computer connects the path

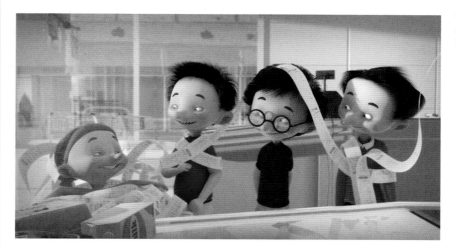

Technological advances have enabled the realistic simulation of hair and skin, which are notoriously hard to recreate.

between each vertex with a line known as a 'vector'. Subsequent vector lines define squares, rectangles and triangles that can be pieced together to create the properties and contours of the imagined shape. These shapes can also be joined together to create the basic model. And like stop motion, virtual armatures can be created inside the model to be coded to perform particular roles in the production if necessary.

Rigs and texturing

With the basic model assembled virtually, more complex adjustments can be made throughout the process by clicking a vertex or vector and dragging it across the screen to a desired position through a process known as 'rigging'. Rigging provides the ability to finely adjust the virtual model, but it also enables a series of connected moves to be established through parenting objects. This effectively groups together shapes and enables animators to mimic real-life actions by anticipating or following on actions. With rigging complete, the animator can begin to colour and texture the virtually modelled object, applying surfaces that give added information and authenticity to the shape.

The transparency and opacity of coloured and textured surfaces can be altered using alpha channels. These are graded controls, created in the computer program, that allow the animator to try different visual description options to give maximum versatility. In recent years, imaging technology has developed to simulate more natural properties like fur, hair and skin, but identical matches with real examples are difficult to achieve and are, perhaps, overrated. Instead, the animator's ability to ingeniously improvise and experiment with importing surfaces into the computer program can pay handsome dividends in creating unique and specialized results that interpret situations and circumstances more convincingly on screen than a faithful rendition.

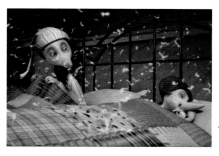

Exquisite lighting design in this frame plays on the sense of anticipation and wonder in a dreamscape environment, as Marc Craste directs a television advertisement for The National Lottery in the UK.

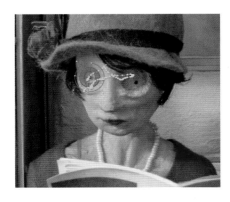

Animating and lighting

To animate convincingly, the virtual environment needs to be correctly staged just as in any other animated process. The spatial properties of the set and character design, and their relationship with each other, must be considered in tandem or the results on screen will seem awkward and forced. The animator first establishes a path in virtual space with a start and end key frame where the character will move from and to, calculating how much time will be required to deliver the move. Using these key frames and processing the time required to enact the movement, the computer simulates the action by in-betweening the missing frames.

Lighting design, established as being important in traditional stop motion, is crucial in a digitally rendered environment. Here, the animator has the luxury of not having to worry about the physical weight and bulk of a real lighting rig and instead can move the virtual light source to any position without restriction. Key and fill lights can be dragged to various positions and can equally be used in multiple configurations to amplify the key components of an overall scene. This can create really atmospheric and surprising results if used intelligently, but can also seem unnatural and glaringly wrong if the animator does not have an empathy with the subject. Experimentation and testing are thus key.

Visual special effects, rendering and compositing

Despite the multiple tools at an animator's disposal in the shaping, texturing, colouring and lighting processes, the application of visual special effects gives production crews an extra set of tools to authenticate a project with unique structural and atmospheric attributes. Custom-made visual special effects are invented to simulate everything from violent thunderstorms to spring blossoms, and from explosions to the glow of a candle. Major animation studios occasionally employ visual special-effects studios, such as George Lucas's influential and celebrated ILM, to specifically create effects to give their work an added dimension. For example, Steven Spielberg's film *Jurassic Park* (1993) was the first time ILM's digital visual special-effects technology was used to depict a complete and 'living' detailed creature.

Once designed, visual special effects produced for characters, sets and props are rendered, along with all of the previous processes, to blend them together creating an overall visual outcome. The rendering process ranges from relatively simple processing of data for independent productions right the way through to industrial studio-sized render farms where banks of computer processors harness the colossal processing power required to blend the layers of information together. The compositing process takes all the visually recorded material (such as characters, props and sets) and merges them together with aural components (such as dialogue, soundtrack and sound effects) in the order that the audience will see them. This shows up any mistakes, which are then touched up before the material is distributed.

Opposite The application of visual special effects gives a production an added dimension, helping to achieve the director's vision by intensifying the atmosphere and creating theatrical drama.

Unorthodox animation

Experimentation with creating artificial forms of movement and recording them has given artists plenty of opportunities to explore the medium of animation. As a testimony to this, the range of unorthodox processes continually expands, incorporating ideas from advances in technological innovation, cultural awareness or scientific advancement. Unorthodox animation might encapsulate the re-programming of games or devices to create animation or to showcase it in an unexpected venue or surprising situation. Examples of unorthodox processes include pixilation, brick animation, auteurist or artistic approaches, performance, live-action/animation hybrid productions, installations, Machinema and augmented reality.

Such developments are enthusiastically embraced by the animation community and continue to make the subject evolve in culturally rich and diverse ways. Unorthodox works are occasionally screened by national broadcasters, but with the growth of the Internet have quickly and inevitably established a cult fan base online, and also at the various international animation festivals.

Norman McLaren's experimental work, represented here by *A Chairy Tale* (1957), marked him out as being an important figure in the field, and he eventually founded an animation department at the National Film Board of Canada.

Pixilation

Exemplified by the work of such artists as Norman McLaren through films including *Neighbours* (1952) and *A Chairy Tale* (1957), the technique of pixilation allows the creator to use a natural subject such as a human form but manipulate it to perform in stylized ways that are surprising or unexpected. By moving the real-life subject incrementally, and shooting each incremental hold of a pose as a frame, the animator is able to build a sequence that seems to move when played back. These incremental moves may be recorded by still or moving image cameras, and the frequency of captured movements, together with their resulting playback, can communicate ideas in ways that live action cannot. Filming and playback speeds can be determined before, during or after motion capture by the animator. A parallel understanding of technology, and an ability to communicate with the actor or subject, is highly desirable.

A variation of this technique, known as variable-speed cinematography, allows the operator of a moving picture camera to record movements at a speed of their choice. A good example of this technique is time-lapse imagery, where a slow-speed camera is positioned to collect real-time imagery, while the resulting footage seems to speed up when played at normal speed. A commonly used example in live action is the depiction of changes in atmospheric conditions leading up to a rain shower or storm.

Brick animation

Simple, cheap animations can be created using children's building bricks to create scenes and then shooting individual frames as stop-motion sequences. The building bricks have the advantage of having a versatile

fixing mechanism that ensures that the models will stay in position throughout shooting. They can be customized in various ways, including by painting or drawing designs on to the surface, by changing the shape and form of the blocks, or by projecting other images, lights or shadows on to the models to create layers of meaning for the audience. Software enhancement also opens up the possibility of adding additional computer-assisted drawn elements and special effects in post-production. From humble beginnings, these films have a cult following all of their own, and many creators have films screened at festivals either based on their own work, or as highly accomplished pastiches of other works, including George Lucas's *Star Wars* (1977).

Auteur or artistic processes

Describing work as 'auteur' (French for 'author') signals the recognition that a defined and charismatic attempt has been made by the creator to imbue their own creative direction and style on a production. Originally coined as a term by film theorists in the 1950s, it champions the idea that the creator or director of the production wields influence in the same way that a writer does through the penning of his or her thoughts. As far as animated processes of production are concerned, the term 'auteur' more usually identifies work that is celebrated as being unconventional and innovative, shaped by the intervening hand of the creator. It covers a huge range of narrative, conceptual and ideological approaches that apply equally to vision and sound.

Auteurist creators have discovered they can add their own imprint to animated productions through manipulating film by cutting, scratching, drawing or painting images on to the surface. Equally, additional representative or even abstracted pictorial elements can be incorporated

German-born exponent of silhouette animation, Lotte Reiniger, took three years to produce *The Adventures of Prince Achmed* (1926).

by collaging found materials, or splicing (cutting and rejoining) previously exposed film footage, to communicate realized or abstracted ideas.
Art and craft techniques such as batik, engraving and stencilling are just a few examples of the spectrum of processes that can potentially work on film. When projected, they give an altogether different and visually arresting result. Recognized influential exponents of auteur animation include animators Len Lye, Lotte Reiniger and Robert Breer. These artists championed pioneering approaches, pushed the boundaries of the form and celebrated the marriage of fine art and technology as an important aspect of animation production.

Performance animation and live-action hybrids

Animation enjoys a successful history of engaging with performance and theatrical events, in both originating and interpretative capacities. Stories are vividly brought to life with immediacy and some degree of improvisation, projecting a sense of awe and magic. A noted historical example includes Winsor McCay's live engagement with his animated character Gertie the Dinosaur on stage as part of his vaudeville shows in 1914. The performative nature of the production consumes the audience as an integral part of the theatrical space and demands some form of engagement.

The opportunity to mix live action with animation is not solely confined to major studios, and there are numerous examples on the independent circuit of animators experimenting with such hybridization, often piecing together material shot on commercial hand-held digital video cameras with animated interjections. Liz Walker and Gavin Glover's Faulty Optic company played with the audience's perceptions of theatre and choreography through often bizarre but heart-warming enactments.

Winsor McCay drew 10,000 illustrations and photographed each of them to create *Gertie the Dinosaur* (1914).

Animation and live-action performance are routinely employed by Liz Walker in her performances, including *Plucked*, which was created in her more recent role as artistic director of Invisible Thread.

Experimenting with 'living painting', Robert Seidel merges explorative imagery with ambient music at the Phyletic Museum in Jena, Germany.

Installations

Several animation film festivals have experimented with the concept of installation animation, thereby bringing art to the public sphere rather than using conventional means of showcasing work, notably the Platform Animation Festival in Portland, Oregon, in 2007. The process exposes animation to different potential audiences and allows featured work to exist in a different scale and surroundings from that originally intended. Installation animation works most successfully where it incorporates some form of audience engagement or interaction, and is becoming more commonplace

for such places as museums, galleries and information centres to explain their exhibits, especially where factual knowledge is still being uncovered. A good example of installation animation might be a planetarium, where images of planets, stars and faraway galaxies are projected into the viewing arena, simulating space travel.

Machinema

Computer games and animation share a number of common attributes, including artificially created worlds, characters and storylines. More fundamentally, many creators of animation have cut their creative teeth in the world of computer games design, or have found animation through playing some form of computer games. The two disciplines have many creative, technical and cultural crossovers.

Machinema exploits these similarities by essentially borrowing scenes, characters, props and even entire sets from computer game engines and using the tools inside the computer game, such as changes in camera angles and editors, to subvert the original meaning of the game into something wholly different. This can be achieved by, for example, reordering scenes, aping environments and transporting game characters into other game worlds. Games such as *Grand Theft Auto*, *Quake* and *The Sims* have all been used by Machinema animators as the basis for their own work. As a note of caution, copyright laws sometimes make the legal copying of material problematic, and some films made using this process have been stung by legal demands from games companies.

Augmented reality

An exciting possibility for animation, augmented reality effectively allows creators the opportunity to modify the audience's real-life view, using animated virtual computer-generated imagery. Augmented reality is an immediate interactive facility that merges real and virtual information in a three-dimensional viewing area. The technology is being explored by both individual creators and major corporations for products and services as diverse as enhancing retail environments, selling properties to interested buyers, supporting museum and gallery interaction and even teaching medical students in the middle of clinical procedures.

Augmented reality can be seen to good effect on many personal digital assistants (PDAs), including Apple's iPhone 4, which uses a global positioning system (GPS) and solid state compass to present a view of what the user can see in real time, regardless of his or her pose. Using layers of information, such as statistical data, collected imagery and other available footage, the device enables a real worldview to be supplemented by interactive 'live' information. An example of this is a televised swimming race, where a world-record pace is established for a viewer by a virtual line that seemingly moves on the pool surface, allowing viewers to measure the real swimmer's progress against a known measurement of time.

Sound in production

In pre-production, sound can be a standalone or an integral catalyst for an animated project. An animated documentary might be based around recorded interviews gleaned in the research and conceptual phase of a project, while an animated music video will have a demonstration (demo) track recorded for reference. These recorded sounds become the basis of the first animatic, building the foundation for the gathering of more reference to be incorporated into later animatics as more direction over the production is exercised. In other instances, some test recordings are made of passages of scripted dialogue or narration for creation of the animatic, and a rough working musical score, known as a temporary (temp) track, is written, performed and recorded. These sound recordings also sometimes provide the starting point for characters to be developed, while occasionally they act as invaluable evidence that the tone of the actor's voice is not right for a particular role and needs changing or recasting.

The animatic is reincarnated over and over again, producing many variables in terms of visual information and instructions to the crew concerning camera angles, which invariably change depending on the director's (or commissioner's) view. However, the variations do develop through decisions made by the director and facilitated by the crew and the animatic will, at the very least, have its timing approved and confirmed. This allows the sound editor to charge the sound engineers with the job of fitting dialogue and/or narration, music and special effects to the scenes. Each stem of every scene is carefully edited, mixing the sound details, playing back the recording and checking for any mistakes or inaccuracies. The meticulous task of processing the information received, from fine-tuning down to the final edit, and against budget schedules and production timelines, is now being prepared for output onto the right format for post-production.

Simple sound design used economically can grammatically alter the pace of a production, ensuring that key information is imparted to the viewer.

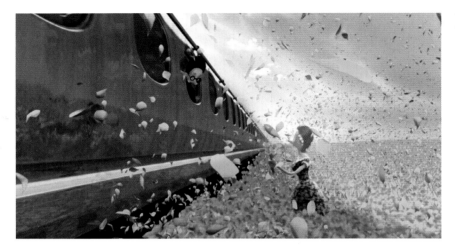

Conclusion

The process of creating an animated production differs depending on the technique being employed by the production crew. While some projects are reasonably simple and straightforward, many rely on mixing production techniques or on preparing animated sequences to be edited into live-action material, and it is imperative that the crew remain vigilant of the final expected outcome. This requires testing completed sequences by seeing them in conjunction with sound, making decisions about the progress of the animation and either altering or confirming the schedule and keeping the workflow on target, or reporting issues that need addressing. The director works with the production supervisor to oversee all the elements of production, managing the crew to keep on schedule and on budget.

Production is both an exciting and nerve-wracking time for many in the studio, but there is also a sense of excitement and anticipation about what is being produced. At this stage, it is sometimes necessary to have pre-screenings with production footage for specially invited audience members. These events offer invaluable insights into how well a story is being absorbed, and the crew will watch closely to see if characters have the necessary appeal to and resonance with the audience. If a product or service is being promoted, the director will carefully screen audience opinion about whether the commercial has the right tone of voice, trying to avoid obvious advertising but making sure the product or service conforms to the brand expectation and the aspiration of the commissioning agency.

Regardless of which production processes are employed, the production process is complete when the rendering has occurred and a final edit can be signed off by the director. This is known as the final workprint, and forms the solid foundation from which the post-production team work on tidying up the animation ready for release and distribution. The next chapter considers these processes in greater depth.

6.

Post-production signals the final phase of the animation project journey. The purpose of post-production is to integrate the image, sound and special effects aspects of the animation process into a cohesive package. This chapter introduces the nature and scope of the animation post-production process for the integration of visuals and sound effects, and considers the range of approaches that can be employed to alter the feel and potential scope of the project. It illustrates how this phase packages the animation into a relevant and compatible output format such that it can be handed over for release, distribution and screening.

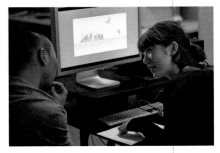

Discussions concerning post-production issues are held between an instructor and student at California Institute of the Arts (CalArts).

The animation pipeline in post-production

Unlike traditional film production, animation post-production is comparatively short as a process but can be time-consuming to complete. While much of the physical creation and manufacture of the animation has happened in the lengthy production cycle, post-production may be significantly longer in terms of time scheduled, depending on the complexity of work needed to prepare the animation for screening. The increasing variety of uses for animation, together with the developing viewing platforms available, require consideration to ensure the work meets the necessary technical, practical and critical expectations of the intended audience or target market.

The adoption of digital editing technology has enabled greater control over the post-production process for independent animators.

Digital processes have massively helped to streamline animated post-production workflow by allowing some editing, rendering and processing jobs to be centralized. In the digital age, increasing amounts of post-production occur in-house, while bigger-budget projects are sometimes sent to specialists to prepare them for screening. Where facilities exist to process a project in-house, considerable time and expense can be saved, while at the same time helping to preserve the director's vision concerning the authenticity and distinctiveness of the production. On a larger scale, many feature-film studios are increasingly using animation processes, especially in relation to special effects in post-production, resulting in greater facilities being required to render and process enormous amounts of digital data. Larger animation studios set aside areas that have become known as 'render farms', where many banks of computers process huge amounts of data for each feature film.

Preparing the production

The post-production process relies heavily on the observation, planning and technical skills of the crew, testing their attention to detail, tenacity and patience to make necessary changes to the production prior to distribution and release. This is the final opportunity for mistakes in the production to be corrected, by skilful editing of the footage through cuts, fades and transitions,

or, as a last resort, by reshooting certain scenes before the production is completed.

Managing post-production

The post-production crew are managed by the director and overseen by the post-production supervisor, who is sometimes known as a technical director. His or her role is to ensure that the completed animation is produced and packaged for distribution. The crew include re-recording mixers, who are responsible for checking and mixing the recordings of dialogue, sound effects and musical scores to ensure parity and fluency between sound and

Each spotting session determines which sound-effect components will be required, and they are logged in a report that describes the kind of sound required, the start and end points of the sound in the sequence and therefore the length of the sound required.

Sound Effect Spotting Record
Title
Sound Effect Editor

Date:
Page:

Sound effect	
Name	
Start Time	
Length	
End Time	

Sound effect	
Name	
Start Time	
Length	
End Time	

Sound effect	
Name	
Start Time	
Length	
End Time	

Sound effect	
Name	
Start Time	
Length	
End Time	

Sound effect	
Name	
Start Time	
Length	
End Time	

Sound effect	
Name	
Start Time	
Length	
End Time	

vision, and the foley editor, who decides what sound effects need adding in post-production to artificially enhance an action.

The first task of bringing the production to this conclusion is to gather the visual and audio elements of the production together. The director and post-production supervisor make creative choices about the project through 'spotting'. Here, observations are made about each aspect of the production, checking for parity between vision, sound and effects and noting any gaps or omissions, and also highlighting where the flow of the animation is stilted or disjointed. Notes are made about these 'spots', and tasks are apportioned to members of the crew with particular expertise in identifying and correcting the issues. The spotting notes in turn create a post-production schedule that is used to direct the team to edit, superimpose and exaggerate material using the various production tools at their disposal. If the problems cannot be rectified, it may be necessary for the voice talent artist to return and re-record a section, but these decisions must be balanced against the production schedule and budget. In a digital age, many problems can be fixed and smoothed over in post-production using software capable of blending elements together to create seamless transitions. It is important here to maintain objectivity and clarity, for the crew are aware that timescales are now short, budget constraints are pressing and both client and creative expectations must be achieved.

Visuals

The variety of animation production techniques has historically meant that material arriving at the post-production studio might be delivered in several formats, including inked and painted animation cels, photographs and assortments of developed film stocks. In traditional film-making, linear editing technically allowed the picture editor to control the composition of a production by physically cutting a section of film and splicing, or assembling, it on to another section, thereby altering the footage to achieve both practical narrative and emotional follow-through goals. In digital animation, in line with many television programmes and feature films shot digitally, the post-production process is commonly undertaken through non-linear video editing, using software applications such as Avid or Apple Final Cut Pro. The latter was used for Tim Burton's animated feature, *Corpse Bride* (2005).

Digital technology has revolutionized the post-production process, especially for productions in which cost and timescale are vitally important considerations. Where the animation process is directly captured in digital or processed to digital in production, efficient control can be exerted to rectify mistakes or review the work incrementally. The clear advantage of digital files is that information can be stored quickly and conveniently but crucially the files can be read instantaneously. Post-production software uses embedded 'codecs' that are designed to read the data encoded in digital files, and

provides extensive tools for shaping and controlling the material. Files self-evidently need to be organized, named and ordered using a method that is clear and understood between the production and post-production phases.

Non-linear editing

The clear advantage of using non-linear editing software is that the choice of editing tools available is maximized without damaging or compromising the original material. Historically, cutting and splicing film meant making irreversible incisions into the stock, both affecting the integrity of the original material and causing issues concerning its use and archiving in years to come. The job would have been undertaken by the negative cutter, who would work closely with the editor to cut a film negative precisely identical to the final edit. Traditionally, the film was cut using scissors and repaired using a piece of equipment called a film splicer and film cement. In recent years, the arrival of digital intermediates means that the skills of the negative cutter have been used to lift selected takes from rushes and composite them to reduce the amount of digital scanning required.

The Disc Cache feature in Avid Pro Tools HD 10 greatly improves system performance, essential when all visual and audio assets are being managed centrally.

Avid Pro Tools HD 10 is the fastest, most powerful version of Pro Tools ever released.

New non-linear editing software allows different video, audio and SFX files to be seen in clear layers as a timeline on screen. The post-production team work simultaneously, synchronizing their workflow through networked computers to ensure that everyone is viewing the latest version of the project. Their task is to piece together the various files, or assets, to provide continuity between the video, audio and SFX design streams, adjusting levels within each to elicit the feeling of movement and progression within the wider work. In short, their work predicates the synchronicity between design and action that is so vital to the animation being believed by the audience.

For an individual crew member, the process of non-linear editing allows a flexibility of actions in an easy-to-use format. For example, using the established principle of cutting and pasting, it is possible to find and isolate a single video frame swiftly in an imported video clip, cut it and transfer the frame to another part of the timeline without destroying, losing or modifying it in any way. This is known as a 'move' and is recorded by the program. In some instances, for example, with layers that need to be moved in a particular sequence through corresponding frames in a sequence, it may be necessary to perform multiple moves in batches, so the program manages this process by performing moves in groups. Extensive records are accumulated so that any individual or group actions can be read, analysed and undone by other individuals, or the crew as a whole, without affecting the rest of the editing workflow.

As the process develops, sections of data can be saved and stored as standard-definition broadcast-quality material, allowing different versions to be created to compare and contrast the subtle differences being engineered. Once decisions have been reached and signed off on the post-production schedule, high-definition broadcast-quality files can be created.

German experimental film-maker Robert Seidel's work is characterized by his continual fascination with blending art with science to examine issues of space and temporality, which has won him many admirers and awards.

Synchronicity

Achieving consistency between the often conflicting aspects of visual, aural and SFX is a challenge in post-production, especially with large numbers of people working on a project, and not necessarily all in the same country. To combat irregularities, an SMPTE time code is often employed, which denotes hours, minutes, seconds and frames that have elapsed in the production to provide continuity and parity to the editing process. The SMPTE coding helps time frame rates to recognize the variation that exists for different broadcast formats, since film and video have different playback rates (film 24 fps [frames per second] and video 25 fps) for the number of frames processed.

00:26:47:00

Hours (reel) Minutes Seconds Frames

The SMPTE is an industry-standard way of ensuring synchronization.

Colour correction

The colour timer (also known as a colour grader) is responsible for regrading film stock by altering, enhancing or subduing its appearance using photochemical or, more commonly, digital processes. The process of colour correction is required for a number of reasons. Variations in the quality of each frame can be adjusted to provide an overall balance and continuity, eradicating any irregularities. The process compensates for variations in the quality of production materials or studio conditions, by artificially returning the frames to their intended condition.

Crucially, correcting the colour through the digital grading process allows certain aspects of the image to be isolated and altered. For example, primary colour grading allows the intensity of reds, blues and greens (the primary colours), together with mid-tone or gamma colours and blacks and whites, to be manipulated first. Secondary grading concentrates on altering the hues, saturation and luminance in the secondary colours, namely cyan, magenta and yellow, and enables more subtle changes to be made.

Understanding colour

Hue – the property of a colour in the palette, determined by wavelengths of light.

Chromaticity (chroma) – describes the vivid purity of a single hue that has no other hues added to it.

Saturation – denotes the strength or weakness of the hue in certain lighting conditions.

Value – registers the brightness (high) or darkness (low) of a single hue.

Luminance (lightness) – measures the intensity of light per unit area of its source.

Tones, shades and tints – hues can be altered by adding greys, blacks or whites to make hues duller or brighter to the eye.

Canadian actor, Laurie Maher, is made up with motion-tracking markers so that her actions can be recorded smoothly.

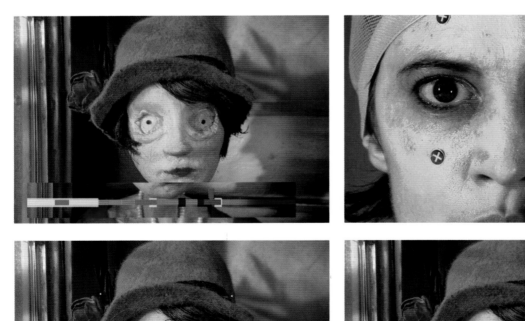

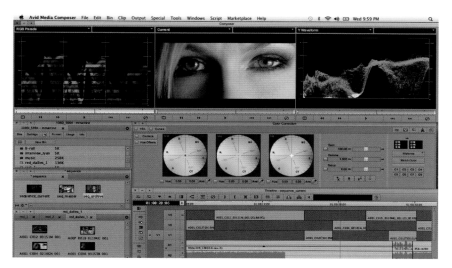

Avid Media Composer offers professional colour-correction technology in an easy-to-use graphic user interface.

Additionally, creating layers with mattes allows separate elements to be contrasted. A matte is effectively a mask that can be applied to a particular object or background as part of a layer. The matte blocks the particular object or background element from being seen or exposed and effectively allows other objects to be overlaid on separate layers, altering the composition and perception of the frame. It is obviously possible to apply mattes to many images that make up the overall frame, giving the post-production supervisor and crew the opportunity of making incremental but significant corrections to scenes where spotting has indicated that actions are required.

By using software such as Adobe Photoshop, it is possible to emphasize the presence of a certain object by changing its colour qualities against other pictorial elements in the composition, while equally toning down other elements to control the look and feel of the scene. For even greater dexterity and specificity over the process, motion tracking can be employed to isolate a particular component of a shot and make necessary adjustments, without affecting the whole frame. A good example of motion tracking occurs in Clyde Henry Productions' animated short film *Madam Tutli-Putli* (2007), where the central character's eyes are manipulated on to the stop-motion puppet in post-production.

Colour-correction technology essentially allows the mood of the production to be altered according to the director's overview of the process, as the desired visual atmosphere is sought. Historically, this process was centred in the photography lab, where the reel of film was altered by hand. Digital technology has superseded this method of post-production and files are increasingly altered in the studio colour suite, with such programs as Autodesk Lustre, Sony Vegas and Apple Final Cut Pro.

Designing title sequences is an important aspect of post-production activity and should be given sufficient attention, as they represent the outward face of the production to the audience.

Titling and credits

The title designer is responsible for designing the opening and closing titles and credits for the production. Animated productions, especially feature films, shorts and independent releases, have a good track record for producing title sequences that are inventive and memorable. A good animated feature example is *Monsters, Inc.* (2001), where the title sequence not only pastiches children's picture book illustration in terms of style, but also foreshadows the plot by mimicking the forthcoming chase scenes through the use of dynamic title credit transitions. Additionally, animated sequences have been frequently used to provide title sequences for live-action feature film and television productions to dramatic effect. Examples include Saul Bass's iconic titles for Alfred Hitchcock's masterpieces *Anatomy of a Murder* (1959) and *Vertigo* (1958), as well as Steven Spielberg's 2002 film *Catch Me If You Can*, with animated titles that reflect the playful nature of the content by Olivier Kuntzel and Florence Deygas (Kuntzel+Deygas).

Information concerning titles, credits and potential menu designs for DVD releases needs to reflect the agreed hierarchy of a production. This is achieved either through internal studio decisions or, in some larger productions, through agreed protocols with outside employers and unions. The title designer uses software applications such as Adobe Photoshop and Illustrator to communicate basic information, including the title and creators, as well as highlighting the main talents lying behind the production. The titles serve to provide a cue about the tenor and scope of the work, creating a sense of anticipation in the audience. In foreign-language films, subtitles may also require designing. They perform a vital role in helping the audience understand the plot, and can be used as a valuable support tool to help visually or aurally impaired viewers to appreciate the work.

Student independent animators sometimes overlook the importance of title sequences and credits, especially in relation to their timing and

placement. Titles must remain on screen long enough to be absorbed by the audience but not obscure important visual elements. Information not relevant to the title sequence should be reserved for the credits at the conclusion of the production. Again, in the end credits, the rules on establishing a hierarchy of information need following, but it is especially important to thank supporters and funding agencies if the work has been made possible by commissions or donations.

With the content edited and synchronized, the titles and credits added and the production quality approved and signed off, a final print can be made. The production is now ready to hand over to the sound post-production team to work on prior to release.

Sound in post-production

The post-production phase essentially allows the different sound stems – narration and dialogue, music and sound effects (see pages 112–24) – to be drawn conclusively together. Discussions about how the sound will support and enhance the audience's enjoyment and appreciation of the production fall to the director, post-production supervisor and sound editor and team. They recommend and schedule a workflow that will allow a soundtrack to be finalized.

Producing a soundtrack
To create an integrated soundtrack, the director needs to conduct a series of further spotting sessions. The director views the final film print with the sound editor, together with possibly a conductor, sound designer and sound-effects designer, depending on the scale and nature of the production, to determine where the stems that will constitute the soundtrack will be placed and plotted. These sessions may happen individually or collectively, depending on the production. The resulting conversations generate detailed spotting notes that

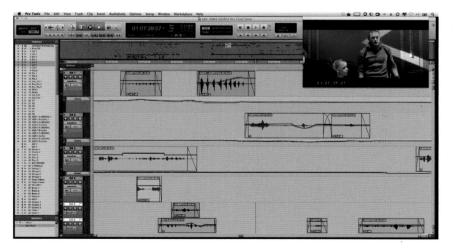

New features like Clip Gain dramatically save time while mixing in Avid Pro Tools HD 10.

form layered accounts of every aspect of the soundtrack, from dialogue, narration and music to special effects, creating an agreed workflow for the synchronization of post-production.

Premix

Each element of a stem is first mixed to create a premix. This allows the number of individual audio file assets to be reduced into, typically, eight-channel premixes, which are more streamlined, manageable chunks of audio information, illustrating where cleaning or re-recording is required. For example, dialogue and narration are synchronized to specific characters and objects. Meanwhile, music premixes divide the rhythmic, melodic and harmonic music recordings from the orchestral or man-made, while specifically designed recorded sound effects, and accompanying foley sound effects, are premixed together at this point.

Final mix

When the finished premixes are complete, they are played together with images for the first time in the final mix. Here, the director and sound editor make decisions regarding the specific balance and panning of the sound, matching them with the sequencing of images to create a pleasing flow, free of jumps and technical glitches. It is now important to condense the number of files down to a manageable amount, and this is achieved by 'mixing down' each music, dialogue and sound-effect stem to a six-channel output to enable clean mastering through global compression compliant with the technical output requirements of the destination of the final production. For example, mono mixes are used widely for 16mm films, while stereo mixes are sometimes prepared for festival screenings, compatible with the sound technology capability at most auditoriums. Increasingly, the standard for most output is Dolby 5.1, which is used for release on DVD, supported in

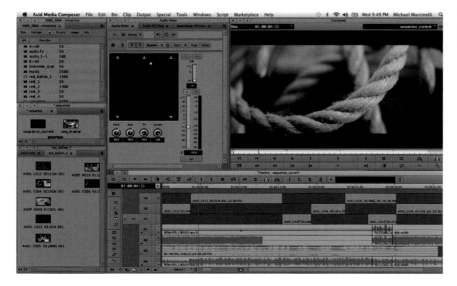

The final mix enables the director and sound designer the opportunity to place and shape sound in screen with the synchronized visuals.

most larger auditoriums and used for surround-sound experience in the home. The final mix allows the sound to be placed (panned) to different parts of the auditorium, enhancing the viewing experience by shaping the sound in synchronicity with the visual content.

Multichannel mixing

In the final mix, it is possible to separate or blend sound to create different characteristics and amplify the sonic experience for the audience. A two-channel mix essentially creates fields of sound on the left and right sides of the auditorium and, as they merge in the centre, a stereo sensation is achieved. Adding further channels deepens and intensifies the soundscape, panning sound to specific areas of the auditorium to maximize impacts, provide ambient sensations or impart deliberate sonic information. An example is the lower-frequency effects channel that is used to convey sounds such as tremors that build intensity and suspense.

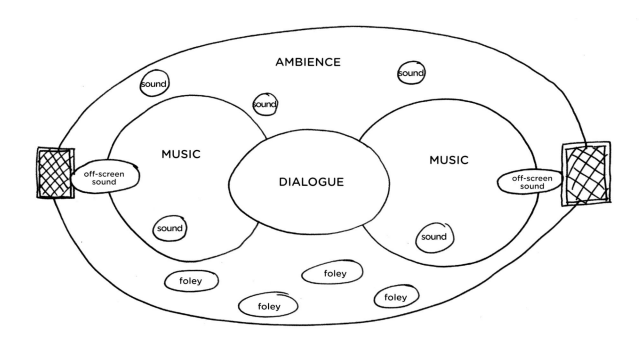

In this example of a traditional stereo mixing, dialogue is anchored in the centre of the mix with accompanying music panned equally left and right. Sound and foley effects are dotted into the mix at specific intervals to echo the actions taking place on screen.

Post-production panning

The final mix also offers the opportunity to pan sounds in synergy with the visuals on screen. This process is important as it helps establish a seamless link between the sounds and visuals by smoothing out any jarring. Two types of panning are used in animation post-production. A 'static' pan can be used to emphasize fixed sounds to a static shot. A 'moving' pan supports on-screen action. For continuity, dialogue is usually panned centrally, while music and special effects benefit from being more spatially panned, linking them to specific visual objects to evoke certain atmospheric moods and conditions, and to support transitions.

Digital mastering

The sound equivalent to colour correction, mastering processes the final soundtrack by equalizing the sound and compressing it ready for release. Equalization effectively filters final mixed sounds to a frequency that will be comfortable for the audience, and supports the format in which the production will be shown. Compression is applied to lower-frequency sounds to limit irritating sounds like clipping, where editing may not be completely smooth.

Formatting

The process of formatting prepares the production for its release format. Traditionally, mono formats were prepared, and occasionally exist today, for television and 16mm film, but the limited bandwidth and narrow frequency ranges, plus the desire for digital broadcast, have paved the way for stereo and multichannel formatting. The most commonly available stereo format is DigiBeta, a form of digital video, which is used for showreels and at festivals. Dolby SR (spectral recording) is also a popular format for festivals, since it can be used with both stereo and multichannel mixes, and is characterized by noise reduction applied on optical tracks to boost frequency. Digital video is used for DVD releases played with a surround-sound system.

This delightful animated short by Steve Small for the charity Sing Up uses minimal sound panning to create maximum impact.

Release and distribution

The release of an animation is akin to a book being published, but no one will see the work unless the prints are successfully distributed. The releasing and distributing of an animation production are controlled by the distribution manager. In an animated feature context, the distribution manager works with one or more distribution agents, who in turn represent the international distribution networks and media broadcast organizations vying to win contractual rights to show the animated production globally. In other instances, including animated commercials and television series where the client has commissioned work, the distribution manager liaises with the broadcast agents and creative directors to ensure smooth handover of the finished material.

Once an animated production has been approved by the director and post-production editor and supervisor, a master can be created, synchronizing the image to the sound to create an 'answer print'. This is transferred to either video or digital video, depending on the playback format, to create the 'print master'. For film releases, the print master is then sent away to a laboratory to transfer it to film, known as the 'release print'. Full production files can be compressed and sent using FTP (file transfer protocol) to remote server sites or through direct systems such as Telestream, which can stream large data files direct to clients, advertising agencies or broadcasters.

There is no universal standard video or digital video format. Instead, world regions have variations that need to be considered when preparing productions for release (although an all-region DVD format does exist), and there remain dangers of copying and piracy.

A distribution network is essential for getting work into the public domain and needs careful consideration by independent animators in particular.

Video and digital video formats

Video formats can be grouped in three dominant clusters:
PAL – Phase Alternating Line is prominent in the United Kingdom, parts of Europe and Scandinavia, Australia, Southeast Asia and China.
NTSC – National Television System Committee is the predominant format in the Americas.
SECAM – Séquential Couleur à Mémoire was developed and mainly used in France and is also found in Eastern Europe, Russia and some areas in Africa.

Digital video defines its regions in numerical values:
Region 1: United States and Canada
Region 2: Western and Central Europe, the Middle East, Japan, South Africa.
Region 3: Southeast Asia, Hong Kong, South Korea and Taiwan.
Region 4: Australia, New Zealand, Central and South America, the Caribbean and Oceania.
Region 5: Africa, Russia, the Indian subcontinent and North Korea.
Region 6: China.

Marketing and publicity

It is perhaps in the fields of marketing and publicity that the difference among animated productions is most noticeable. Feature films and television series have the commercial might and media connections to create networking and distribution capabilities, investing huge sums of money in promoting their product for market. At the opposite end of the spectrum, independent animators struggle to get their work noticed without the goodwill, support and persistence of a few who believe in the production. That said, allowing time and devoting energy to thinking about how a film will be marketed and publicized is worthwhile, and need not fall on the shoulders of one individual.

Releasing films on DVD allows for effective direct and indirect marketing of the production through the inclusion of selected supplementary material. Besides the final work, with a choice of subtitles and viewing format possibilities, a DVD allows the chance to include bonus elements, such as behind-the-scenes footage, documentary pieces exploring 'the making of', games, interviews and film stills. It may also allow bigger studios to preview future releases and even offer concessions for animation fans.

Regardless of the size of the production, targeted marketing is vital to bring in the required demographic and volume of audience needed to ensure success and possible future commissions. Some studios have dedicated marketing departments that work endlessly on promoting and advertising their directors, productions and awards, while some use outside agencies to do the job, preferring instead to devote their creative energies to the work

itself. Many productions create press packs, issue press releases or offer sneak previews of productions to raise awareness and promote their offerings and, of course, will tempt media critics, broadcasters and publicists by holding film premieres or special screenings for invited audiences. Social media such as Facebook and Twitter have ensured that it is possible to launch highly focused and genre-specific viral campaigns that promote directly, but permit and encourage the spread of self-directed communication to like-minded parties.

Based around an orchestrated campaign that promotes roving live public appearances by directors, animators and writers nationally and internationally, social media offer cost-effective, immediate and tangible benefits to those wishing to get to the heart of the audience they need to convince to watch. Animation festivals are an important forum for introducing works to an invested and knowledgeable audience, made up not only of fans but also of publicists, financiers, critics and executives, where the independent animator of today might well be the executive animation producer of years to come.

Marketing a film release has been given a whole new lease of life by the advent and adoption of social media, including blogs that can be explicitly targeted to reach a desired audience and create the necessary hype.

Film festivals

A great way to see new films, meet their creators and generally get inspired by contemporary animation is to visit the many dedicated animation film festivals.

Here is a selection of global events that take place in different locations, all year round.

2d Or Not 2d Animation Festival, Seattle: United States
Anifest Czech Republic, Teplice: Czech Republic
Anifest India, Mumbai: India
Anifilm, Třeboň: Czech Republic
Anima Mundi, Rio de Janeiro / São Paulo: Brazil
Animac, Lleida: Spain
Animasyros, Syros Island / Athens: Greece
Animated Dreams, Tallinn: Estonia
Animated Encounters Festival, Bristol: United Kingdom
Animateka, Ljubljana: Slovenia
Animerte Dager, Fredrikstad: Norway
Anim'est, Bucharest: Romania
International Animated Film Festival, Poznan: Poland
Animex International Festival of Animation and Computer Games, Teesside: United Kingdom
Annecy International Animated Film Festival, Annecy: France
Bradford Animation Festival, Bradford: United Kingdom
Brickfilmsfestivalen Sweden, Örnsköldsvik: Sweden
Brisbane International Animation Festival, Brisbane: Australia
Canterbury Anifest, Canterbury: United Kingdom
Cartoons on the Bay: International Festival of TV Animation, Positano: Italy
China International Cartoon and Animation Festival, Hangzhou: China
Cinanima, Espinho: Portugal
CTN animation eXpo, Los Angeles: United States
Fantoche International Animation Festival, Baden: Switzerland
Flip Animation Festival, Wolverhampton: United Kingdom
GIRAF, Calgary: Canada
Holland Animation Film Festival, Utrecht: Holland
Hiroshima International Animation Festival, Hiroshima: Japan
International Digital Film Festival Kinofest, Bucharest: Romania
KLIK! Amsterdam Animation Festival, Amsterdam: Netherlands
London International Animation Festival, London: United Kingdom
Melbourne International Animation Festival, Melbourne: Australia
New York Animation Festival, New York: United States

Ottawa International Animation Festival, Ottawa: Canada
Platform International Animation Festival, Portland: United States
Red Stick International Animation Festival, Baton Rouge: United States
Savannah International Animation Festival, Savannah: United States
South Beach International Animation Festival, Miami: United States
Stuttgart Festival of Animated Film, Stuttgart: Germany
Tecnotoon Animation Fest, Miami: United States
Tofuzi Festival of Animated Film, Tbilisi: Georgia
Waterloo Festival for Animated Cinema, Waterloo: Canada
Zagreb World Festival of Animated Films, Zagreb: Croatia

Over the years, countless animation festivals have sprung up all over the world. The annual Ottawa International Animation Festival, held in September each year, is one of the oldest, with more than 20,000 festival-goers regularly attending.

Conclusion

With this chapter the animated project draws to a conclusion, synthesizing all the components into a coherent and logical package ready for broadcast. With the process of animation complete and the work out in the public domain, inevitably a period of evaluation is desirable to reflect on what has been achieved and how the animation was received in the wider public sphere. Depending on the kind of production released, this might range from a company looking at its financial figures in relation to an animated advert, or it could be measured against a reported audience viewing share. On a more pragmatic level, it could simply be the acclaim and recognition of fellow animators at a festival screening, or the plaudits of fans. Any reflection is destined to be short-lived. In reality, productions seldom happen in isolation and it is quite conceivable that the conclusion of one workflow simply heralds time and space for other projects that have been waiting to assume their place in the production hierarchy.

The next chapter considers some relevant practical steps to getting started in the animation field. It covers topics that animators who have contributed to this book have highlighted as being essential to understand before embarking on a career path in this expanding discipline, suggesting ways of exploring the subject and showcasing your particular strengths and talents, and offering some guidance on how to avoid making time-consuming mistakes. That said, the process of animation is evolving and some mistakes will inevitably happen, for they prove that decisions are being made and acted upon.

7.

This final chapter provides practical advice for those wanting to enter the exciting field of animation. As this book has illustrated, there are many different opportunities available. Whether you hope to work as an independent creator or as part of a global studio, on small-scale charity projects or full-length animated feature films, on a modest budget or a multi-million dollar contract, the journey will certainly be interesting and rewarding.

The chapter considers educational routes to acquiring knowledge and understanding of the discipline, outlines the core skills required by focusing on what potential employers are looking for, and examines some of the promotional choices available, including portfolios and showreels. Information is also provided on the benefits of gaining relevant knowledge and experience through placements and residencies, and on the places where job adverts and opportunities might be found, as well as advice on preparing covering letters, application forms and curricula vitae and on performing in interviews. The chapter concludes with a brief overview of other forms of employment, such as freelance representation, and what you can expect from your new position.

The much-respected California Institute of the Arts attracts excellent would-be animators from all over the world and has an impressive list of alumni.

Education, knowledge and understanding

In a world where more people appear to be 'qualified' than there are job opportunities, one might cynically ask, 'What is the point of doing a degree?' It is certainly true that a degree is not required for employment in the animation industry, and many people are employed globally without any formal art training. This merely illustrates, however, the massive developing opportunity of the medium, as witnessed by any visit to an animation festival, where the audience will routinely be made up of scientists, architects, artists, computer programmers, developers and investors, drawn to the possibility of animation as a compelling communication tool.

So while formal education is not wholly necessary, anyone who wants to succeed in the animation field must possess knowledge and understanding. This can be achieved only through being prepared to educate yourself about the subject. Given the complexity of animation, the idea of signing up to a course that has done all the structural planning for you, has designed classes to explain the subject in varying degrees of detail, and which provides a supportive and creative environment to study in, suddenly becomes more appealing.

Established teaching environments have the added advantage of dedicated technical facilities populated by highly trained and experienced staff, and excellent resources and connections to networks that are influential and hard to penetrate independently. They are also able to demonstrate their success through current student projects and awards, and through long-

American animation phenomenon Don Hertzfeldt was the youngest film-maker to receive the San Francisco International Film Festival's Persistence of Vision Lifetime Achievement Award. He was thirty-three years old.

Students from all over the world enrol on the MA Animation course at the Royal College of Art in London every year, drawn by the many successful animation graduates to have made their names here.

established alumni who hold jobs in prestigious and inspiring places. And, of course, it is possible to continue your animation education to an extremely advanced academic, technical or philosophical level, allowing your study journey to take you all over the world seeking the knowledge you desire. Without an educational framework, all of this planning, mapping and resourcing falls on the shoulders of the individual, when all he or she wants to do is to create.

Skills for future employment

Animation is a developing industry full of possibilities for students with a wide and varied skill set and an appetite to learn. Preparation for employment is vital and should be treated seriously. To demonstrate how focused and committed you are, taking time and effort to create the very best impression of yourself is fundamental to your future success. Critically, you will need to consider whether you want to be employed, or whether your future lies in controlling your own destiny by being self-employed. There are benefits and pitfalls to both approaches, and your decision will depend on your personal ambitions, core skills and resilience, together with your ability to market and promote what you do.

Preparation, commitment and focus – three core skills required to be a successful animator.

Skills and attributes

As a general rule, you will need to present yourself positively to people who do not know you, so their first impressions of you are extremely important. In order to do this, you first need to understand what it is that you are offering. This can be difficult, as the idea of being objective about yourself is not altogether straightforward. In some cases, you may have to recognize your weaknesses before you can concentrate on your strengths. And you may have to answer difficult questions about whether any of those weaknesses can be addressed, and if so, how to go about this process convincingly.

Understanding and evaluating yourself

If you find the process of being objective difficult, perhaps ask a critical friend or mentor to list your qualities and faults. Asking more than one person to do this helps depersonalize the results and can show trends, thereby being more reliable and informative.

Being honest about your strengths and weaknesses – even if the truth hurts – will help you to be more focused in promoting your skills and concealing your faults in your search for employment.

Learning how to take and respond to criticism positively and learning from experience is part of everyday life. Everyone has been through it – learn from others' mistakes and acknowledge your own.

Take time to reflect on these soundings. Are they a fair and accurate interpretation of you and your career goals?

Summarize your experience and make an action plan that can help you address your findings by focusing your energy and resolve.

If the initial process of investigating your core abilities has revealed unexpected questions (or confirmed what you had already suspected), what are you going to do to answer them? Tenacity and ambitiousness are important qualities in every aspect of animation and by demonstrating that you have not given up at the first hurdle, you are already providing evidence to employers, partners and collaborators of a desire to succeed.

The dedication and commitment needed to study animation should not be underestimated, but the rewards are often very satisfying.

Answering your critics

If you need inspiration or more dedicated action to address your current weaknesses, consider one or more of the following as a way of positively helping to hurdle the obstacles to your success:

Research – finding innovative ways of investigating, understanding, recording and analysing subjects through concentrated periods of exploration and discovery should be at the heart of what you do as a way of questioning, interpreting and authenticating your world.

Drawing classes – these are helpful in understanding not only classical anatomy and figurative form, but also nuances of the subject, such as the figure in the environment and, crucially, the body in movement. You will also see the way that others interpret the same subjects, as you develop your critical, technical and aesthetic skills.

Writing classes – these are useful for meeting other writers and learning how to write scripts, develop characters, and create plot lines, subplots and narratives that animation production is predicated on. Writing classes can also provide a critical environment in which to ask questions and be questioned, help provide excellent networking opportunities and offer a supportive environment to learn, develop and test your craft.

Concerts, performances, gigs and recitals – regardless of what entertainment you prefer, go and see different performances, concerts and so forth live. Watch how the performers engage with their audience and observe how the stage is set to allow maximum connection between them and the spectators. Live venues allow you to 'feel' and 'experience' the show by evoking all of your senses. Understanding this will help you to create better work, evoking similar feelings in your audience.

Animation events – again, move away from your comfort zone. Keep abreast of industry news by going to see directors and creators talk about their latest projects at festivals, film openings and gallery events. Sign up to become a friend of places that promote animation and make a point of attending events, workshops and activities so that you understand what is happening in the field you want to be part of.

Film clubs – get involved in local clubs and societies and meet fellow admirers and critics as you watch films, organize and participate in festival visits and perhaps even arrange your own. Investing time, effort and energy is a great way to interact socially with others, encouraging you to engage critically with the subject with like-minded people who will support, question and challenge your point of view – usually on the same night.

Social media – seek out and follow inspiring talent online through sites such as Twitter, Facebook or LinkedIn to find out what plans are afoot, how particular productions were created, and to establish where future opportunities might exist as they unfold. Being up to date and aware is important in animation since the subject, and the industry that supports it, is in constant flux.

There is no better way of finding out what is new and exciting than by getting out and about on the festival circuit to actually talk to like-minded creators and enthusiasts about animation, as here at Ottawa.

What are employers looking for?

Given the variety of possible roles in animation, there is a range of core and transferable skills that are required to perform various functions. Some people possess very specific technical skills that are highly sought after, while others prefer to be more generalist in approach, enjoying the variety and diversity of their creative existence. Whether you are a specialist or a generalist, you can maximize your opportunities in a changing marketplace by keeping your skills up to scratch. Look to resources such as Animation World Network (www.awn.com) or Skillset (www.skillset.org) for information and advice to contextualize your requirements.

Employers invariably are looking for really talented people who are engaging and enthusiastic and who truly understand the medium. Demonstrating that you are a good communicator and a team player, and possess the flair and drive to work unsupervised to tight deadlines will be advantageous. It also helps to be able to have a good sense of humour, a calm disposition and the ability both to see the bigger picture and to concentrate on the smaller details. Above all, be yourself. Being honest about your limitations suggests that you know your capabilities and hopefully you will get the chance to showcase them, allowing others to see where you can develop creatively, organizationally and strategically, and flourish with support and guidance.

While a perception of animators is that they spend hours alone, employers look for a range of skills that often involve teamwork and shared responsibility.

Skills

General

Regardless of your projected 'dream' animation job role, it is imperative to demonstrate a knowledge of and preferably expertise in the following skills:

Animation – the ability to be able to animate forms convincingly using the principles of animation to convey movement in visual form.
Observation – the art of seeing through looking, being able to recognize and record pertinent critical thoughts that connect with both the production team and the wider viewing audience.
Writing – the dexterity to communicate ideas, thoughts and sequences convincingly with an awareness of different genres, styles and expectations.
Professionalism – the ability to work to deadlines through self-motivated tasks or dedicated team working where appropriate to meet production challenges and schedules with an awareness for others in the wider process.
Communication – the ability to listen and talk, both within and outside a production, using appropriate language, protocols and technology to talk to global markets, funders, supporters and audiences.

Specific

By demonstrating an awareness of, and strengths in, the above general skills, it is possible to position yourself as a candidate for roles that require specific attributes and skills. As an illustration, the following roles are characterized by some or all of the listed skills:

Director – needs to have an overview of the entire production. He or she must possess good coordination and management skills in order to oversee the production crew, and must be able to make decisions about every aspect of the production and also to delegate tasks that require completion. Managing the schedule and budget also requires organizational, strategic and detail-planning skills.
Researcher – must have an attention to detail, an inquisitive and enquiring mind, good organizational and communication skills and an ability to edit out irrelevant material.
Scriptwriter – needs the creative skills to write the script and develop dialogue, story arcs and sequential narrative for the production. He or she also needs to ensure that written material is originated, developed and revised in tandem with the storyboard and pre-visualization of the work.
Storyboard artist – must be able to communicate through drawing and visualization, to think sequentially, and to apply acting and dramatic skills and interpret dialogue, sound and special effects.
Animator – needs to demonstrate the ability to draw and visualize movement, interpret dialogue, sound and special effects, and communicate effectively. He or she also needs to be patient.

Students at California Institute of the Arts learn that the animation industry is varied, requiring a range of creatives with differing skill sets.

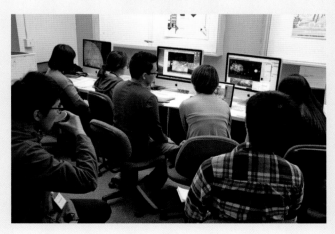

Promotion

There is no argument that the best industry professionals promote themselves intelligently, but there is plenty of discussion about how this can be achieved. In a competitive environment, the need to stand out is obvious, but the promotional approach is not quite so clear-cut. Time spent looking at what others have done is useful, but should also be set against quality advice from the people you actually want to see your work. This involves doing extensive research and analysis, through visits, events and openings where animation is being screened and reviewed, as well as thoughtful, intelligent and well-constructed questions directed to individuals and organizations earmarked as being able to provide you with insightful answers. Remembering that a base level of aesthetic, technical and critical prowess is a given, what you will need to show when promoting yourself is that you have a personalized take on the subject that differentiates you from others in the field, and which invites inspection and scrutiny from those you are trying to impress.

This level of expectation and rigour raises the obvious questions of how much promotion is required and what format that promotion should take. The quantity and quality of promotional material will largely depend on the kind of work that you want to do, your budget, the time you have available to promote yourself, and the level of engagement in the industry you expect to attain. It is very important for you to set the agenda in relation to your own promotional strategy, manage the content of your own marketing and appraise whether your branding of yourself is fair, accurate and inviting for the market you are selling to.

The whole promotional strategy must be consistent in terms of design, language and sentiment. Any poorly researched marketing strategy will undermine the story about you. This in turn necessitates decisions concerning the promotional devices you will employ to tell your story effectively. Showreels, traditional portfolios and supplementary paper-based promotion should certainly be explored as they are basic expectations, but you should also make efforts to research a digital presence in the form of websites, blogs and social media.

What remains crucial is making the right statements about yourself, using the correct choice of promotional tool to illustrate a coherent story. Inevitably, that story will change as you progress, acknowledging skills that you have acquired, successes that you have achieved and knowledge you have harnessed. Your promotional material must recognize and promote these developments effectively. It is, therefore, essential to recognize that different promotional materials have different lifespans. For example, a blog can be maintained chronologically like a diary, requiring continual feeding if you want your target market to consult it frequently. Printed cards advertising your latest production, however, have a longer shelf life, acting as a central focus to your advertising when the project is live or providing a useful back history of previous achievements as well as supporting material for future projects.

London's Studio AKA have won a commercial and critical following with their intelligent and witty productions that span short animated features, television advertising and collateral projects where animated content is desired.

Promotional material must quickly hit the mark and provide an instantaneous insight into the work you create.

The following sections on promotional tools assume you have the right to publish material that is your own. However, any material that is not created by you, or has been created in collaboration with others, must be cleared for publication so as not to infringe copyright. Never assume that you have the right to publish, or you may be faced with a hefty legal bill. If in doubt, check with previous employers, collaborators and clients, and credit their involvement where appropriate so that your work can be seen in this wider context.

The portfolio

The most necessary passport into the animation industry for anyone considering a visual role is the portfolio and showreel. These are the true showcases of your ability to demonstrate an understanding of animation as a form. It is imperative that the portfolio and showreel work together, emphasizing the message that you are a talent worth seeing and harnessing.

A strong portfolio provides you with a crucial tool to bridge the gap between training and employment. The work contained in the portfolio may explain your work better than you are able to do verbally, and can create a level of reassurance and confidence. Planning what to include, and where to position it, adds to the all-important story about you, and it is important, therefore, that the portfolio is frequently updated.

The portfolio provides reviewers with evidence of your skills in origination, development and creative decision-making, and of the potential in your work. Consider having both a physical and virtual portfolio so that your work is showcased in static and moving form. Using a digital platform to show work is vital since moving images on screen can be effectively displayed and accessed on a website. Crucially, the portfolio can be laid out differently depending on your changing aims and objectives. Designing it to have a coherent and consistent visual style demonstrates that you are able to see your work as part of a bigger picture, which is appealing to employers wanting you to work as part of a team, especially in work for commissioned television series or feature films.

The portfolio must further showcase and project your skills and abilities, as anyone inviting you to show your work will have already searched for

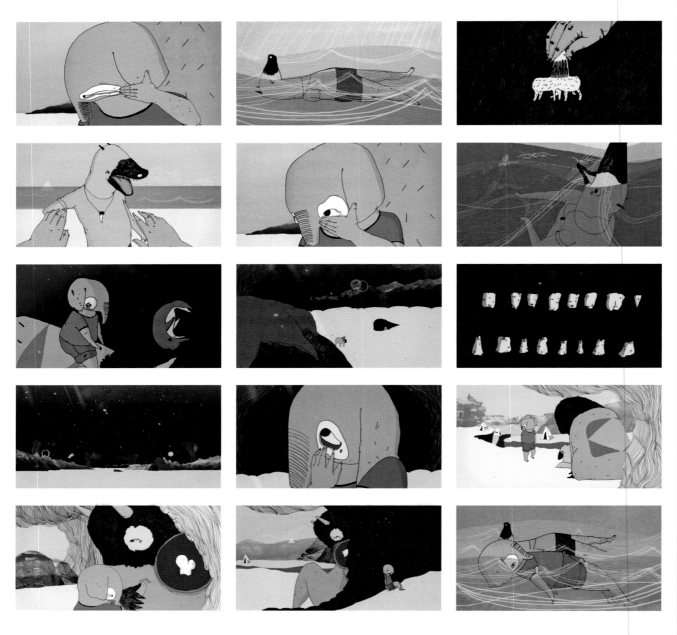

Recent RCA graduate Julia Pott's film *Belly* (2011) has been popular on the animation festival circuit, being selected for the Sundance International Film Festival 2012.

examples online. If your main area of interest lies in the development of characters, for example, then you should promote this by showing where your ideas come from, how the characters develop their significant and underlying characteristics, and how they are differentiated from one another. In this regard, you might consider supporting your portfolio with sketchbooks showing figure studies and the starting points from which you have developed characters, or by including sheets that demonstrate your understanding of anatomy, movement and body rhythm.

Animation relies on the development of ideas, so do not feel pressured to include only finished pieces. The portfolio need not be laid out chronologically, but it must illustrate how your working process allows you to develop your ideas sequentially. Briefly captioning material can be helpful if the portfolio is being looked at without the creator present. If you have material in the portfolio that has been produced as part of a partnership, ensure you have obtained permission from those concerned to show it to others. Above all, the portfolio must be easy to look at, quick to catch the viewer's attention and, perhaps most difficult of all, memorable.

The showreel

The showreel provides your main opportunity to reveal your ability to animate. Like the portfolio, the showreel should ideally focus on those core skills relevant to the nature of work you want to create, emphasizing them through carefully selected and edited material. Reels should be no more than five minutes in length and should show your most recent work first. It is generally accepted that not all reels are viewed in their entirety, so it is important to

A portfolio should show your ability to animate with sensitivity for the subject matter being depicted.

A showreel offers the chance to get an overview of animated work, presenting core technical skills with evidence of an ability to expressively interpret material through the synergy of sound and vision.

present your strongest work at the beginning and to consider your edits carefully so that they provide a coherent, punchy statement of intent about the kind of work you do and the ideas and skills you can bring to the employer. Crucially, the showreel should demonstrate that you have sensitivity to the way that subjects move, and this is often best achieved by including well-edited clips rather than full productions. Incorporating such elements as lip-synching or extreme moves is a good way to show the basic animation principles underpinning your work.

Again, a showreel may be physical, in which case it is usually supplied on a DVD (or on a format dictated by the studio), or embedded into your website, usually as a QuickTime movie or Windows player. The showreel should be attractively packaged, complete with a title, contact details and a credits list. It is worth briefly explaining shots, techniques and software applications used to help viewers understand what they are looking at and to provide a context of how and why different works have been created. This explanation also allows you the chance to distil some of your knowledge concerning shot selection, choice of camera positions, moves and editing transitions.

When you come to output your showreel, make sure your playback settings are regionally compatible if you are intending to send it to international destinations, and be aware that certain subjects may be interpreted differently culturally than you had anticipated. You may need to consider editing several versions and adding subtitles if you are intent on working abroad. The showreel should be packaged sympathetically to resonate with any supporting documentation, such as flyers or posters.

Print-based promotion

The emergence of digital media does not necessarily mean that self-promotion needs to be exclusively digital. Print media still has a strong resonance with some and allows a tangible opportunity to engage your audience through a medium that, depending on the materials used, relies on touch and smell, two sensory routes not embraced by digital technology. For example, screen printing your own promotional posters or flyers with oil-based inks will create both a tactile artefact and one that releases an aroma when it is unpacked. However, you can also be certain that anyone serious about the subject of animation will expect you to have at least some online presence, often because they will have familiarized themselves with you through an online search engine.

Many animators and writers try to maintain a portfolio of promotional devices. While there is no prescriptive formula, you might consider including paper letterheads, cards, envelopes, flyers, posters, small booklets (perhaps with interesting dimensions, folds or printing effects such as foil stamping, embossing or die-cutting), promotional toys and games as part of your promotional checklist. Some of this material will be designed to be sent out, but it is equally valuable to have cards, booklets and flyers available to hand out at festivals and events, where recipients can make personal connections

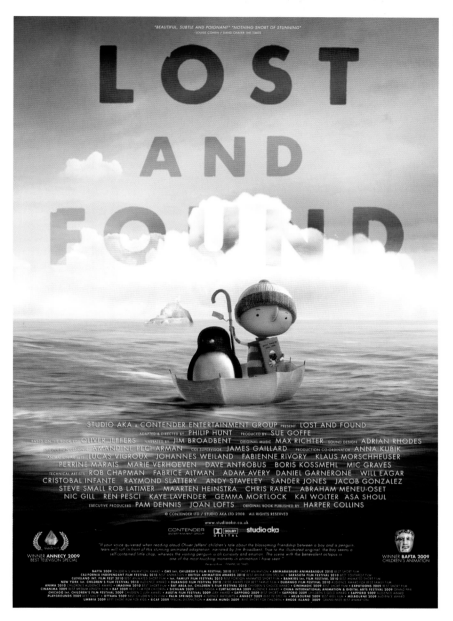

Promotional material comes in many sizes and forms, creating interesting opportunities to promote work to expectant audiences.

with you and place your work more effectively. Many festivals, galleries and organizations are happy to accept printed matter to promote your work, provided that you have asked permission rather than assumed they will do your promotion on your behalf.

When designing any physical literature, it is essential to consider the recipients carefully. Receiving material through the post can be exciting, but it should be in a size and format that is friendly and non-obtrusive, otherwise the first impression is one of frustration and annoyance rather than delight. The choice of printing methods, sizes and quantities is also important. Many prospective animators underestimate the cost of promotion,

so you will need to work out what best fits your budget, resources and ambition. Getting a professional printer involved with your promotional needs may not be as expensive as you think, can save time and creates a professional, cohesive look. If your budget will not stretch that far, you might consider using a print cooperative where you can create your own promotional material, or one of the many online resources such as Blurb (www.blurb.com), Qoop (www.qoop.com) or MyPublisher (www.mypublisher. com) that offer a customizable set of templates leading to a range of professional, fully bound publications. These kinds of services are an economical way of creating a good impression, and the buyer can stipulate the scale of the print run, format, materials used and a choice of bindings to present the publication ready for market. However, these services do require a sympathetic eye when designing in order to maintain your personal design direction and embrace your work ethos.

Websites

The Web is an immediate resource with many benefits for aspiring promoters. However, it is also one that should be treated with great care. The apparent attractiveness, versatility and accessibility of the Internet must be measured against its security and volatility. While the site must promote your work, it is quite conceivable that it will also need to handle your daily productivity, as you use email, upload files and generally go about your business.

It is worth spending time and money on choosing a service provider and Web host who can accommodate the kind of website you are intending to build, site and maintain, especially if it will involve such functions as streaming video, which take up a great deal of bandwidth. Comparison sites are useful in enabling you to see providers, services and charges in one place. Web space should be free of advertising and annoying pop-up banners, and should include the provision to host email accounts, online purchasing where necessary and some form of FTP functionality that allows large data files to be sent and received. Inevitably, these services cost more as indirect revenue from advertising is not forthcoming, but the price is worth paying because they avoid any contradictory messages or unwanted statements, allowing the viewer freedom to look at your work.

Your website should have a clear hierarchy of design to reflect the visitor's needs and should use simple navigational devices to help access the site. To achieve this, it is necessary to plan the site in detail and test out its structure on people whose opinions you trust. Some sites offer templates that can be used to create sites, such as www.weebly.com, but beware of keeping within corporate guidelines that do not best showcase your work.

Website checklist

Where possible, keep information simple, concise and correct within a consistent designed framework that promotes continuity but does not impede the work.

- The home page should include your name, contact details and a menu of information as simple, uncluttered headings that act as links to other pages.
- The home page must be well designed, inviting and immediately understandable to the visitor. It should reassure them that this is a site of note and entice them to explore further.
- It is helpful to include a brief but relevant biographical history of yourself, citing meaningful examples of your experience to date.
- It may also be worth publishing testimonials, provided that they are seen as supportive and informative for the viewer.
- Choices about what work to show and how best to show it largely depend on the kind of work you create, but it is at least worth considering some images (and possibly brief descriptions) of work in progress as well as final film stills.
- Think carefully about where and how to embed moving-image components and consider the user in the process, as it is not certain they will have the same access to technology that you do.
- Make certain that the design works on different devices and Web browsers (Safari, Chrome, Firefox, etc.) and that the examples fairly and accurately reflect the work that you do.
- You will need to view the site on a smartphone to check whether your proposed design is compatible with this increasingly popular format.
- Good website navigational practice suggests that visitors should never find themselves more than three clicks away from the home page.
- The website should be built to a detailed schedule and should be reviewed regularly, especially checking spelling and grammar, as mistakes in basic language annoy users and send out a poor message concerning your attention to detail.

Once you have built your website, ask for critical guidance by placing it on a host server and making it initially available only to invited viewers. Importantly, listen and respond to the feedback you receive and make the necessary changes. Don't become despondent by the comments, but instead accept that content or systems you have designed may not be perceived in the same way by someone using the site. A dysfunctional website, with broken links and inaccurate content, can seriously damage your reputation, so it is important to make any changes before you go live.

Social media platforms

The emergence of social media has had a profound effect on the way that information is published, read and digested. Online forums and the blogosphere provide scope to report and respond to posted information, encouraging increasing numbers of the public to review their consumption of news and information from traditional sources such as newspapers, magazines and television. Blogs and forums have no length limitations, allowing correspondence to be archived and retrieved by both the writer and the user. Social networking sites, such as Facebook, allow individual users to create profiles to report news and events, or read the postings of others. They also allow common-interest user groups to be established, promoting information, awareness and debate to a wide community of like-minded individuals, groups and organizations. Most animation studios have their own Facebook page that they routinely update with news, job opportunities and events. Microblogging sites, such as Twitter, offer further opportunities to instantaneously post news or feedback to stories or events globally. Their capacity to facilitate such immediacy is tempered by the limit to the number of characters that may be utilized.

The crucial thing to remember about social media is that their currency lies in the moment. Posting information is instantaneous, and it must be accurate and non-discriminatory. Your responsibility lies in ensuring that the information contained on any social media platform that you manage is professional, rigorous and reflects well on you as a host. Ensure that your profile and information are well maintained and never share information that you do not want in the public domain. Posted information cannot be recalled and may cause irrevocable damage to you and your career. Maintain your sites and immediately remove or block posts that may in any way harm your chances of being perceived as professional. Guard against viruses and hacking attempts both by understanding privacy guidelines published by sites where you hold accounts, and by setting levels that tightly control what can and cannot be posted. If in doubt, seek advice from others first.

Gaining experience

Getting experience of the workplace is an excellent way to understand the nature and diversity of animation as a career path. Some college and educational courses offer opportunities to undertake visits and placements as a way of testing your skills in a real-life studio environment, while residencies may be granted by some larger organizations where space and funding permits. Studio visits organized in advance give students a chance to see the inner workings of a production, offering behind-the-scenes exposure to the working process, and allowing them the chance to meet and question employees about their roles on the project. Access may be restricted at busy times or where projects are in a sensitive state of development. If you are not

Nexus Productions use social media such as Facebook to showcase the latest work from their directors, and link themselves creatively to other organizations to create an online community that permits greater exposure.

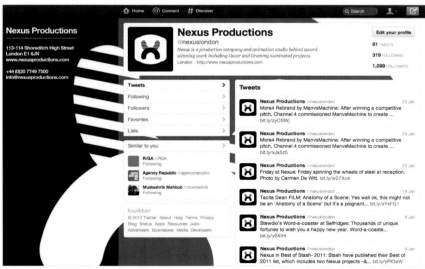

enrolled on an education programme, it is still possible to request a visit and some studios additionally have 'open studio days' where the community is invited to see the work being done in its neighbourhood.

For those with more time available, placements (sometimes known as 'internships') are worth considering as a prolonged foray into life in the animation industry. Placements may last for days or weeks at a time, and can be paid, unpaid, or 'expenses only', depending on the size of the studio, the duration of the placement and the location. Some college courses offer placement opportunities with established studios, while others are content for their students to forge their own career paths and promote themselves externally. It is worth asking admissions tutors about this route of study in advance as this may help determine which course is right for you.

Securing placements requires good communication and diplomacy skills, and you will need to agree terms, such as the duration of your stay, the work you will be undertaking, any fees that you may earn and whether the work you do is subject to any legal restrictions concerning your right to promote it. It is important to negotiate these details before commencing the placement to avoid misunderstandings and difficulties occurring. Currently, the whole issue of placements is undergoing scrutiny in the United Kingdom with regard to employment rights. It is worth checking in your intended country

Working in a studio environment while at college is a very useful way of understanding the intricacies of a career as an animator.

The perils of the wider world face all students of animation, but it is important to remember that famous directors once started from scratch.

of placement what employment rights surround temporary placements. For longer periods of study, residencies provide an opportunity for intensive work and immersion into a subject. A residency might occur through an organization inviting an artist to work in the studio, encouraging shared creative practice and mutual inspiration for resident and employees alike. Residencies are usually offered through particular invites, will last for weeks or months, and usually involve payment. It is also worth noting that a different kind of experience can be achieved for those already employed in the industry through a paid or unpaid sabbatical. Organizations that offer residencies usually ask for examples of work from invited participants, or through a 'competitive' process. Animate! Projects, based in the United Kingdom, are an excellent example of an organization that promotes thoughtful, intelligent residencies as a way of illustrating the diversity and ingenuity of the talent in the field.

Opportunities, applications and interviews

Job opportunities in animation tend to follow one of two paths, namely an advertised position or an opening becoming available. Some studios advertise that they are hiring for positions both within the studio itself and through trade publications, on their own studio website or on linked sites or forums where they are likely to attract suitable applicants with the necessary skills and expertise. The Career Connections part of the Animation World Network site (www.awn.com) is an example of an online marketplace where studios can advertise positions and employees can upload résumés.

Applications for job interviews vary according to the role being advertised. In some instances, the job description will ask for a completed application form and will require you to register your interest so that the company can

keep a record. On other occasions, applying for a job usually involves writing a covering letter and sending a curriculum vitae (CV). Following the wider employment arena will help you identify opportunities, compare job titles and responsibilities across the sector, and give you helpful information about salaries and benefits.

Job adverts and opportunities

Some jobs emerge in-house as studios either take on more work or perhaps need to bolster their human resources to meet deadlines. Since these 'spikes' in productivity may be temporary, most studios are reluctant to employ staff on a permanent basis, and will look to an accomplished freelance pool of talent instead to buy in the skills they require to complete the production. Some animators make a career choice to follow this path as it can provide higher fees and a more flexible working life, but they must also contend with periods of unemployment and limitations on where they can locate themselves in order to be close to studios. Where openings become available, staff working in the studio as 'runners' or on low grades will be in a good position to benefit, as studio staff will have worked with them and built up an opinion of their capabilities.

When seeking employment, it is important to survey the market rather than jumping at the first advertisement, as you will need to show reasoned judgement about why the particular role is right for you. This means researching into the studio or organization that is advertising and investigating its history, current work and projected future output. Your contacts and knowledge should help you be objective about your findings. It is also worth considering whether an advertised job fits your career profile,

Employment in the animation industry is hugely varied, from major studios and production houses through to small independent creators, each offering opportunities for growth and development.

or whether strategically it would be better to wait until you have more experience before applying. It is quite acceptable to ask if you can speak to the advertisers for more information on any job role. Always be professional and courteous in your request and acknowledge any help you receive in developing your application.

The application form

If you are required to complete an application form, you should have the job description to hand in order to match up the essential requirements for the role and to articulate these clearly. It is important to be concise and fluent in your responses, so take your time to read the application form before filling it in. Allow yourself enough time to complete the form, as you may need to check specific details, such as dates, levels of responsibility or references. Always communicate in advance with the people you wish to use as referees to validate your application, and choose people who know your work best for the role you are applying for.

Application forms provide the all-important introduction to you, and allow prospective interviewers to formulate interview questions that try to align your previous experience to their current and future requirements. Aim to include details that are relevant and specific to the role being advertised, and provide clear details of how you feel your skills and attributes match or exceed expectations. At the same time, you may wish to introduce facts in such a way as to necessitate specific follow-up interview questions, so balancing how much information to give with how much to keep back is a strategic move that requires planning.

The covering letter

In your personal absence, the covering letter becomes your representative and ambassador. Any document leaving you must provide a consistent and coherent story about you that is professional and articulate. A well-designed, thoughtfully written covering letter is often the passport to ensuring that your CV gets read, and brings the offer of an interview a step closer. It is also one of those instances where having physically printed letterheads on specially chosen paper stock can be worth the investment, as the impression created by a professionally printed document is often subconscious but long-lasting. Print-on-demand means that it is possible to use decent stationery to create the right impression at the same time as allowing for contact details to be updated without having redundant stock.

Again, thoroughly researching your recipient and attending to the details you find out is vital to ensuring your letter is well received. If you are looking for work speculatively it is worth bearing in mind that enquiries by post are more formal and less likely to be ignored than an email approach. You should make efforts to obtain your recipient's name, job title and correct address and include this in the letter. Briefly explain who you are and give relevant details of your background, qualifications and interests, and demonstrate that

you are aware of what the recipient and company has recently done. If you are writing formally to answer an advertisement, you should additionally state your availability to answer questions or to informally introduce yourself in person. Spellcheck and proofread your covering letter, correcting any mistakes and ensuring that your contact details are correct. Make sure you keep a copy of the letter and log when it was posted. It is best to allow a period of seven to ten days before making any follow-up approaches. These can be conducted through email or telephone, again being respectful and concise in your manner of inquiry.

The curriculum vitae

The curriculum vitae (CV), or résumé, is intended to provide an overview by briefly introducing you, illustrating your experience, skills and qualifications and summarizing your recent achievements. It should provide a complete body of information for potential employers so that they can ascertain your suitability for a particular role. For animation positions, the CV will usually accompany the showreel and portfolio. If this is the case, allow those visual devices to show your ability and try not to replicate this information in the CV, but perhaps describe or denote the work in a descriptive summary that provides a wider context for those viewing your material.

Taking a design lead from the covering letter, the CV should provide information in the order that you want the recipient to read about you and should expressly address the position being applied for. The CV should never be more than two sides in length so, when constructing the document, you will need to bear in mind that it will be reviewed by people wanting to extract information from it. Therefore, keep your CV factual rather than overly conversational.

The basic requirements for a CV are that it contains your name and contact details, together with well-defined sections detailing your qualifications, experience, skills and achievements, concluding with details of references. Provide your full contact details and make certain that these are permanent numbers and addresses wherever possible. State your nationality and whether you have relevant rights to work in the country to which you are applying. Information should be given chronologically, indicating your most recent relevant qualifications and experience first. Be explicit about the work you did for each job or production, as this will allow the reader to focus on your skills. You should also include any skills accreditations, listing the most recently acquired first, as this promotes the idea that you are continually improving your skills.

Make sure the language used in the CV is representative of your personality, as striking the right tone is important and, again, shows you have researched the recipient. Spellcheck and proofread the information carefully and consider asking a trusted, but critical, friend to do this as well. Always ask your intended referees for permission to list them and provide their correct job titles and contact details. Finally, review the information on the

CV to check it is focused and applicable to an advertised post before sending the document.

The interview

If you are called for interview, it is important to be professional in your dialogue before the date, ensuring arrangements are made to suit both parties. Having a portfolio and showreel to hand is a real advantage if you are nervous. Remember that the people interviewing you have invariably been in your situation themselves and so will take any anxiety into account. Additionally, they will have a view on you already as your application, CV and showreel will have preceded your arrival, and they may have sought references.

Preparation is the key to a successful interview and the hard work should be done beforehand by researching the company, finding out about their history and current output, their competitors and ambitions, and by understanding how the role you have applied for can help contribute positively to these targets. Your preparation should make you more confident, so practise talking about your work, explaining your choices and decisions and making sure you are focused on the job in hand.

On the day of the interview, dress professionally but comfortably. Arrive in good time and introduce yourself clearly. Be friendly but professional at all times and maintain eye contact and exhibit positive body language with your interviewers.

Questions during the interview will centre on your relevant previous experience, your qualities, strengths and interests, and your ambitions for the future. Always try to answer questions clearly and concisely, by providing information that answers the question, rather than veering off at a tangent. If you are encouraged to elaborate on a particular answer, try to use a pertinent example to make your point, but again be mindful of the answers you have already given, and refrain from repeating examples as it suggests your experience is limited. In an interview situation, you should be prepared to ask questions of your interviewer, so it is worth configuring your previous research into a list of questions that you have not been able to find answers to. These might include opportunities for flexible working, appraisal opportunities, opportunities for career development and team-building exercises. This demonstrates your personality and shows your suitability for the post or to be part of a creative team.

You may be required to provide evidence of your employability status, so it is worth taking some form of official documentation with you, such as a passport or driving licence. Contrary to popular belief, it is not necessary to disclose your current salary. Instead, it is perfectly acceptable to answer that you are prepared to negotiate a mutually beneficial package. It is unlikely that a package will be discussed in an interview setting, but you must be prepared to be called back in once the interview is completed to discuss personal terms if you are successful.

The interview situation need not be a nightmare boardroom experience if you have prepared yourself correctly and believe in your own ability to make a positive difference to your potential employer.

Avoid being put on the spot in an interview situation by doing your homework about the employer well in advance and absorbing the information so that you can answer questions truthfully and accurately.

Salary scales are sometimes available in larger organizations and these are useful in seeing your prospective employment threshold and projected earnings, but you should also consider other benefits in kind, such as pension arrangements, holiday, insurance and healthcare cover, as these all contribute to the overall package. It is quite appropriate to ask for time to consider any offer that is made, and you will need to carefully weigh up the benefits in relation to the responsibilities of the position. Consult with legal representatives, employment agencies, teachers, friends and confidants if it will help you arrive at a measured and informed decision. Accepting a position can be done by phone or email, but must be followed up with a letter of acceptance. Declining a position should also be done via letter, remaining polite, courteous and professional throughout.

Representation

Some animators, voice-over artists and directors who choose to work in a freelance capacity opt to be represented on agency sites. For an annual fee, the agency and creator agree representation terms and work together to satisfy the creative and commercial needs of the commissioning client. Such arrangements are attractive to freelancers as they promote their work to a wide audience professionally, contextualizing it against other professionals and providing an attractive and inviting shop window for viewing. The arrangement benefits the agency through the commission and advertising revenue received, the awards that might accrue with representing a stable of exciting artists, and the diversity and specificity of talent on offer for hire. Many agencies have branches or sister agencies throughout the world, allowing maximum exposure to a variety of clients and markets.

Most agencies operate on a contractual basis that is mutually negotiated and agreed between the agency and the creator. The contract covers the terms of representation, the percentage of commission and royalties that are charged, and the operational costs to the agency that will be charged to the artist. If your work is represented by an agency then it is likely you will be asked to contribute to advertising expenditure, marketing campaigns and promotional costs that will benefit your work. Agencies should be open and transparent about the costs of representation and you should ask for their terms and conditions of service before signing any contract. In return, it is likely that they will demand exclusivity in representing you or, at the very least, an assurance that any promotion you do will not conflict or interfere with their publicity.

The commission rates of agencies can differ according to the kind of work commissioned, the method of broadcast and the type of rights required. You should never sell your copyright to any works under any circumstances, and should agree to limited rights purchases only where you have gathered sufficient specialist legal advice. Selling any form of rights gives the buyer

more control over how your work is used and viewed. Retaining and asserting your rights as the creator in a digital arena is hugely important, since any works created may have a completely different currency in years to come and may be sold several times over for different purposes. By retaining your rights, you have custody of those decisions that may benefit your work financially, professionally and critically.

Some studios actively promote their directors as effectively 'for hire' creatives for clients to pick and commission, and then produce the project in-house using the studio talent behind the scenes directed by the commissioned artist. Examples of such studios include Studio AKA, Ridley Scott Associates and Tandem Films.

Animation draws a wide and varied crowd with a range of skills and expertise into an ever-developing learning environment.

Making it!

With your employment confirmed, now all that is left is to live up to your billing. Many organizations have introductory processes to help new employees become established, but it is not uncommon to have to demonstrate your skills quickly in a pressurized, challenging environment. If you have a period of time before commencing work, it may be helpful to meet your new production team in advance, perhaps for coffee or drinks after work, so that you become acquainted with the working dynamic on friendly and informal terms. Remember, these are the people you are going to work with, so first impressions count for a great deal.

If the studio gives you documentation to read prior to starting your period of employment, you should read it and absorb the information. It is likely that you will be working alongside others rather than in isolation, but being employed means accepting responsibility for tasks. Above all, enjoy it – it is supposed to be fun! Immerse yourself in your new world. Be committed, enthusiastic and capable, accept others' ideas and offer some of your own in the spirit of professional teamwork and an ethos of collective ambition.

Conclusion

This book has chronicled the journey of an animated project through a notional production pipeline: from the origination of a concept to the collecting of research and developing the idea, from structuring the story to developing the images and sounds to a point where they can be manufactured and tested, produced and synthesized, then finally outputted, released and distributed. That such a simple, linear process can have so many wonderful and astonishing variations is credit both to the versatility and possibility of a continually evolving medium, and to the intellect, expertise and fascination of the people who call it their home. Animation needs new pioneers: those who can bring their talents, questions and answers to the field, examining, challenging and redefining the boundaries of the medium and thereby encouraging a whole new audience to become enthralled by the wonders of the form.

Glossary / Further reading / Resources / Index

Glossary

analogue: a reproduction that is directly physically connected to its source material, such as a sound recording of a breaking wave.

animatic: a collection of static images composited together with a soundtrack that creates a sequence in pre-production.

armature: a structural framework (static or jointed) that acts as a base for stop-motion models.

aspect ratio: the dimensional shape of a projected image.

axis: virtual line on which a character moves, defining direction, height and space.

bandwidth: the quantity of digital data that can be processed by a network connection in a set time period.

camera-ready: a model that has been built, placed, positioned on set and tested.

cel animation: clear acetate cels inked with a design, back-painted and filmed under a rostrum camera.

compositing: the process of combining layers of imagery in a single frame.

computer-generated imagery (CGI): animated images made using a computer program.

digital: a reproduction that uses binary mathematical information to construct the form.

dope sheet: a spreadsheet indicating how images will be recorded, including their duration and production.

extremes: also known as key movements, these are depictions of the pivotal points of a moving action.

field size: the area of information captured by a camera in relation to the original piece of artwork that the camera is pointing at.

file: a digital document of captured data, measured in kilobytes, megabytes or gigabytes.

film stock: a transparent strip of celluloid holding sequential photographic frames that could be played through a projector. Strips were typically 8mm, 16mm, 35mm and 70mm wide.

frame: a single image.

frame rate: the number of frames per second of film.

full animation: the technique of depicting full movement of figures or objects in a scene using a high proportion of frames created specifically to show the 'fullness' of the movement.

genre: a category of animated production characterized by purpose, style, process and variety of narrative construction. Examples include 'documentary' and 'performance'.

green screen(ing): characters are filmed in front of a plain green (or blue) screen and other layers of scenery are composited into the final edit in post-production.

in-betweener: a person traditionally employed to create the 'in-between' animation cels between key frames.

increment (incremental movement): the slight sequential shift from one position to the next that animators make when animating a given movement on a stop-motion set.

ink and paint: a process used in traditional cel animation, where individual acetate cels would be inked and coloured by studio teams in large numbers and to a set pattern in a manner reminiscent of industrial manufacturing.

installation: a site-specific piece of artwork that creates an environment in which animated projection can occur.

key frame: a frame that signifies an important beginning or end action to a movement.

layer: a physical or virtual surface providing anchorage for material, which can be seen in isolation or in combination with other layers and stacked in different orders, thereby revealing or obscuring information.

layout: the process of planning and mapping out content visually in pre-production to identify issues to be resolved before production.

limited animation: uses an economy of visual frames to create a movement, instead relying on supporting production facets such as dialogue or soundtrack to 'fill in' gaps.

lip-synch: a process of synchronizing a character's mouth movements with the words spoken.

loop: a cyclical piece of film that can be played continuously and that may have no natural beginning or ending.

maquette: an early 3D rendition of a character or object, which is used for reference and guidance when constructing camera-ready versions.

medium: a substance or technology employed to portray visual or aural thoughts and ideas.

metamorphosis: the process of transformation from one form to another.

motion blur: a technique created by moving an object in a frame as it is being shot, giving a 'natural' look or feel to a sequence.

motion capture: a technique of recording human movements using data capture, with a motion sensor detecting signals transmitted from sensors attached to the actor's body.

motion control: a camera independently operated by a member of the production crew and often used to capture shots from awkward or extreme vantage points on a stop-motion set.

multiplane camera: a vertical camera attached to a rig, beneath which surface layers can be manipulated and filmed. This camera is often used to capture oil or sand animation.

narrative: a story or plot that can be told in various stylistic and structural forms.

PAL and NTSC: two different types of video broadcast signals, widely used in different regions of the world.

PDA (personal digital assistant): a mobile digital device with a high-quality colour screen that can be used to make and receive telephone calls, surf the Internet, compose and receive data, and pinpoint the user's position via satellite tracking.

performance animation: live-action acting with animated material projected into a physical space.

perspective: a series of rules determining the captured visual depiction and description of space.

pixel: a minute block of digital visual data on a display screen that has channels that can alter the value, hue and saturation of colours and tones. When pieced together, pixels form images.

pixilation: An animation process by which actors are incrementally moved shot by shot as individual frames that go to make up a greater sequence.

rendering: the process of making an animated product complete, either through the digital synthesis of collected data involving aspects such as mass and movement of a form, or, in traditional contexts, by 'working up' material to a camera-ready stage.

Further reading

rhythm: a series of visual, aural or narrative points that occur with a similar frequency and appear to give the production a continuous 'beat'.

rostrum camera: a vertically positioned camera, under which traditional cels are photographed on a platform that can be raised or lowered.

rotoscoping: live-action footage is filmed and each individual frame is projected on to a surface, allowing it to be traced and manipulated by the creator.

showreel: a collection of animated material that acts as a promotional or explanatory vehicle for animators, studios and production companies looking to showcase their work to potential employers and partners.

single lens reflex (SLR): an analogue or digital camera capable of taking high-quality single-frame images with film stock or a data storage card, with a wide choice of interchangeable lenses able to alter the recorded view from an original scene or setting in various ways.

stop motion: an animation technique by which objects are moved and recorded in increments.

storyboard: a collection of frames that represent the basic outline of an animated production, with descriptions detailing scenes, camera actions and elements of narration where applicable.

timeline: a visual marker found in contemporary animation production software, allowing the creator to review visual and aural components of an animated project in tandem, much in the same way a dope sheet allows traditional animators to see how different elements of the production piece together.

tweening: a digital process that 'fills in' required frames between two key action points as stipulated by the animator.

variable-speed technology: a process allowing the speed by which frames are captured by a camera to be altered, seemingly accelerating or slowing down a filmed action.

video-assist: a device that helps stop-motion animators see exactly what the camera is filming on set and how that will look during playback on screen.

walk cycle: a sequence of frames in which an animator draws a flowing walking movement, taking account of a character's natural body positions through the repeated action.

Alexander, K., Sullivan, K. & Schumer, G., *Ideas for the Animated Short: Finding and Building Stories*, London and New York: Focal Press, 2008

Bacher, H., *Dream Worlds: Production Design for Animation*, London and New York: Focal Press, 2007

Barrier, M., *Hollywood Cartons: American Animation in the Golden Age*, New York and Oxford: Oxford University Press, 1999

Beck, J., *Animation Art*, London: Flame Tree Publishing, 2004

Beckerman, H., *Animation: The Whole Story*, New York: Allworth Press, 2004

Bell, E. et al. (eds), *From Mouse to Mermaid: The Politics of Film, Gender and Culture*, Bloomington, VT, and Indianapolis: Indiana University Press, 1995

Birn, J., *Digital Lighting and Rendering*, Berkeley, CA: New Riders Press, 2000

Blair, P., *Cartoon Animation*, Laguna Hills, CA: Walter Foster Publishing, 1995

Brierton, T., *Stop-Motion Armature Machining*, Jefferson, NC: McFarland & Co., 2002

——, *Stop-Motion Puppet Sculpting*, Jefferson, NC: McFarland & Co., 2004

——, *Stop-Motion Filming and Performance*, Jefferson, NC: McFarland & Co., 2006

Brophy P. (ed.), *Kaboom! Explosive Animation from Japan and America*, Sydney: Museum of Contemporary Art, 1994

Bryman, A., *Disney and His Worlds*, London & New York: Routledge, 1995

Byrne, E. & McQuillan, M., *Deconstructing Disney*, London and Sterling, VA: Pluto Press, 1999

Cabarga, L., *The Fleischer Story*, New York: Da Capo, 1988

Canemaker, J. (ed.), *Storytelling in Animation*, Los Angeles: AFI, 1988

Cholodenko, A. (ed.), *The Illusion of Life*, Sydney: Power/AFC, 1991

Chong, A., *Basics Animation: Digital Animation*, Lausanne: AVA Publishing, 2007

Cohen, K., *Forbidden Animation*, Jefferson, NC, and London: McFarland & Co., 1997

Cook, B. & Thomas, G. (eds), *The Animate! Book*, UK: LUX, 2006

Corsaro, S. & Parrott, C. J., *Hollywood 2D Digital Animation*, New York: Thompson Delmar Learning, 2004

Cotte, O., *Secrets of Oscar-winning Animation*, London and New York: Focal Press 2007

Culhane, S., *Animation: From Script to Screen*, London: Columbus Books, 1998

Currell, D., *Puppets and Puppet Theatre*, Marlborough: The Crowood Press, 1999

Demers, O., *Digital Texturing and Painting*, Berkeley, CA: New Riders Press, 2001

Drate, S. & Salavetz, J., *Pure Animation – Steps to Creation with 57 Cutting-Edge Animators*, London and New York: Merrell, 2007

Edera, B., *Full Length Animated Feature Films*, London and New York: Focal Press, 1977

Faber, L. & Walters, H., *Animation Unlimited; Innovative Short Films Since 1940*, London: Laurence King, 2004

Finch, C., *The Art of Walt Disney: From Mickey Mouse to Magic Kingdoms*, New York: Portland House, 1988

Frierson, M., *Clay Animation: American Highlights 1908–Present*, New York: Twayne, 1993

Furniss, M., *Art in Motion: Animation Aesthetics*, London and Montrouge: John Libbey, 1996

——, *The Animation Bible: A Guide to Everything – From Flipbooks to Flash*, London: Laurence King, 2008

Gardner, G., *Computer Graphics and Animation: History, Careers, Expert Advice*, New York and London: GGC Publishing, 2002

Gehman, C., & Reinke, S. (eds), *The Sharpest Point: Animation at the End of Cinema*, Toronto: YYZ Books, 2006

Glebas, F., *Directing the Story: Professional Storytelling and Storyboarding Techniques for Live Action and Animation*, Boston and Oxford: Focal Press, 2008

Grant, J., *Masters of Animation*, London: Batsford, 2001

Hahn, D., *The Alchemy of Animation: Making an Animated Film in the Modern Age*, Los Angeles: Disney Editions, 2008

Halas, J., *Masters of Animation*, London: BBC Books, 1987

Harnes, P. (ed.), *Dark Alchemy: The Films of Jan Svankmajer*, Trowbridge: Flicks Books, 1995

Harryhausen, R. & Dalton, T., *A Century of Model Animation: From Méliès to Aardman*, London: Aurum Press, 2008

Hart, C., *How to Draw Animation*, New York: Watson-Guptill Publications, 1997

Hoffer, T., *Animation: A Reference Guide*, Westport, CT: Greenwood, 1981

Holman, L. Bruce, *Puppet Animation in the Cinema: History and Technique*, Cranberry, NJ: Tantivy Press, 1975

Hooks, E., *Acting for Animators*, Portsmouth, NH: Heinemann, 2000

Horton, A., *Laughing Out Loud: Writing the Comedy Centred Screenplay*, Los Angeles: University of California Press, 1998

Johnson, O. & Thomas, F., *The Illusion of Life*, New York: Abbeville Press, 1981

Kanfer, S., *Serious Business: The Art and Commerce of Animation in America from Betty Boop to Toy Story*, New York: Scribner, 1997

Kerlow, I. V., *The Art of 3D: Computer Animation and Effects*, New York: John Wiley & Sons, 2003

Kuperberg, M., *Guide to Computer Animation*, Boston and Oxford: Focal Press, 2001

Laybourne, K., *The Animation Book*, Three Rivers, MI: Three Rivers Press, 1998

Lent, J. (ed.), *Animation in Asia and the Pacific*, London and Paris: John Libbey, 2001

Leslie, E., *Hollywood Flatlands: Animation, Critical Theory and the Avant Garde*, London and New York: Verso, 2002

Levi, A., *Samurai from Outer Space: Understanding Japanese Animation*, Chicago: Open Court, 1996

Leyda, J. (ed.), *Eisenstein on Disney*, London: Methuen, 1988

Lord, P. & Sibley, B., *Cracking Animation: The Aardman Book of 3D Animation*, London: Thames & Hudson, 1999

McKee, R., *Story: Substance, Structure, Style and the Principles of Screenwriting*, London: Methuen, 1999

Missal, S., *Exploring Drawing for Animation*, New York: Thomson Delmar Learning, 2004

Murphy, M., *Beginner's Guide to Animation: Everything You Need to Know to Get Started in Animation*, New York: Watson-Guptill, 2008

Napier, S., *Anime: From Akira to Princess Mononoke*, New York: Palgrave, 2001

Neuwirth, A., *Makin' Toons: Inside the Most Popular Animated TV Shows and Movies*, New York: Allworth Press, 2003

Paik, K. & Iwerks, L., *To Infinity and Beyond! The Story of Pixar Animation Studios*, London: Virgin Books, 2007

Patmore, C., *The Complete Animation Course*, London: Thames & Hudson, 2003

Pilling, J. (ed.), *That's Not All Folks: A Primer in Cartoonal Knowledge*, London: BFI, 1984

——, (ed.), *Women and Animation: A Compendium*, London: BFI, 1992

——, (ed.), *A Reader In Animation Studies*, London and Paris: John Libbey, 1997

——, *2D and Beyond*, Hove and Crans-près-Céligny: RotoVision, 2001

Pointon, M. (ed.), *Art History (Cartoon: Caricature: Animation)*, Vol. 18, No. 1, March 1995

Priebe, K., *The Art of Stop-Motion Animation*, Clifton Park, NY: Delmar, 2006

Purves, B., *Basics Animation: Stop-motion*, Lausanne: AVA Publishing, 2010

——, *Stop Motion: Passion, Process and Performance*, Boston and Oxford: Focal Press, 2007

Rattner, P., *3D Human Modeling and Animation*, New York: John Wiley & Sons, 2003

Roberts, S., *Character Animation in 3D*, Boston and Oxford: Focal Press, 2004

Russett, R. & Starr, C., *Experimental Animation: Origins of a New Art*, New York: Da Capo, 1988

Sandler, K. (ed.), *Reading the Rabbit: Explorations in Warner Bros. Animation*, New Brunswick: Rutgers University Press, 1998

Scott, J., *How to Write for Animation*, Woodstock and New York: Overlook Press, 2003

Segar, L., *Creating Unforgettable Characters*, New York: Henry Holt & Co, 1990

Selby, A., *Animation in Process*, London: Laurence King, 2009

Shaw, S., *Stop Motion: Crafts for Model Animation*, Boston and Oxford: Focal Press, 2003

Simon, M., *Storyboards*, Boston and Oxford: Focal Press, 2000.

——, *Producing Independent 2D Character Animation*, Boston and Oxford: Focal Press, 2003

Smoodin, E., *Animating Culture: Hollywood Cartoons from the Sound Era*, Oxford: Roundhouse Publishing, 1993

Stabile, C. & Harrison, M. (eds), *Prime Time Animation*, London and New York: Routledge, 2003

Subotnick, S., *Animation in the Home Digital Studio*, Boston and Oxford: Focal Press, 2003

Taylor, R., *The Encyclopaedia of Animation Techniques*, Boston and Oxford: Focal Press, 1996

Tumminello, W., *Exploring Storyboarding*, Boston and Oxford: Focal Press, 2003

Wasko. J., *Understanding Disney*, Cambridge and Malden: Polity Press, 2001

Webster, C., *Animation: The Mechanics of Motion*, Boston and Oxford: Focal Press, 2004

Wells, P., *Around the World in Animation*, London: BFI/MOMI Education, 1996

——, (ed.) *Art and Animation*, London: Academy Group/John Wiley, 1997

——, *Understanding Animation*, London and New York: Routledge, 2010

——, *Animation: Genre and Authorship*, London: Wallflower Press, 2002

——, *Animation and America*, Edinburgh: Edinburgh University Press, 2002

——, *Basics Animation: Drawing for Animation*, Lausanne: AVA Publishing, 2008

Wells, P. & Hardstaff, J., *Re-Imagining Animation: The Changing Face of the Moving Image*, Lausanne: AVA Publishing, 2008

Wiedemann, J. (ed.), *Animation Now!* London and Los Angeles: Taschen, 2005

Resources

Whitaker, H. & Halas, J., *Timing for Animation*, Boston and Oxford: Focal Press, 2002

White, T., *The Animator's Workbook*, New York: Watson-Guptill Publications, 1999

Williams, R., *The Animator's Survival Kit*, London and Boston: Faber, 2001

Winder, C. & Dowlatabadi, Z., *Producing Animation*, Boston and Oxford: Focal Press, 2001

Withrow, S., *Toon Art*, Lewes: Ilex, 2003

International Animation Festivals

A great way to see new films, meet their creators and generally get inspired by contemporary animation is to visit the many dedicated animation film festivals. Here is a selection of global events that take place in different locations, all year round.

2d Or Not 2d Animation Festival
Seattle, United States
Anifest Czech Republic
Teplice, Czech Republic
Anifest India
Mumbai, India
Anifilm
Třeboň, Czech Republic
Anima Mundi
Rio de Janeiro / São Paulo, Brazil
Animac
Lleida, Spain
Animasyros
Syros Island / Athens, Greece
Animated Dreams
Tallinn, Estonia
Animated Encounters Festival
Bristol, United Kingdom
Animateka
Ljubljana, Slovenia
Animerte Dager
Fredrikstad, Norway
Anim'est
Bucharest, Romania
International Animated Film Festival
Poznan, Poland
Animex International Festival of Animation and Computer Games
Teesside, United Kingdom
Annecy International Animated Film Festival
Annecy, France
Bradford Animation Festival
Bradford, United Kingdom
Brickfilmsfestivalen Sweden
Örnsköldsvik, Sweden
Brisbane International Animation Festival
Brisbane, Australia
Canterbury Anifest
Canterbury, United Kingdom
Cartoons on the Bay, International Festival of TV Animation
Positano, Italy
China International Cartoon and Animation Festival
Hangzhou, China
Cinanima
Espinho, Portugal
Cineme International Animation Festival
Chicago, United States
CTN animation eXpo
Los Angeles, United States
Fantoche International Animation Festival
Baden, Switzerland
Flip Animation Festival
Wolverhampton, United Kingdom

GIRAF
Calgary, Canada
Holland Animation Film Festival
Utrecht, Holland
Hiroshima International Animation Festival
Hiroshima, Japan
International Digital Film Festival Kinofest
Bucharest, Romania
KLIK! Amsterdam Animation Festival
Amsterdam, Netherlands
London International Animation Festival
London, United Kingdom
Melbourne International Animation Festival
Melbourne, Australia
New York Animation Festival
New York, United States
Ottawa International Animation Festival
Ottawa, Canada
Platform International Animation Festival
Portland, United States
Red Stick International Animation Festival
Baton Rouge, United States
Savannah International Animation Festival
Savannah, United States
South Beach International Animation Festival
Miami, United States
Stuttgart Festival of Animated Film
Stuttgart, Germany
Tecnotoon Animation Fest
Miami, United States
Tofuzi Festival of Animated Film
Tbilisi, Georgia
Waterloo Festival for Animated Cinema
Waterloo, Canada
Zagreb World Festival of Animated Films
Zagreb, Croatia

Important Reference Sites

Here are some interesting starting points to see and hear what others are doing.

Animation World Network
www.awn.com
Animation resources
www.toonhub.com
Animation links
www.animationarena.com/animation-links.html
American animated cartoons reference
www.toonarific.com
UK animated cartoons reference
www.toonhound.com
Cartoon news and discussion
forum.bcdb.com

Index

Picture credits

The author and Laurence King Publishing Ltd wish to thank the institutions and individuals who have kindly provided photographic material for use in this book. If sources for illustrations and copyright credits have not been given in the captions or on page 2, then they are given below. While every effort has been made to trace the present copyright holders, the publishers and author apologize in advance for any unintentional omission or error, and will be pleased to insert the appropriate acknowledgment in any subsequent edition.

Numbers in bold refer to pages in the book unless otherwise stated.

T = top, **B** = bottom, **L** = left, **R** = right, **C** = center

5 Science Museum, produced by Studio AKA, directed by Grant Orchard; **6** © Fischinger Trust, courtesy Center for Visual Music (www.centerforvisualmusic.org); **8T** Courtesy American Museum of Natural History; **8B** Courtesy BFI; **9** Kevork Djansezian/Getty Images; **10** Characters and images depicted © Otomo Katsuhiro, cel photographs © Joe Peacock and Art of Akia Exhibit; **12** A Close Shave © Aardman Animations Limited / Wallace & Gromit Ltd 1995; **14, 15** Science Museum, produced by Studio AKA, directed by Grant Orchard; **16** © Chris Shepherd; **17** © Suzie Templeton/BreakThru Peter Ltd; **18** Courtesy Ottawa Animation Festival; **19L** © National Media Museum/SSPL; **19C** Courtesy Anne Simon, Lobster Films; **19R, 20L** Courtesy Ray Pointer, Inkwell; **20CT** Courtesy BFI; **20RT** Courtesy BFI; **20RB** © Fischinger Trust, courtesy Center for Visual Music (www.centerforvisualmusic.org); **21RT** ©1952 National Film Board of Canada. All rights reserved; **21RB** Courtesy The Halas & Batchelor Collection; **22C** Courtesy Dan Postgate, Smallfilms; **22R** Courtesy BFI; **23L** Ed Emshwiller. "Sunstone," 1979. Courtesy Electronic Arts Intermix (EAI), New York; **23R** Characters and images depicted © Otomo Katsuhiro, cel photographs © Joe Peacock and Art of Akia Exhibit; **25** © Beryl Productions International Ltd./S4C; **26** © Chris Shepherd; **28T** Crew: Guilherme Marcondes, Andrezza Valentin, Cia Stromboli, Trattoria, Cassiano, Joao, Samuel Casal, Birdo Studio, Paulo Beto, Zeroum; **28C, 28B** Nexus Productions; **32** Skype, produced by Studio AKA, directed by Grant Orchard, agency: AMV, client: Skype; **33** Courtesy Julia Pott; **34T** Courtesy The Halas & Batchelor Collection; **34B** BBH Creative Team/Directors: Nick Kidney & Kevin Stark, BBH Producer: Matt Towell, BBH Strategy Director: Simeon Adams, Neil Godber, BBH Team Manager: Polly Knowles, BBH Team Director: Simon Coles, Production Company: Passion Pictures, Director: Chris Curtis, Producer: Belle Buckley, Post Production/Editing: Passion Pictures, Sound: Factory Studios, Exposure: UK TV, cinema, online; **35** © Chris Shepherd; **38** BBH Creative Team/Directors: Nick Kidney & Kevin Stark, BBH Producer: Matt Towell, BBH Strategy Director: Simeon Adams, Neil Godber, BBH Team Manager: Polly Knowles, BBH Team Director: Simon Coles, Production Company: Passion Pictures, Director: Chris Curtis, Producer: Belle Buckley, Post Production/Editing: Passion Pictures, Sound: Factory Studios, Exposure: UK TV, cinema, online; **39** Courtesy The Halas & Batchelor Collection; **40** Science Museum, produced by Studio AKA, directed by Grant Orchard; **41** © Beryl Productions International Ltd./S4C; **44** Crew: Guilherme Marcondes, Andrezza Valentin, Cia Stromboli, Trattoria, Cassiano, Joao, Samuel Casal, Birdo Studio, Paulo Beto, Zeroum; **45** LoveSport, produced by Studio AKA, directed by Grant Orchard; **47** Courtesy Johnny Hardstaff (www.johnnyhardsraff.com); **48** © Elizabeth Hobbs; **49** Produced by Studio AKA; **50** The Wrong Trousers © Aardman Animations Limited / Wallace & Gromit Ltd 1993; **51** Take Me Out, client: Franz Ferdinand, commissioner: John Moule, production company: Nexus Production / Filmtecknarna, producer: Julia Parfitt; **52T** Courtesy The Halas & Batchelor Collection; **52B** Director: Mr. Ari Folman, Art Director and Illustrator: Mr. David Polonsky; **54** Head

Gear Studio; **55T** © Elizabeth Hobbs; **55B** Back to the Start, client: Chipotle, agency: CAA and Chipotle, director: Johnny Kelly, producer: Liz Chan; **57** © NFB, courtesy Koji Yamamura; **58** Headgear Sketches; **59** Courtesy Johnny Hardstaff (www.johnnyhardsraff.com); **60** © Joanna Quinn/TransEuropeFilm; **61** © Beryl Productions International Ltd./S4C; **63** Courtesy Royal College of Art; **65** Lost and Found, produced by Studio AKA, based on the book by Oliver Jeffers, adapted and directed by Philip Hunt; **66** Courtesy Jason Walker, Clyde Henry Productions, and The National Film Board of Canada; **69** Animation: Sherbet, Animation Director: Jonathan Hodgson, Animation Producer: Jonathan Bairstow, Producer / Director: Zac Beattie, Executive Producer: Nick Mirsky, All Rights BBC; **71** Courtesy Julia Pott; **72** Courtesy Royal College of Art; **74** Courtesy of CalArts; **76** BBH Creative Team/Directors: Nick Kidney & Kevin Stark, BBH Producer: Matt Towell, BBH Strategy Director: Simeon Adams, Neil Godber, BBH Team Manager: Polly Knowles, BBH Team Director: Simon Coles, Production Company: Passion Pictures, Director: Chris Curtis, Producer: Belle Buckley, Post Production/Editing: Passion Pictures, Sound: Factory Studios, Exposure: UK TV, cinema, online; **77** Varmints, produced by Studio AKA, directed by Marc Craste; **78B** Courtesy The Halas & Batchelor Collection; **80** Lost and Found, produced by Studio AKA, based on the book by Oliver Jeffers, adapted and directed by Philip Hunt; **81** © Beryl Productions International Ltd./S4C; **82** BBH Creative Team/Directors: Nick Kidney & Kevin Stark, BBH Producer: Matt Towell, BBH Strategy Director: Simeon Adams, Neil Godber, BBH Team Manager: Polly Knowles, BBH Team Director: Simon Coles, Production Company: Passion Pictures, Director: Chris Curtis, Producer: Belle Buckley, Post Production/Editing: Passion Pictures, Sound: Factory Studios, Exposure: UK TV, cinema, online; **83** Science Museum, produced by Studio AKA, directed by Grant Orchard; **84T** John Coombes – photography, Liz Walker – puppet maker; **84B** © Suzie Templeton/BreakThru Peter Ltd; **85** Back to the Start, client: Chipotle, agency: CAA and Chipotle, director: Johnny Kelly, producer: Liz Chan; **87** Courtesy Barry Purves; **88** Courtesy Jason Walker, Clyde Henry Productions, and The National Film Board of Canada; **89T** © Joanna Quinn/TransEuropeFilm; **89B, 90** Courtesy Royal College of Art; **91** Courtesy Barry Purves; **92T** © NFB, courtesy Koji Yamamura; **92B** Courtesy Royal College of Art; **93** BBH Creative Team/Directors: Nick Kidney & Kevin Stark, BBH Producer: Matt Towell, BBH Strategy Director: Simeon Adams, Neil Godber, BBH Team Manager: Polly Knowles, BBH Team Director: Simon Coles, Production Company: Passion Pictures, Director: Chris Curtis, Producer: Belle Buckley, Post Production/Editing: Passion Pictures, Sound: Factory Studios, Exposure: UK TV, cinema, online; **95** Collision, director: Max Hattler, production: Royal College of Art, 2005; **96** Streeter Lecka/Getty Images; **97T** Courtesy BFI; **97B** Courtesy Royal College of Art; **99B** Creature Comforts © Aardman Animations 1989; **101** Courtesy Library of Congress; **102** BEEP, BEEP and all LOONEY TUNES characters, names and all related indicia are ™ and © Warner Bros. Entertainment Inc. All Rights Reserved; **105** © Robert Seidel, robertseidel.com; **109** Spin, director: Max Hattler, production: Autour de Minuit, 2010; **110** Courtesy of Jan Svankmeyer; **112** Courtesy Barry Purves; **113** © Warner Bros. Entertainment Inc. All Rights Reserved; **114** © S4C; **115** © UNEP, Isabelle Pierrard: Communication Specialist UNEP, Natasha Serlin: Producer / Director, Shroomstudio – Alexander Hatjoullis, Simon Ansell, Arnau Millet, Christian Krupa, Christos Hatjoullis: Animation Team; **118** Courtesy Royal College of Art; **120** Courtesy The Halas & Batchelor Collection; **121** © Robert Seidel, robertseidel.com; **122** Winter Olympics, produced by Studio AKA, directed by Marc Craste, designed by Jon Klassen, client: BBC, agency: RKCR/Y&R; **124** Courtesy Jason Walker, Clyde Henry Productions, and The National Film Board of Canada; **127** Courtesy BFI; **128** Lloyds TSB, produced by

Studio AKA, directed by Marc Craste, agency: RKCR/Y&R, client: Lloyds TSB; **129** Courtesy Barry Purves; **130** © Chris Shepherd; **131** © National Media Museum/SSPL; **132T** © NFB, courtesy Koji Yamamura; **132B** Courtesy Royal College of Art; **133B** Courtesy Center for Visual Music; **134** Courtesy Toon Boom Animation Inc. – toonboom.com; **136** TOUCH created by Ferenc Cakó (writer, animator, director, producer), C.A.K.Ó. Studio Ltd; **137** Courtesy Dan Postgate, Smallfilms; **138** Courtesy Jason Walker, Clyde Henry Productions, and The National Film Board of Canada; **139T** Courtesy BFI; **139B** John Coombes – photography, Liz Walker – puppet maker; **140** Courtesy Barry Purves; **141** Crew: Guilherme Marcondes, Andrezza Valentin, Cia Stromboli, Trattoria, Cassiano, Joao, Samuel Casal, Birdo Studio, Paulo Beto, Zeroum; **142** Courtesy Jason Walker, Clyde Henry Productions, and The National Film Board of Canada; **143T** The Wrong Trousers © Aardman Animations Limited / Wallace & Gromit Ltd 1993; **143B** Headgear set; **144** Holy Flying Circus, client: BBC, production company: Nexus Productions, director: Jim Le Fevre, producer: Luke Youngman; **145** Courtesy Jason Walker, Clyde Henry Productions, and The National Film Board of Canada; **146T** Courtesy Barry Purves; **146B** © Suzie Templeton/BreakThru Peter Ltd; **147** Crew: Guilherme Marcondes, Andrezza Valentin, Cia Stromboli, Trattoria, Cassiano, Joao, Samuel Casal, Birdo Studio, Paulo Beto, Zeroum; **149T** Lloyds TSB, produced by Studio AKA, directed by Marc Craste, agency: RKCR/Y&R, client: Lloyds TSB; **149B** The Big Win, produced by Studio AKA, directed by Marc Craste, client: The National Lottery, agency: AMV; **150** Courtesy Jason Walker, Clyde Henry Productions, and The National Film Board of Canada; **152** © 1957 National Film Board of Canada, All Rights Reserved; **153** Courtesy BFI; **154** Courtesy Ray Pointer, Inkwell; **155T** John Coombes – photography, Liz Walker – puppet maker; **155B** © Robert Seidel, robertseidel.com; **157** LoveSport, produced by Studio AKA, directed by Grant Orchard; **158** Lloyds TSB, produced by Studio AKA, directed by Marc Craste, agency: RKCR/Y&R, client: Lloyds TSB; **159** Courtesy Jason Walker, Clyde Henry Productions, and The National Film Board of Canada; **160T** Courtesy of CalArts; **160B** Courtesy Royal College of Art; **164** © Robert Seidel, robertseidel.com; **166** Courtesy Jason Walker, Clyde Henry Productions, and The National Film Board of Canada; **168** Courtesy of CalArts; **170** Avid MC6 Surround Mixer U1; **172** Sing Up, produced by Studio AKA, directed by Steve Small, agency: AMV, client: Sing Up; **173** LoveSport, produced by Studio AKA, directed by Grant Orchard; **175** Nexus Productions; **177** Courtesy Ottawa Animation Festival; **179** Lost and Found, produced by Studio AKA, based on the book by Oliver Jeffers, adapted and directed by Philip Hunt; **180T** Courtesy of CalArts; **180B** Courtesy Ottawa Animation Festival; **181T** Courtesy Royal College of Art; **181B** Courtesy Jason Walker, Clyde Henry Productions, and The National Film Board of Canada; **182** Courtesy Royal College of Art; **183** Courtesy Ottawa Animation Festival; **184** Courtesy Royal College of Art; **185** Courtesy of CalArts; **186** Lost and Found, produced by Studio AKA, based on the book by Oliver Jeffers, adapted and directed by Philip Hunt; **187** Nexus Productions; **188** Courtesy Julia Pott; **189T** Lloyds TSB, produced by Studio AKA, directed by Marc Craste, agency: RKCR/Y&R, client: Lloyds TSB; **189B** Nexus Productions; **191** Lost and Found, produced by Studio AKA, based on the book by Oliver Jeffers, adapted and directed by Philip Hunt; **195** Nexus Productions; **196** Courtesy of CalArts; **197** Lost and Found, produced by Studio AKA, based on the book by Oliver Jeffers, adapted and directed by Philip Hunt; **198** Courtesy Jason Walker, Clyde Henry Productions, and The National Film Board of Canada; **201T** Nexus Productions; **201B** Lloyds TSB, produced by Studio AKA, directed by Marc Craste, agency: RKCR/Y&R, client: Lloyds TSB; **203** Courtesy Royal College of Art; **205** John Coombes – photography, Liz Walker – puppet maker

Acknowledgements

I am grateful to Laurence King and Helen Rochester for commissioning *Animation* as part of the Portfolio Series, and indebted to Melanie Walker and Donald Dinwiddie for their help and support in shaping and editing the manuscript.

I owe a huge debt of gratitude to my picture researcher, Jemma Robinson, who turned up leads and chased down contributors with dignity and grace when others would have simply declared the task impossible. Without her help, *Animation* would not have such varied and inspiring images. My thanks go to the many contributors who generously supplied images and to the rights holders who granted permission for their images to be reproduced.

This book began and ended its preparation in San Francisco. I started this project on study leave with my family and concluded the final edit in a café on the junction of Mason and Washington Streets. It has been a long time coming – I thank my colleagues at Loughborough University for their encouragement and support, and especially Felicity, Thomas and Imogen at home for their patience, understanding and love.

Andrew Selby
San Francisco, March 2012.